DRAPING FOR FASHION DESIGN

Third Edition

HILDE JAFFE NURIE RELIS

Fashion Institute of Technology
New York, New York

Prentice Hall
Upper Saddle River, NJ 07458

Library of Congress Cataloging-in-Publication Data

Jaffe, Hilde
 Draping for fashion design / Hilde Jaffe, Nurie Relis. — 3rd
ed.
 p. cm.
 ISBN 0-13-082666-9
 1. Costume design. 2. Dressmaking—Pattern design. I. Relis,
Nurie, 1929– II. Title.
TT507 .J34 2000
746.9′2—dc21
 99-33717
 CIP

Acquisitions Editor: Elizabeth Sugg
Director of Manufacturing & Production: Bruce Johnson
Manufacturing Buyer: Ed O'Dougherty
Managing Editor: Mary Carnis
Production Liaison: Adele Kupchik
Editorial Assistant: Delia Uherec
Full Service Production/Formatting: BookMasters, Inc.
Creative Director: Marianne Frasco
Cover Design Coordinator: Miguel Ortiz
Cover Design: Wanda España
Marketing Manager: Shannon Simonsen

© 2000 by Prentice-Hall, Inc.
Upper Saddle River, New Jersey 07458

Printed in the United States of America

10 9 8

ISBN 0-13-082666-9

Prentice-Hall International (UK) Limited, *London*
Prentice-Hall of Australia Pty. Limited, *Sydney*
Prentice-Hall Canada Inc., *Toronto*
Prentice-Hall Hispanoamericana, S.A., *Mexico*
Prentice-Hall of India Private Limited, *New Delhi*
Prentice-Hall of Japan, Inc., *Tokyo*
Prentice-Hall (Singapore) Pte. Ltd.
Editora Prentice-Hall do Brasil, Ltda., *Rio de Janeiro*

Dedicated to Mary Ann, Tony,
Lisa D., Benetta, Lisa G.,
Wayne, Wally, and George
who shared their years of
professional experience with us.

Contents

Foreword

They are back better than ever; Hilde Jaffe and Nurie Relis have done it again. Just when you think they could not top themselves they, have done intense research to update *Draping for Fashion Design* and brought it into the new millennium.

As a successful and working designer on Seventh Avenue for nearly 35 years, I feel qualified to give the highest praise and my enthusiastic stamp of approval to this new book by Hilde Jaffe and Nurie Relis. My love for draping goes back to the time I was a student and, even though I have great respect for flat patternmaking, there is no way to achieve subtle nuances of fit and shape on the flat table without draping first.

This new book will fill a big need for students and designers alike. It goes way beyond the highly successful first and second editions of *Draping for Fashion Design,* which have been my bible for many years. They have served me well in my work in the fashion industry and have also provided inspiration to me as adjunct assistant professor at the Fashion Institute of Technology. Many of my colleagues at F.I.T. and in the industry, as well as countless students in America and around the globe, are never without this textbook. We use it as a working tool.

I am extremely pleased that Hilde and Nurie have updated the very valuable section on tailoring in their new book, as tailored clothing has been my love and area of expertise throughout my career and business.

The great value of this book is that the professors share their knowledge in such a wonderfully understandable way, with familiar, time-tested methods newly revised to include the computer in order to fit the needs of today's designers. We need this book to constantly refer to, to brush up our skills, to let it be a springboard for our creativity and give us unlimited potential and success in our business. This is clearly the writers' finest work. This book takes us to the new millennium of "Draping For Fashion Design."

George Simonton, President
George Simonton, Ltd.

Preface

Since the publication of the second edition of *Draping for Fashion Design,* methods of developing new designs in the fashion industry have changed dramatically. The computer is now used at virtually every step of apparel design and manufacturing, requiring that designers must become knowledgeable in its functions and must develop the skills to utilize this highly versatile and efficient tool. Our purpose here is not to describe the technical process of computer-aided design, nor do we propose to teach people how to use the computer. Other books and courses are available for teaching the computer. We do, however, show how the computer is integrated into the basic design and pattern development process.

As important as the computer is, our discussions with various designers have reinforced our belief that designing on the computer is impossible without the basic background of draping in fabric. By draping, the design student acquires the sense of proportion, which can only be developed by seeing the design take shape on the human figure. A feel for texture and the drapability of fabric can only be acquired by actually handling the fabric. Computers are, indeed, used to sketch and draft patterns for new designs, but to do this well requires the ability to correctly visualize the proportions of the finished garment. This skill is developed only by experience with full-size three-dimensional models.

The book has now been significantly expanded. A new chapter, Sportswear and Casual Wear, which includes working with knitted fabrics, has been added. The technique for draping the basic jacket has been revised. We added a section on developing the jacket lining pattern. We also added a simplified method for developing the Peter Pan collar that combines flat pattern-making and draping. The Boned Princess Bodice is also now included. The development of the waistband, along with facings and closures are now combined in a new chapter on functional finishes. Fitting on a live model has been added to the chapter on draping in fabric; and throughout, we have added more sketches to illustrate various procedures.

Although we needed to add and expand a number of narrative sections, we have tried to maintain the basic format of a workbook. Almost every step in the text is clarified with illustrations. Nevertheless, the illustrations cannot work alone, and the text is pertinent to the execution of each project.

We gratefully acknowledge the support and help that we have received from our colleagues at the Fashion Institute of Technology (F.I.T.). The techniques used in this book have been developed over the course of many years of teaching and experimentation by the Fashion Design faculty at F.I.T. Refinements in precision were developed as various methods were tested at faculty workshops and in the classroom. Both students and teachers contributed in this process and mentioning everyone who participated over the years is impossible. Some people, however, were particularly instrumental in the development of the draping curriculum at F.I.T. Most noteworthy are Professor Emeritus Ernestine Kopp, the first chairperson of the Fashion Design Department, and Professor Emeritus Vittorina Rolfo, who for many years was the assistant chairperson and in that capacity was responsible for the development of new teachers in the department. Her expert guidance in the organization and presentation of the material is remembered gratefully by both of us.

We are also deeply indebted to the many faculty members from numerous colleges and universities who, in response to our inquiry, thoughtfully pointed out areas where a third edition of *Draping*

for Fashion Design might be made more useful. The information they shared was invaluable. We carefully considered all responses and wherever possible, followed their suggestions. We especially want to thank Professor Sally I. Helvenston of Michigan State University for pointing out the difficulties encountered when beginners attempted to drape the Peter Pan collar. In response, we have now included a simpler method combining draping with patternmaking. Professor Sharon Bell of the Academy of Art College, San Francisco, and Professor Smock of the Philadelphia College of Textiles and Science, as well as several others, suggested a larger format and more illustrations for additional clarity. This third edition is now a larger book with more, larger, and clearer illustrations. To Professor Jacqueline Keuler of Syracuse University and to the many others who responded anonymously, a huge thank you for your words of encouragement. You inspired us to get back into industry to research current methods and bring our book into the twenty-first century.

Writing this book would have been an impossible task without the unstintingly generous help from currently working designers and other industry professionals. They gave us the opportunity to observe firsthand today's methods of fashion design and pattern development. They shared with us the benefits of years of professional experience, gave us access to their sample rooms, and finally reviewed our material after it was completed.

Many thanks go to Mary Ann Ferro, Designer for Woolrich Industries and Adjunct Assistant Professor at F.I.T., for sharing with us her method of developing the unstructured drop shoulder jacket. Anthony J. Nuzzo, Senior Director at Victoria's Secret Stores and Adjunct Assistant Professor at F.I.T., worked with us on techniques of draping basic patterns in knitted fabrics. Lisa Donofrio, freelance designer and Adjunct Instructor at F.I.T., explained to us the particulars of sweater design. Benetta Barnett, Director of Merchandising at Calvin Klein Jeans/Warnaco, was most helpful regarding the procedures of planning, sourcing, and executing a line. Lisa Goldman, CAD/CAM Systems Director for Donnkenny Apparel, Inc., and Wayne Slossberg of Lectra Systems worked with us regarding the state-of-the-art use of computers in the apparel industry.

A very special thank you is due to Professor Wallace Sloves of F.I.T. for sharing with us the know-how he acquired throughout many years of experience fitting garments on live models and couture customers. His help with the new section on fitting was invaluable.

As in the previous edition, we are again deeply indebted to our friend and colleague, the designer George Simonton. He and his sample-room staff worked with us on the revisions and additions in the chapter on tailored garment design. George served as an enthusiastic cheerleader along every step of the way as this book took shape.

In getting this edition ready for publication, we received unstintingly generous technical support from Dr. Robert Jaffe and Nirdi Relis. Thank you, thank you!

Finally, we want to especially thank our students, who gave us essential feedback and with their enthusiasm inspired us to go on from the beginning to the completion of this work.

HILDE JAFFE
NURIE RELIS

1

Introduction

Draping in fabric on the dress form is a method that is used to create three dimensional models, which will ultimately be developed into a collection of finished sample garments. Although some designers are highly creative as they work out their ideas directly in fabric on the dress form, most designers, or their assistants, drape from a sketch. As draping proceeds and the two-dimensional sketch is transformed into three-dimensional reality, modifications of the design often take place. These modifications occur as proportions of design details are related to the human body and the effect of fabric as it flows and drapes becomes apparent.

When draping, the designer must keep in mind the properties of the fabric to be used for the finished garment. Hand, weight, construction, and surface finishes all contribute to the final effect of the design. Some fabrics have such unique properties that draping the garment pattern in the actual fabric of the finished garment is best. This, however, requires an experienced hand because the cost of most fabrics makes mistakes prohibitively expensive. Muslin, a plain-weave fabric of unfinished cotton, is usually used for draping. The direction of the grain in muslin is easily visible, and its relatively low cost permits free use for experimentation and development. Muslin can be marked with pencil lines, and the finished muslin pattern, which is the end product of draping, can be used repeatedly. Although garments are usually draped on a dress form, the muslin pattern, when stitched together, may also be used for adjusting the fit on the human body.

Although draping is the ideal way to develop ideas and create new silhouettes, it is sometimes combined with flat patternmaking. This combined approach is especially useful when variations on an existing silhouette are produced. In order to combine draping with flat pattern-making, a hard-paper pattern is developed from the basic draped model, and the variations are worked out by manipulating this paper pattern. If the paper pattern has been digitized into a computer, variations can be developed easily on the screen. Several computer patternmaking programs, developed for this purpose, are currently commercially available.

Once the basic principles of draping have been mastered, the designer is free to translate an endless variety of ideas into finished garments. Various types of fit can be developed to achieve the current fashion silhouette. Garments can fit close to the body, be relaxed and easy for freedom of movement, or be created in various degrees of oversizing. The loose fit of oversizing is often very fashionable, and in addition, it accommodates endless variations of body dimensions and results in freely flowing apparel when soft fabrics are used. Tailored garments are very precisely oversized, and fabrics are reinforced with interfacing and/or backing to achieve a well-defined silhouette.

The elementary steps of fashion design presented in this book can be modified and combined in ever-changing ways to reflect the current fashion picture. Our aim throughout is to reduce the endless changes of fashion to the basic principles that form the foundation from which the creative designer can take wing.

Equipment Needed

MUSLIN—Muslin is available in three basic types:

1. A coarse weave of medium weight used by beginners because the grain is easily recognized.
2. A lightweight, finely woven fabric used for soft draping.
3. A heavyweight, firmly woven fabric used for draping tailored garments. This type is also known as toile muslin.

SCISSORS—9-inch, good-quality scissors are recommended; they must be kept well sharpened (Figure 1.1).

Figure 1.1 / Scissors

TAPE MEASURE—The tape measure should have a smooth surface and be clearly marked in inches. A tape measure marked in inches on one side and in centimeters on the reverse side simplifies conversion when that is necessary.

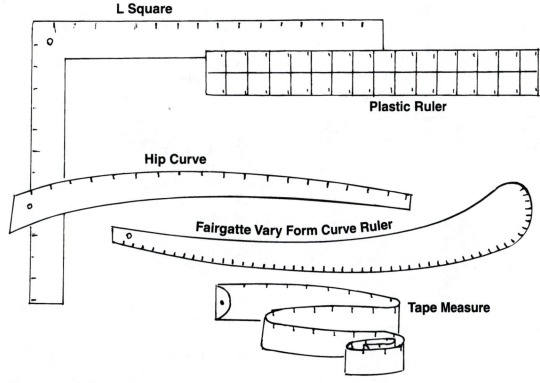

Figure 1.2 / Measuring tools

CLEAR PLASTIC RULER—18 inches by 2 inches, marked with squared lines at one-quarter-inch intervals is recommended.

FAIRGATE VARY FORM CURVE RULE—An 18-inch curved ruler that is particularly useful for shaping sleeve caps and armholes in tailored garments.

HIP CURVE—A shallow curved, 24-inch metal ruler.

L-SQUARE—An L-shaped metal ruler; the long arm measures 24 inches and the short arm 14 inches.

FRENCH CURVE—A clear plastic, irregular curve used for armholes and necklines (Figure 1.3).

PINS—Number 17 steel satin pins are recommended (Figure 1.4).

Figure 1.4 / Pins

Figure 1.3 / French curve

TRACING WHEEL—Two types of tracing wheels are available. The tracing wheel with the small serrated edge is used to mark fabric for draping purposes, and the tracing wheel with small spikes is used on paper for flat patternmaking (Figure 1.5).

Figure 1.5 / Tracing wheel

TRACING PAPER—Large sheets of carbon tracing paper should be mounted on oak tag or poster board to facilitate the transfer of lines from one piece of muslin to another. Contrasting colors may be used on muslin for easy visibility, but because these colors are indelible they cannot be removed and should never be used when draping directly in the fabric of the finished garment (Figure 1.6).

Figure 1.6 / Tracing paper

PENCILS AND PENS—Number 2 pencils, well sharpened at all times, are used to mark and draw pattern outlines on muslin. Some designers prefer an automatic fine-line pencil or a fine-line ball point pen for this purpose.

STYLE TAPE OR GRAPHIC TAPE—Style tape is a narrow, woven ribbon tape, usually black to contrast with muslin. Graphic tape is non-woven tape that adheres to paper or fabric. It is made in various widths but only the narrow width is recommended for our purpose. Either tape may be used to indicate style lines.

SKIRT MARKER—A skirt marker marks hem lengths accurately. Markers are adjustable and are available for use with chalk powder or pins (Figure 1.7).

Figure 1.7 / Skirt marker

The Dress Form

A professional dress form is essential for draping. Although various types of adjustable forms that are adequate for fitting are available for dressmaking purposes, these don't provide the solid shape and surface quality required for pinning, which are necessary for creating original garment patterns.

Dressmaker forms, dress forms for short, are not only used to design dresses. They also serve for separate tops and skirts. Pants are draped and fitted on a bifurcated pants form specially designed for that purpose. The forms required for most apparel do not exactly replicate the human body. The undulations of the body are smoothed out to provide a simplified surface on which to work. Nevertheless, forms are molded to the exact measurements specified for each size. Specially molded forms are also available for body-fitted apparel such as swimsuits, brassieres, and body wear, as well as specially sized forms for coats and suits.

Most designers of women's apparel work on a dress form in the sample size used by their company. This form may be molded to the body measurements of the live model used for fittings, or it may be a standard size. Many companies use a size 8 for samples.

PREPARING THE DRESS FORM FOR DRAPING—The seams on the dress form are precisely and conventionally placed. They are used as reference points in draping and must be properly aligned to result in well-balanced patterns. Occasionally, the seams on some dress forms have been shifted and their position must be corrected (Figures 1.8 and 1.9).

1. Align shoulder and side seams so that the shoulder seam and side seam form a continuous line from neckline to waistline passing through the center of the plate screw at the armplate. Use the edge of the tape measure to determine the correct alignment.
2. Make the side seam from the waistline to the lower edge of the torso a plumb-line to the floor.
3. Check that the waistline tape is placed so that it flows in a smooth, continuous line around the narrowest point of the waistline.
4. Make all corrections on the dress form by sinking pins into the form at the corrected seam intersections.

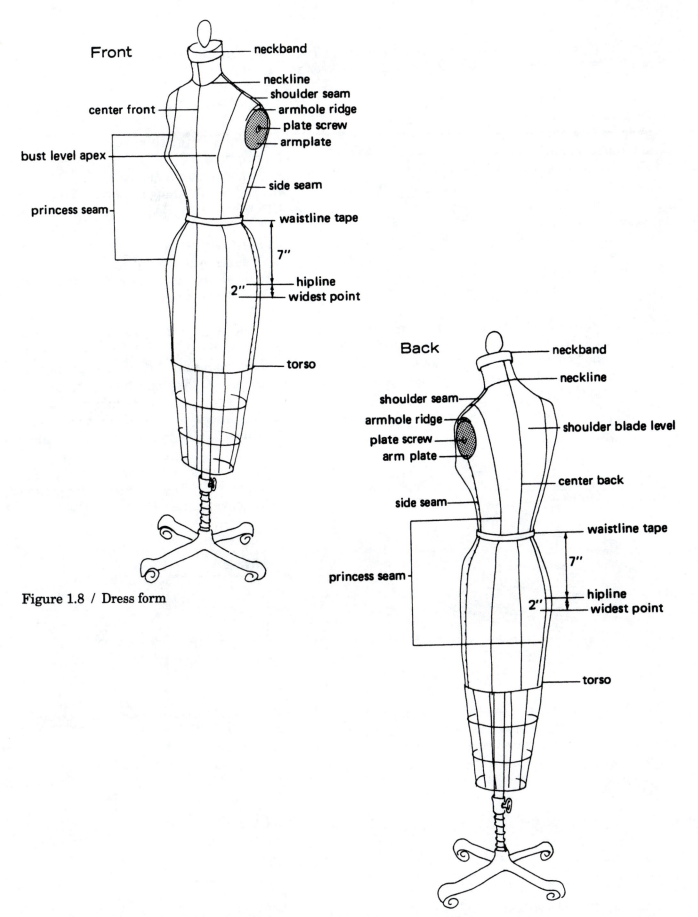

Front

neckband

neckline

shoulder seam

center front

armhole ridge

plate screw

armplate

bust level apex

side seam

princess seam

waistline tape

7"

hipline

2"

widest point

torso

Figure 1.8 / Dress form

Back

neckband

neckline

shoulder seam

armhole ridge

plate screw

arm plate

shoulder blade level

center back

side seam

princess seam

waistline tape

7"

hipline

2"

widest point

torso

Figure 1.9 / Dress form

Pressing Equipment

Home equipment may be used; however, equipment for a professional design studio should include:

IRON—The professional pressing iron, used for hand pressing, is heavy with an adjustable temperature control and a thumb press for automatic steam. Distilled water is heated in a separate boiler attached to the ironing board, and the resulting steam is fed to the iron where it is released with the thumb press while pressing (Figure 1.10).

Figure 1.10 / Iron

IRONING BOARD—The professional ironing board, used for hand pressing, is a well-padded, shaped and heated board. It is equipped with a vacuum blower that instantly dries excess steam (Figure 1.11).

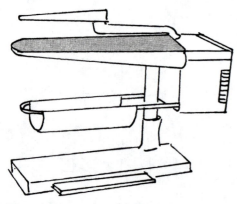

Figure 1.11 / Ironing board

SLEEVE BOARD—A well-padded miniature of a full-sized ironing board is used to press sleeves and hard-to-reach small details (Figure 1.12).

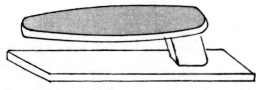

Figure 1.12 / Sleeve board

Grain

Grain is the direction of the fibers or yarn in woven fabric.

1. LENGTHWISE GRAIN—also known as *warp.*
 a. Parallel to the selvage.
 b. Strongest.
 c. Least amount of stretch.
 d. Falls easily along the lines of the body.
2. CROSSWISE GRAIN—Also known as *weft* or *fill.*
 a. Perpendicular to the selvage.
 b. Weaker yarn (in muslin).
 c. Somewhat more stretch than the lengthwise grain.
3. BIAS
 a. A diagonal line across the weave of the fabric.
 b. Maximum amount of stretch as compared to the lengthwise grain and crosswise grain of the fabric.
 c. Clings softly to the body when draped.
 d. *Garment bias* is achieved when fabric is cut off the grain at any angle.
 e. *True bias* is achieved when fabric is cut at a 45° angle to the crosswise and lengthwise grain (Figure 1.13).

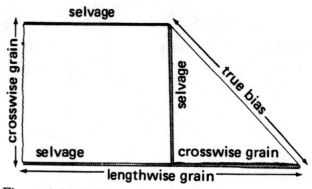

Figure 1.13 / Grain

Preparation of Muslin for Draping

1. TEARING
 a. Estimate the size of muslin needed, allowing a reasonable amount of extra fabric for ease, seam allowance, and styling.
 b. Clip edge of muslin with scissors, and tear across the grain with sufficient pressure to break yarns evenly.
 c. The true crosswise grain, or the true lengthwise grain, should form the edge of muslin used for draping. Because the selvage is closely woven, it tends to hold in the muslin and often will throw the weave off; therefore center front and center back should be planned at least 3 inches from the selvage.

2. BLOCKING
 Before draping, muslin may have to be reshaped so that yarns of the crosswise and lengthwise grain are at perfect right angles to each other. To reshape muslin, pull the edges diagonally until the fabric is squared (Figure 1.14).

muslin off grain

blocked muslin

Figure 1.14 / Blocking

3. PRESSING
 a. Once the fabric has been blocked, the position of the yarns is set with the steam and heat of pressing.
 b. Press in the direction of the lengthwise and the crosswise grain; never press on the bias.
 c. Apply steam followed by the dry iron.

Seam Allowances

Seam allowances in apparel depend to a large extent on the type of sewing machine used in manufacturing. The conventional lockstitch machine can stitch seams of any width. The width of the seam allowance depends on the shape and location of the seam, the anticipated need for alteration, and the selling price of the finished garment. The over-edge and safety-stitch machines, widely used in knitted apparel, sportswear, sleepwear and other casual clothing require seam allowances ranging from ¼ inch to ½ inch.

Beginning students of draping are usually expected to add 1-inch seam allowances on all straight seams, including side seams, shoulder seams, waistline seams, and underarm seams. All curved seams are planned with ½-inch seam allowances.

2

Basic Patterns

Most of the procedures of draping are utilized in the development of basic patterns and therefore, this chapter serves as an excellent introduction to draping for the beginner. Here all the essential skills are introduced. Once these skills have been mastered, the novice is ready to proceed to the more exciting and challenging work of creative draping for fashion design.

These basic patterns, or foundation patterns as they are often called, serve as the basis for all pattern-making. Although basic patterns can be drafted from measurements directly on paper, draping them in muslin on the dress form is simpler. Precise fit is important, because the fit of a company's basic patterns may affect the fit of the entire collection (Figure 2.1).

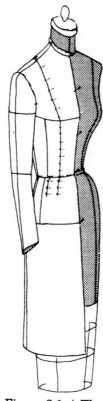

Figure 2.1 / The basic patterns

Basic Bodice—Front

A. PREPARATION OF MUSLIN

1. Tear the end of the muslin along the crosswise grain.
2. On the dress form, measure the distance from the top of the neckband to the waistline. 17.5"
3. Measure along the selvage of the muslin the distance from the top of the neckband to the waistline plus 4 inches. 17.5+4 = 21.5
4. Clip the selvage and tear along the crosswise grain.
5. On the dress form, measure the distance from the side seam to the center front at bust level. 10.5
6. Measure along the crosswise grain of the muslin the distance from side seam to center front at bust level plus 4 inches. 10.5+4 = 14.5
7. Clip and tear along the lengthwise grain.
8. Block and press the muslin.
9. Draw the grain line for center front 1 inch from the lengthwise grain torn edge (Figure 2.2).

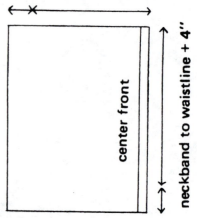

center front to side seam + 4″

center front

neckband to waistline + 4″

Figure 2.2 / Steps A1–9

10. Divide the muslin in half at the center front on the crosswise grain to establish the bustline level. Draw a crosswise grain line at bustline level.
11. On the dress form, determine the apex of the breast with a pin. Measure the distance from the apex to the center front.
12. On the muslin, mark the position of the apex at the bust-level crosswise grain line.
13. On the dress form, measure the distance from the apex to the side seam.
14. Add ⅛ inch for ease, and indicate the position of the side seam on the bust-level crosswise grain.
15. Divide the distance between the apex and the side seam in half to determine the center of the princess panel (Figure 2.3).

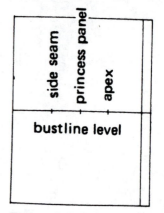

side seam

princess panel

apex

bustline level

Figure 2.3 / Steps A10–15

16. Draw lengthwise grain lines from the apex and the center of the princess panel to the lower edge of the muslin. If necessary, block and press muslin again before draping.

17. Fold under the 1-inch extension at center front.
18. Crease the lengthwise grain line at the apex (Figure 2.4).

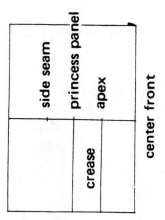

Figure 2.4 / Steps A16–18

B. DRAPING STEPS

1. Pin the muslin to the dress form at the apex. Two pins inserted in opposite directions will prevent the muslin from shifting.
2. Smooth the muslin up from the apex so that the center front grain line of the muslin lies directly over the center front seam of the dress form.
3. Pin at the center front and neckline.
4. Pin at the center front halfway between the neckline and bust level.
5. Drape the muslin so that the bustline level is straight across the dress form, leaving the lower half of the muslin hanging like a box jacket; pin on the bustline level between apex and side seam to prevent the muslin from sagging (Figure 2.5).

6. Pin the princess panel grain line at the waistline, taking a pinch. The pinch pickup equals ¹⁄₁₆ inch.
7. Slash the princess panel grain line from the lower edge of the muslin to ½ inch below the waistline.
8. Pin the muslin to the side seam at the waistline and underarm intersections.
9. Hold the muslin at the center front and waistline without disturbing the direction of the straight grain.
10. Pin the dart pickup at the waistline; the apex grain line must be at the center of the dart.
11. Pin the center front at the waistline so that the crosswise grain is straight between the dart and center front. Move the excess muslin up toward the bust level and pin below the curve of the breast at center front. A hollow space will be between the breasts allowing the muslin to maintain a straight grain across the entire front of the bodice (Figure 2.6).

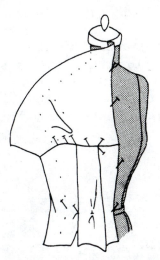

Figure 2.6 / Steps B6–11

12. To drape the neckline:
 a. Cut away a rectangular piece of muslin 1 inch above the neckline and center front intersection. The cut should be 1 inch deep and extend upward to the edge of the muslin (Figure 2.7).

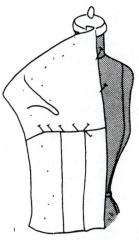

Figure 2.5 / Steps B1–5

Figure 2.7 / Step B12(a)

b. Smooth the muslin *on grain* from the center front across and then up at a right angle toward the shoulder and neckline intersection.

c. Slash carefully from the outer edge to within ⅜ inch of the neckline so that muslin lies smoothly. Pin at the neckline and shoulder intersection (Figure 2.8).

Figure 2.8 /
Steps B12(b and c)

13. Smooth the muslin along the shoulder seam from the neckline to the princess seam; dot the intersection of the princess and shoulder seams.
14. Crease lightly from the dot toward the apex, smooth around the armhole from the side seam up toward the shoulder, and move in the excess fullness so that it lies flat underneath the crease and forms the shoulder dart. Pin at the shoulder seam and armhole intersection (Figure 2.9).

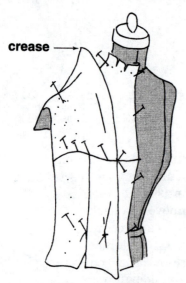

crease →

Figure 2.9 / Steps B13–14

15. Pin the dart so that the muslin lies flat at the shoulder seam.
16. Pin across the vanishing points of the shoulder dart and the waistline dart. The *vanishing point* is the end of the dart (Figure 2.10).

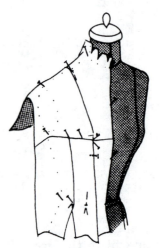

Figure 2.10 / Steps B15–16

C. MARKING—Mark all muslins with a well-sharpened pencil. Crossmarks and dots indicate the seam lines of the garment being draped. Crossmarks follow the direction of intersecting seam lines. Dots should be precisely marked, small points.

1. NECKLINE—Crossmark at center front; dot to shoulder along neckline; crossmark at shoulder and neckline intersection.
2. SHOULDER—Crossmark both edges of the dart at the shoulder seam; crossmark shoulder seam and armhole intersection.
3. ARMHOLE—Dot armhole ridge from the shoulder seam to plate screw level; dot the edge of the armplate at the plate screw level; crossmark the intersection of the armplate and side seam. Place the mark for the front bodice side seam directly behind the ridge of the side seam of the dress form.
4. WAISTLINE—Crossmark the waistline and side seam intersection; dot along the lower edge of the waistline tape from

side seam to dart; crossmark both sides of the dart pin (Figure 2.11).

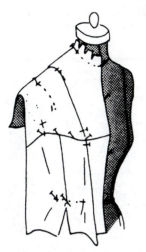

Figure 2.11 / Steps C1–4

D. TRUEING—*Trueing* the muslin is drawing the lines that define the exact dimensions of the finished pattern.

 1. Remove the muslin from the dress form, and remove all pins except those indicating the vanishing points of the darts.
 2. Check that the dart crossmarks at the waistline are equally distant from the apex grain line. Adjust, if necessary (Figure 2.12).

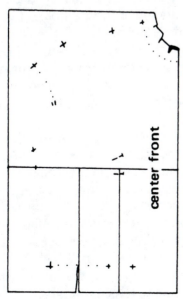

center front

Figure 2.12 / Steps D1–2

3. True waistline dart by drawing lines from the vanishing point through the waistline crossmarks to the lower edge of the muslin. Extend all lines for seams or darts beyond the dimensions of the pattern.
4. True shoulder dart by drawing a line from the apex to the crossmark nearest the neckline. Mark the vanishing point on this line at pin level; connect the shoulder crossmark nearest the armhole with the vanishing point.
5. Draw the side seam by connecting crossmarks at the armhole and waistline.
6. Lower the armhole for a basic set-in sleeve by measuring down on the dress form from the armhole ridge at the shoulder, over the center of the plate, to the side seam. Armhole depth should be lowered as indicated in the following table.

ARMHOLE DEPTH FOR BASIC SIZES

Size	5	6	7	8	9	10	11	12
Armhole Depth	5⅜	5½	5½	5⅝	5⅝	5¾	5¾	5⅞

At the side seam of the dress form, mark the depth of the lowered armhole with a pin. Determine the distance between this pin and the lower edge of the armplate. Lower the armhole at the side seam of the muslin accordingly (Figure 2.13).

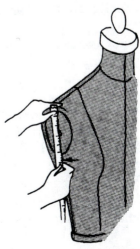

Figure 2.13 / Step D6

7. True the armhole by placing the French curve so that the straight edge touches the shoulder seam and armhole crossmark, passes along the dots of the armhole ridge near the shoulder, and falls midway between the dots at the plate screw level. The curved edge should touch the crossmark at the side seam and the lowered armhole (Figure 2.14).

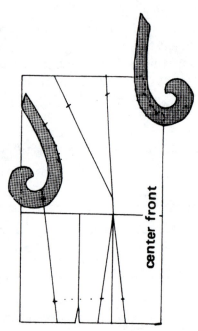

Figure 2.14 / Steps D7–8

8. True the neckline by placing the French curve so that the curved edge follows the neckline dots and touches the crossmarks at center front and shoulder seam (Figure 2.14).
9. Fold the muslin on the crosswise grain at the vanishing point of the shoulder dart. Crease the dart line nearest the center front and bring this line to meet the dart line nearest the armhole. Slide a ruler under the dart line and pin the dart as illustrated. Pin darts and seams by inserting the pin on the folded edge, through all the layers of muslin, and at a right angle to the seam line. Pins should be spaced about 2 inches apart.

10. True the shoulder seam by connecting the crossmarks at the neckline and armhole ridge with a ruler.
11. Add seam allowance to the neckline and shoulder seam, and trim away excess muslin (Figure 2.15).

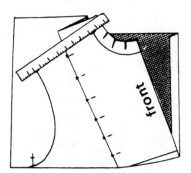

Figure 2.15 / Steps D9–11

12. Trim the armhole roughly, leaving about 1½ inches beyond the seam line.
13. Pin the waistline dart by bringing the side closest to the center front to the other side of the dart.

Basic Bodice—Back

A. PREPARATION OF MUSLIN
1. On the dress form, measure the distance from the top of the neckband to the waistline at center back. 51.5 cm +10 = 61.5
2. Along the selvage of the muslin, measure the distance from the top of the neckband to the waistline plus 4 inches. 47+4 = 51
3. Clip selvage and tear along the crosswise grain.
4. On the dress form, measure the distance from the side seam to the center back at the widest point across the back, which is located at the armplate and side seam intersection. 20
5. On the muslin, measure along the crosswise grain the distance across the back at the widest point plus 4 inches. 20+4
6. Clip and tear along the lengthwise grain.
7. Block and press the muslin.

8. Draw the grain line for the center back 1 inch from the lengthwise grain torn edge (Figure 2.16).

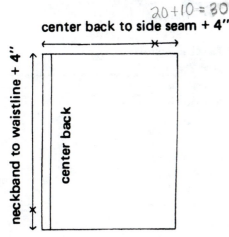

20+10 = 30

center back to side seam + 4"

neckband to waistline + 4"

center back

Figure 2.16 / Steps A1–8

9. Fold under the 1-inch extension at center back.

10. Measure down 3 inches from the top edge of the muslin at center back and crossmark for the neckline.

11. On the dress form, measure the distance from the neckline to the waistline at center back. 42.5

12. On the muslin, indicate with a crossmark the distance from the neckline to the waistline at the center back grain line.

13. Divide the distance between the neckline and waistline at center back into quarters. 10.6

14. On the muslin, measure down one quarter of the center back from the neckline to establish the shoulder blade level.

15. Draw a crosswise grain line at the shoulder blade level (Figure 2.17).

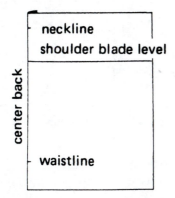

neckline
shoulder blade level

center back

waistline

Figure 2.17 / Steps A9–15

16. On the dress form, measure the distance from center back to the armplate at the shoulder blade level. 17.5

17. On the muslin, indicate with a crossmark this measurement plus ⅛ inch for ease on the shoulder blade crosswise grain.

18. Measure 1¼ inches toward the center back from the armplate crossmark; from this point draw a grain line toward the lower edge of the muslin (Figure 2.18).

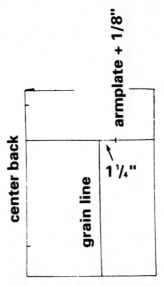

armplate + 1/8"

center back

grain line

1¼"

Figure 2.18 / Steps A16–18

B. DRAPING STEPS—Before draping the back bodice, the front bodice must be pinned to the dress form, taking care that all seam and dart lines correspond with those on the form. Sink pins at the shoulder seam completely into the dress form. Once in set position, place a row of pins approximately ½ inch away from the side seam. Remove pins at the side seam and fold back excess muslin as illustrated (Figure 2.19).

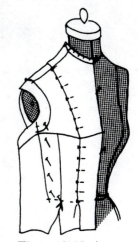

Figure 2.19 / Step B

1. Pin the center back of the muslin to the dress form at the neckline and shoulder blade level.

2. Smooth the muslin across the shoulder blade level from center back toward the armplate; pin the armplate crossmark to the armhole ridge, distributing excess ease evenly; then pin along the shoulder blade level to prevent muslin from sagging (Figure 2.20).

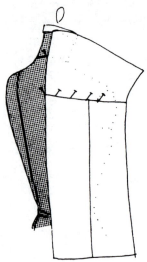

Figure 2.20 / Steps B1–2

3. Smooth down on the lengthwise grain line to the level of the lower edge of the arm-plate. Continue on the crosswise grain to the armplate and side seam intersection, and pin (Figure 2.21).

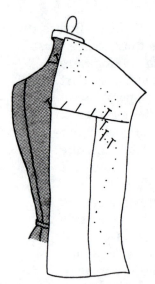

Figure 2.21 / Step B3

4. Balance the side seams by pinning the front and back muslin together at the armplate and side seam intersections. Before pinning the side seams together at the waistline, make sure that the grains

are parallel at the uncut edges of the muslin. If the grains do not balance, adjust back bodice. Pin side seam together at the waistline (Figure 2.22).

5. Smooth down on the lengthwise grain line to the waistline; take a pinch and pin into place at the waistline.

6. Slash lengthwise grain line from lower edge of muslin to ½ inch below the waistline.

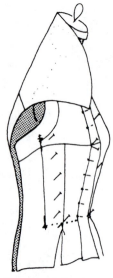

Figure 2.22 / Step B4

7. Pin the muslin at the center back and waistline intersection.

8. Smooth along the waistline to the princess line and pick up excess muslin for dart. Pin the dart only at the waistline and princess line intersection. With a pin, indicate the vanishing point of the dart. The dart must not extend beyond the lowered level of the armhole (Figure 2.23).

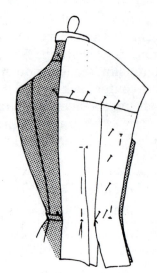

Figure 2.23 / Steps B7–8

9. To drape the neckline:
 a. Cut away a rectangular piece of muslin 1 inch above the neckline and center back intersection. The cut should be 1½ inches deep and extend upward to the edge of the muslin.

b. Smooth the muslin *on grain* from center back across and then up at a right angle toward the shoulder and neckline intersection.

c. Slash carefully from the outer edge toward the neckline so that muslin lies smoothly.

10. Smooth the muslin along the shoulder seam from the neckline toward the princess line and take a pinch near the neckline; dot the intersection of princess seam and shoulder seam.

11. Smooth around the armhole toward the shoulder seam, and pin at the intersection of the shoulder seam and the armhole ridge.

12. Take a pinch at the shoulder seam near the armhole (Figure 2.24).

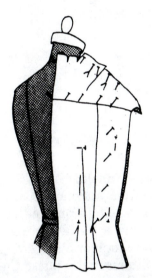

Figure 2.24 / Steps B9–12

13. Move excess fullness underneath the dot at the princess line to form the shoulder dart. The dart pickup must not exceed ¼ inch (Figure 2.25).

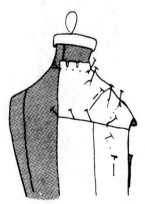

Figure 2.25 / Step B13

C. MARKING

1. NECKLINE—Crossmark at center back; dot to the shoulder along neckline; crossmark at the shoulder seam and neckline intersection.

2. SHOULDER—Dot directly over the front shoulder seam; crossmark at the shoulder seam and armhole ridge intersection.

3. ARMHOLE—Dot armhole ridge to the armplate crossmark; crossmark the intersection of the armplate and side seam.

4. WAISTLINE—Crossmark the waistline and side seam intersection; dot along the lower edge of the waistline tape from side seam to dart; crossmark both sides of the dart pin; dot from dart to center back (Figure 2.26).

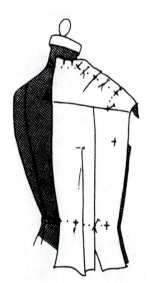

Figure 2.26 / Steps C1–4

D. TRUEING

1. Leaving the side seam pinned together, remove the front and back muslin from the dress form.

2. Place the muslins, still pinned together, on tracing paper with the waist front on top.

3. Using a ruler, trace the front side seam.

4. Add ease for a set-in sleeve. At the lowered armhole, dot ½ inch beyond the width of the bodice; connect this mark with the side seam and waistline intersection.

5. Add a 1-inch seam allowance at the extended side seams, and cut away excess muslin while front and back are still

pinned together; separate front and back (Figure 2.27).

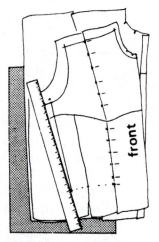

Figure 2.27 / Steps D1–5

6. True waistline dart by locating the center of the dart at the waistline crossmarks; draw a grain line at the center of the dart from the waistline to the level of the vanishing point pin; remove pin; draw lines from the vanishing point, through the waistline crossmarks, to the lower edge of the muslin (Figure 2.28).

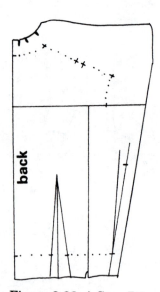

Figure 2.28 / Step D6

7. True the shoulder dart by drawing a line from the vanishing point of the waistline dart to the crossmark nearest the neckline; on this line, mark the vanishing point of the shoulder dart 3 inches down from the shoulder seam; connect the

shoulder crossmark nearest the armhole with the 3-inch mark.

8. True the neckline by placing the French curve so that the curved edge follows the neckline dots and touches the crossmarks at the center back and shoulder seam (Figure 2.29).

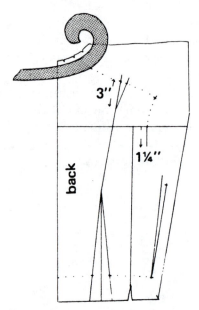

Figure 2.29 / Steps D7–8

9. To true the armhole:

 a. Pin the front and back bodice together along the extension line of the side seam. Draw a 1¼-inch grain line down from the shoulder blade level and armplate intersection; place the French curve so that it rests against this grain line, and the curved edge touches the extended side seam and blends into the front armhole (Figure 2.30).

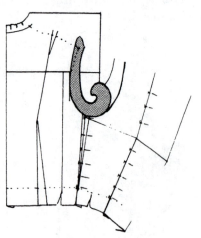

Figure 2.30 / Step D9(a)

b. Reverse the French curve so that the dots along the armhole ridge blend into a continuous shallow curve with the lower armhole (Figure 2.31).

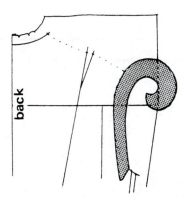

Figure 2.31 / Step D9(b)

10. Pin the shoulder dart by creasing the dart line nearest the center back and bringing it to meet the dart line nearest the armhole.

11. Connect the shoulder seam dots using the straighter end of the French curve as illustrated (Figure 2.32).

Figure 2.32 / Step D11

12. Add seam allowance to the neckline, shoulder seam, and armhole; trim away excess muslin.

13. Pin the extended side seam together, and if needed, blend the lower armhole into a smooth curve.

14. True the waistline by dropping the waistline approximately ¼ inch at the side seam. Blend, using the French curve, to the back waistline dart and the front waistline dart. If a slight upward point occurs at the darts, blend so that the waistline forms a continuous curve. Connect the dots from the waistline dart to center back; follow the crosswise grain from the waistline dart to center front. Add seam allowance, and trim away excess muslin (Figure 2.33).

Figure 2.33 / Step D13

15. Pin the shoulder seam back over front. The back shoulder seam will be ¼ inch longer than the front shoulder seam. Match front and back shoulder darts, neckline, and armhole ridge intersections.

16. Place on the dress form and check fit.

17. See finished pattern (Figure 2.34).

Figure 2.34 / Finished pattern

Basic Skirt

A. PREPARATION OF MUSLIN

1. Measure the dress form 9 inches down from the waistline. This location is usually the widest point of the hip area. Determine the measurements from center front to the side seam and from center back to the side seam at this level.
2. Tear muslin:
 a. Lengthwise grain—the desired length of the skirt plus 4 inches. *9.5+4 = 13.5*
 b. Crosswise grain—for both front and back, distance from center front to center back at the widest point plus 6 inches. *13.5+6 =19.5*
3. Draw the grain line for center front 1 inch from the lengthwise-grain torn edge.
4. Measure down 2 inches from the top edge of the muslin at center front to indicate the waistline intersection.
5. Measure down 7 inches from the waistline crossmark to establish the standard hipline. Draw the crosswise grain line to indicate the hipline (Figure 2.35).

CF to CB + 6"

Figure 2.35 / Steps A1–5

7.75" +

6. On the hipline, indicate with a crossmark the hip level measurement from center front to side seam plus ⅜ inch for ease. Draw a lengthwise grain guide line for the side seam of the front skirt at this point.
7. Beyond the front side seam, add 2 lengthwise grain lines, 1 inch apart. These lines are for front seam allowance and the back seam allowance.

8. On the hipline, indicate with a crossmark the hip level measurement from the back side seam to center back plus ⅜ inch for ease. Draw center back grain line at this point.
9. On the hipline, measure 2 inches from the side seam on both front and back. At these points, draw lengthwise-grain lines from the hipline to the upper edge of muslin.
10. Indicate the hem level 2 inches up from the lower edge of the muslin (Figure 2.36).

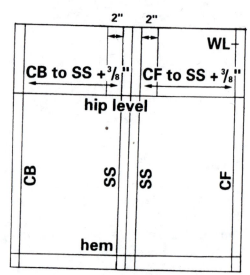

Figure 2.36 / Steps A6–10

11. Separate the front skirt from the back skirt at side seam.
12. Clip into the side seam at the hipline; pin the skirt together below the hipline letting the seam allowance above the hipline extend outward (Figure 2.37).

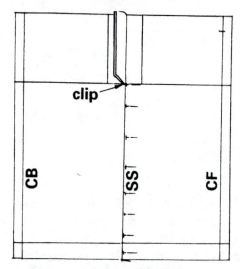

Figure 2.37 / Steps A11–12

B. DRAPING STEPS

1. Turn under 1-inch allowance at center front, and pin indicated waistline mark to tape.
2. Pin at center front and hipline.
3. Drape muslin so that the hipline is straight around the dress form, leaving the lower skirt hanging smoothly without any diagonal pull; pin at center back and around the hipline to prevent muslin from sagging (Figure 2.38).

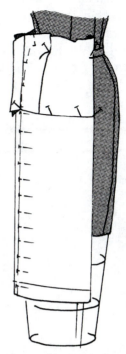

Figure 2.39 / Steps B4–5

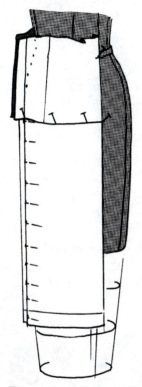

Figure 2.38 / Steps B1–3

4. On both front and back, smooth the lengthwise grain line near the side seam straight up to the waistline; pick up a pinch and pin to the waistline.
5. Pin front and back side seams together from the hipline to the waistline. Maintain balanced grain for approximately 2 inches above the hipline. The side seam at the waistline should curve in ½ to ¾ inch from the straight grain line at the side seam (Figure 2.39).

6. Establish the position of the skirt darts so that they are in line with the darts of the basic bodice. When draping a skirt without the basic bodice, use the princess line of the dress form as a guide for positioning the dart. In order to keep the grain straight in the hip area, 2 darts are used both in the front and in the back of the basic skirt.
7. To drape the front darts:
 a. Smooth muslin along the waistline from center front to the established dart point.
 b. Divide the excess fullness into two darts between the dart point and the waistline pinch. The pickup of each dart depends on the shape of the hip. Pin darts only at the waistline.
 c. With a pin, indicate the level of the vanishing point for each dart (Figure 2.40).

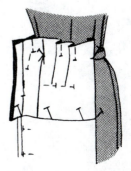

Figure 2.40 / Step B7

8. Drape the back darts—working from center back, establish the position and pin the darts the same way as for the front skirt, leaving enough ease for another pinch between the darts. Two pinches will be in the back waistline of the skirt. The vanishing points of the back darts should be at least 1 inch above the hipline (Figure 2.41).

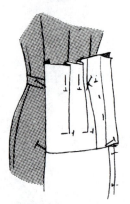

Figure 2.41 / Step B8

C. MARKING
1. Dot the waistline; crossmark both sides of the dart pins.
2. Mark front and back of side seam pins from waistline to hipline.

D. TRUEING
1. Keeping skirt sections pinned together, use the hip curve to true front side seam from the hipline to the waistline connecting pin marks (Figure 2.42).

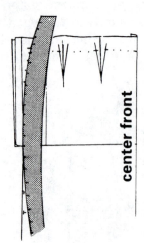

Figure 2.42 / Step D1

2. Trace the front side seam above the hipline to the back. Trim away excess muslin, leaving seam allowance (Figure 2.43).

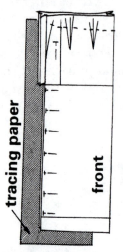

Figure 2.43 / Step D2

3. True front waistline darts by locating the center of each dart at the waistline crossmarks; extend a grain line at the center of each dart from the waistline to the level of the vanishing point; using the straighter end of the French curve, draw lines from the vanishing point through the waistline crossmarks (Figure 2.44).

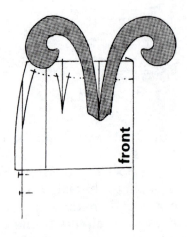

Figure 2.44 / Step D3

4. True back waistline darts by locating the center of each dart between the waistline crossmarks; extend a grain line at the center of each dart from the waistline to

the level of the vanishing point. Using a ruler, draw a light guide line from the vanishing point through the waistline crossmarks; midway between the crossmarks and the vanishing point, mark ⅛ inch inside each guide line; using the hip curve, connect crossmarks at waistline, midway mark, and vanishing point (Figure 2.45).

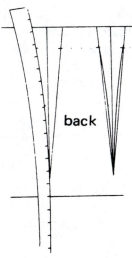

Figure 2.45 / Step D4

5. Pin the side seam from hipline to waistline.
6. Pin all darts.
7. True the waistline by folding the skirt over at the vanishing points, as illustrated, so that the waistline lies flat; using the French curve, connect the waistline dots.
8. Turn up hem and pin as illustrated. The hem will be on the straight grain for a basic skirt (Figure 2.46).

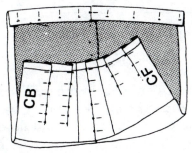

Figure 2.46 / Step D8

9. See the finished pattern (Figure 2.47).

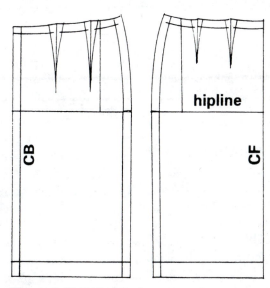

Figure 2.47 / Finished pattern

E. JOINING THE SKIRT TO THE BODICE

1. Place the skirt and bodice on the dress form and check fit.
2. Make all seam and dart lines correspond on the skirt and bodice.
3. Pin the waistline seam so that the bodice is pinned over the skirt with the seam allowance up.
4. Pins should be placed parallel to the waistline (Figure 2.48).

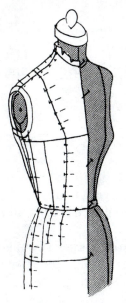

Figure 2.48 / Steps E1–4

Basic Sleeve

SLEEVE MEASUREMENTS FOR BASIC SIZES

SIZES	5	6	7	8	9	10	11	12
Underarm length	16	16¼	16¼	16½	16½	16¾	16¾	17
Biceps circumference	11¼	11½	11¾	12	12¼	12½	12¾	13
Elbow circumference	9½	9¾	10	10¼	10½	10¾	11	11¼
Cap height	6	6⅛	6⅛	6¼	6¼	6⅜	6⅜	6½

UNDERARM LENGTH—Distance from lowered armhole to wrist.

BICEPS CIRCUMFERENCE—Measurement of the upper arm circumference plus 2 inches ease.

ELBOW CIRCUMFERENCE—Measurement around the elbow plus 1 inch ease.

CAP HEIGHT—Measure the complete overarm length from neckline to wrist. Subtract the length of the shoulder seam and the underarm length. The remainder is the minimum cap height required for a smooth sleeve (Figure 2.49).

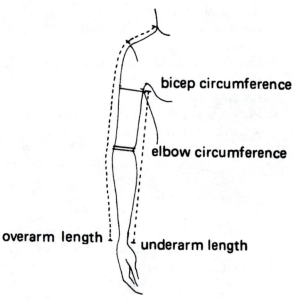

Figure 2.49

A. DRAFTING THE BASIC SLEEVE
1. Fold a large piece of paper in half.
2. Square a line up from the fold for the top of the sleeve.
3. Establish the biceps level by measuring the cap height down from the top of the sleeve.
4. Square a line up from the fold at the biceps level.

5. Establish the wrist level by measuring the underarm length down from the biceps line.
6. Square a line up from the fold at the wrist level (Figure 2.50).

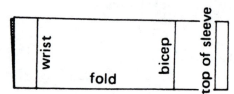

Figure 2.50 / Steps A1–6

7. Establish the elbow level by dividing the underarm length in half; indicate the elbow level 1 inch above the halfway mark.
8. Square a line up from the fold at the elbow level.
9. Indicate one half the biceps circumference on the biceps line.
10. Indicate one-half the elbow circumference on the elbow line (Figure 2.51).

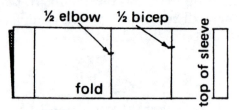

Figure 2.51 / Steps A7–10

11. With a ruler, connect the marks at the biceps and the elbow, extending the line up to the top of the sleeve and down to the wrist (Figure 2.52).

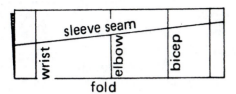

Figure 2.52 / Step A11

12. Cut out the sleeve (Figure 2.53).

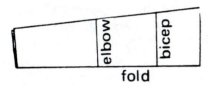

Figure 2.53 / Step A12

B. TO SHAPE THE CAP
 1. Fold the sleeve in half lengthwise.
 2. Fold the sleeve cap in half crosswise.
 3. Crossmark on the lengthwise crease ¾ inch above the creased intersection.
 4. Crossmark on biceps line 1 inch from the underarm.
 5. Crossmark at the top of the sleeve ½ inch from the center fold (Figure 2.54).

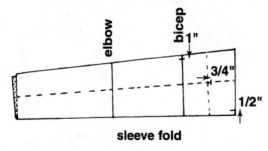

Figure 2.54 / Steps B1–5

6. Connect crossmarks lightly (Figure 2.55).

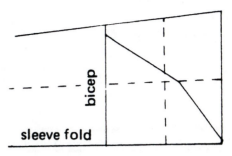

Figure 2.55 / Step B6

7. Curve sleeve cap as illustrated (Figure 2.56).

Figure 2.56 / Step B7

8. Cut out the sleeve cap (Figure 2.57).

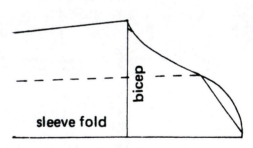

Figure 2.57 / Step B8

9. Open the sleeve.

10. Continue the biceps and elbow lines across the sleeve; draw a line for the center of the sleeve (Figure 2.58).

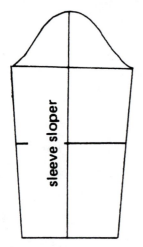

Figure 2.58 / Steps B9–10

11. Fold the sleeve, blank side on the inside, by bringing the underarm seams of the sleeve to meet at the center of the sleeve as illustrated (Figure 2.59).
12. Scoop out ¼ inch along the lower curve of the front cap (Figure 2.59).

Figure 2.59 / Steps B11–12

C. TO DEVELOP THE FITTED SLEEVE—For many sleeves, a straight sloper[1] is sufficient. When, however, a more fitted sleeve is desir-

[1]A *sloper* is a foundation pattern without seam allowances.

able, the elbow must be shaped and the wrist tapered.

1. Slash the elbow line from the back underarm seam to the center of the sleeve.
2. Block and press muslin:
 a. Lengthwise Grain—2 inches longer than sleeve.
 b. Crosswise Grain—3 inches wider than sleeve.
3. Draw the lengthwise grain line at the center of the muslin. From the top edge of the muslin, measure down the cap height plus 1 inch. At this point, draw crosswise grain lines for the biceps and elbow levels.
4. Place the sleeve sloper on the muslin so that the biceps and center of sleeve coincide. Pin the upper portion and front of sleeve sloper to the muslin.
5. Pick up the wrist at the center of the sleeve and fold over until desired shaping is reached (Figure 2.60).

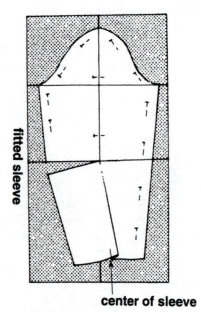

center of sleeve

Figure 2.60 / Steps C1–5

6. Draw the outline of the paper sloper on the muslin. Crossmark the new center of sleeve at wrist line. Add ½-inch seam allowance at the cap and wrist, 1 inch at front underarm, and 1½ inches at the back underarm seam. Cut out and remove paper. Draw in the new center of sleeve below the elbow (Figure 2.61).

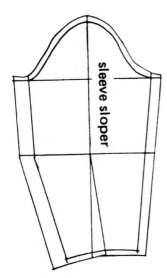

Figure 2.61 / Step C6

der to achieve this shaping, the seam along the sleeve cap must be eased.

1. Using the #10 setting on the sewing machine, stitch at the seam line and ¼ inch above, along the entire cap of the sleeve (Figure 2.63).

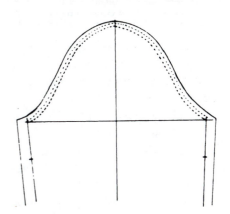

Figure 2.63 / Step D1

7. Fold back the front underarm seam allowance.

8. Fold the muslin sleeve by bringing both sides of the underarm seam to meet at the center of the sleeve.

9. Pin at the underarm and biceps intersection; pin at the underarm and wrist intersection; smooth seam toward elbow from both ends.

10. Resulting fullness at the elbow must be absorbed by shaping one or two small darts, gathers, or pleats.

11. Make a full-length fitted sleeve hang straight by adding ⅜ to ½ inch additional width in the elbow area of the back underarm seam. Draw the corrected line and trim away excess muslin, leaving seam allowance.

12. Crossmark the sleeve seam 3 inches above and 3 inches below the elbow level (Figure 2.62).

13. Mark and true darts, gathers, or pleats.

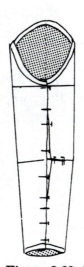

Figure 2.62 / Steps C7–12

2. Pin the underarm seams of the sleeve together, matching crossmarks.

3. Shrink the cap by pulling the bobbin thread at the center of the cap as illustrated. The grain should remain undisturbed at the underarm area of the sleeve. The upper cap should round out about 5/8 inch (Figure 2.64).

Figure 2.64 / Steps D2–3

D. SETTING THE SLEEVE—A properly set sleeve should hang straight. The center grain line of the sleeve should fall in line with the side seam of the basic skirt. The cap must be rounded out to accommodate the arm. In or-

4. Hold the sleeve so that the underarm seam is directly in line with the center of the sleeve, and pin it temporarily into position.

5. Pin the underarm seam of the sleeve to the side seam of the bodice at the armhole. The pin should follow the direction of the seam.

6. Smooth both the front sleeve and the front bodice toward the back, and pin the underarm section of the front sleeve to the front armhole.

7. Smooth both the back sleeve and the back bodice toward the front, and pin the underarm section of the back armhole. (Grains on the sleeve and the bodice should match if the grains on the bodice are balanced.)

8. Bring sleeve cap to shoulder and adjust the cap ease if necessary.

9. Blind-pin the cap into position.

10. Crossmark the sleeve and armhole at the front of the sleeve cap 1 inch below the level of the plate screw. Follow the cross grain around to the back of the sleeve. Crossmark the back armhole and sleeve at the same level and again ½ inch below.

11. Crossmark the sleeve at the point where the cap meets the shoulder seam of the bodice (Figure 2.65).

12. See basic notch placement for sleeve and armhole (Figure 2.66).

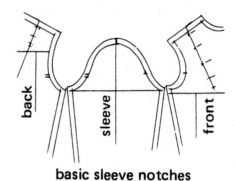

basic sleeve notches
Figure 2.66 / Step D12

E. ADJUSTMENTS

1. To correct too much ease in the cap, lower the armhole the necessary amount.

2. To add ease if the cap is too tight, raise the armhole the necessary amount.

3. If the sleeve swings forward or backward, reset the sleeve considering only grain lines, *not seam lines*. Adjust the bodice side seam to match the underarm seam of the sleeve.

4. When the sleeve hangs correctly, check the armhole and retrue where necessary.

5. See finished pattern (Figure 2.67).

Figure 2.65 / Steps D5–11

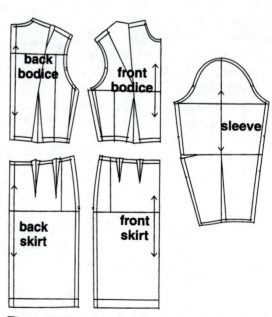

Figure 2.67 / Finished pattern

3

Bodices

Front Bodice with Underarm Dart

This variation of the basic bodice has the shoulder dart shifted to the underarm area. It is a useful dart arrangement when a fitted bodice is desired with the shoulder and neckline area free for some sort of design feature.

A. PREPARATION OF MUSLIN—The same as for basic bodice-front; see page 10. In addition, crease the crosswise grain line from the apex toward the side seam raw edge (Figure 3.1).

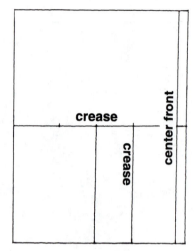

Figure 3.1 / Step A

B. DRAPING STEPS
 1. Pin the muslin at the apex and center front the same way as for the basic bodice.
 2. Pin the bustline level and princess panel grain lines the same way as for the basic bodice.
 3. Drape the waistline dart the same way as for the basic bodice (Figure 3.2).
 4. Slash and pin the neckline the same way as for the basic bodice.
 5. To drape the underarm dart:
 a. Smooth crosswise grain across the upper chest area, and pin at the armhole and shoulder intersection.
 b. Smooth the muslin around the lower armhole so that the excess muslin can be picked up at the bustline level grain line.
 c. Pin the underarm dart centered on the crosswise grain with the grain line extended outward.
 d. Indicate the vanishing point of the dart on the crosswise grain line (Figure 3.3).

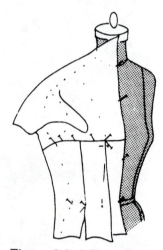

Figure 3.2 / Steps B1–3

C. MARKING
 1. Mark the neckline, shoulder, and armhole the same way as for the basic bodice.
 2. Crossmark the intersection of the side seam at the armplate, underarm dart, and waistline.
 3. Mark the waistline the same way as for the basic bodice.
 4. Leaving the underarm dart pinned together, remove the muslin from dress form.

Figure 3.3 / Steps B4–5

5. Mark both sides of the underarm dart pins; remove pins (Figure 3.4).

Figure 3.4 / Steps C1–5

D. TRUEING

1. True the waistline dart and neckline the same way as for the basic bodice. For a finished round neckline, lower the neckline ¼ inch at center front. Blend the lowered neckline as illustrated (Figure 3.5).

Figure 3.5 / Step D1

2. Draw a straight line for the shoulder seam from the neckline to the armhole.
3. To true the underarm dart, begin at the vanishing point and connect the pin marks with the French curve to half-way between the vanishing point and the side seam. From the half-way point to the side seam, use a ruler to finish trueing the dart (Figure 3.6).

Figure 3.6 / Steps D2–3

4. Pin the underarm dart; fold the waist at the vanishing point of the dart as illustrated; true the side seam, connecting crossmarks at the armplate, dart, and waistline (Figure 3.7).

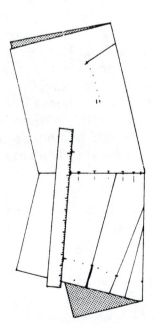

Figure 3.7 / Step D4

5. True the armhole the same way as for the basic bodice.
6. Add seam allowance and cut away excess muslin from the neckline, armhole, and shoulder seams.

Back Bodice with Neckline Dart

A. PREPARATION OF MUSLIN—The same way as for the basic bodice—back; see page 14 (Figure 3.8).

B. DRAPING STEPS—Pin the front waist to the dress form; see page 15.

1. Pin muslin at center back and shoulder blade level the same way as for the basic back.
2. Smooth the lengthwise grain line down to the waistline and pin at the center of the princess panel, taking a pinch.
3. Pin side seams together at the armplate and waistline intersections. The back should fit smoothly, but grains need not necessarily balance with the front waist.
4. Complete the back waistline dart, the same way as for the basic bodice (Figure 3.9).
5. To drape the neckline dart:
 a. Smooth the neckline to the center of the neck curve, and pin.
 b. Smooth the shoulder up at the armhole area the same way as for the basic bodice.
 c. Place two pinches in the shoulder seam for ease. The back of the shoulder seam usually measures ¼ inch more than the front of the shoulder seam.
 d. Pin the shoulder at the neckline and armhole intersections.
 e. Bring excess fullness into a neckline dart and complete draping the neckline. The neckline dart pickup should be approximately ¼ inch (Figure 3.10).

C. MARKING

1. Mark the back the same way as for the basic bodice, except at the neckline.
2. Crossmark the dart and neckline intersections.
3. Indicate the vanishing point of the neckline dart. The length of the neckline dart should not exceed 3 inches, and it should slope toward the vanishing point of the waistline dart.

D. TRUEING

1. Complete the side seam, waistline dart, and armhole the same way as for the basic bodice.

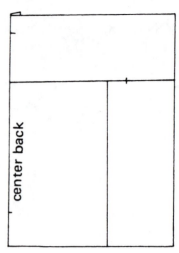

Figure 3.8 / Step A

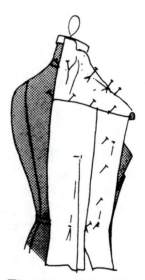

Figure 3.9 / Steps B1–4

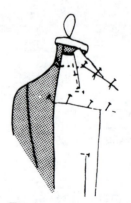

Figure 3.10 / Step B5

2. Connect shoulder dots for the shoulder seam. This line should be slightly curved.
3. True the neckline dart by connecting the neckline crossmarks to the vanishing point with a ruler.

4. True the waistline the same way as for the basic bodice (See finished pattern Figure 3.11).

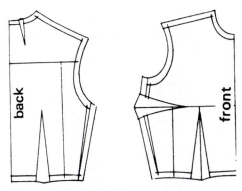

Figure 3.11 / Finished pattern

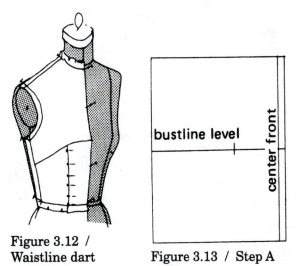

Figure 3.12 / Waistline dart

Figure 3.13 / Step A

Dart Variations

The fundamental arrangement of the shoulder and waistline darts in the basic bodice may be changed in various ways for both functional and design purposes. The possibility of the waistline and bustline dart combination has already been demonstrated. When the bodice is shaped with a single dart above or below the bustline, the crosswise grain will not be straight at the bustline level, and the dart will be quite deep. When fullness is divided above and below the bustline, balanced grain will result and darts will be more shallow. All the dart arrangements that follow may be used alone or in combination. In any case, darts will always radiate from the apex.

Many of the darts, described later, may be centered on the bias grain and care must be taken not to stretch the muslin as they are draped. *Smoothing the muslin only in the direction of the grain* will prevent stretching and will assure the accuracy of the pattern when it is completed. Adequate ease should be maintained throughout the draping process.

The Waistline Dart (Figure 3.12)

A. PREPARATION OF MUSLIN—Prepare the muslin the same way as for the basic bodice—front, except eliminate lengthwise grain lines at the apex and the princess panel (Figure 3.13).

B. DRAPING STEPS
1. Pin the muslin at the apex and center front.
2. Smooth the crosswise grain across the upper chest area, and pin at the armhole and shoulder intersection.
3. Smooth the muslin around the lower armhole, and pin at the side seam and armplate intersection.
4. Smooth the muslin on the grain and bring all the excess fullness down into a waistline dart, slashing below the waistline where necessary.
5. Pin the dart, molding and shaping it to the figure (Figure 3.14).

Figure 3.14 / Step B1–5

6. When a single dart is used to shape the bodice, it is usually quite deep. In order to

eliminate excess bulk, the fabric in the dart is cut away, leaving normal seam allowance at the sewing line (See finished pattern Figure 3.15).

Figure 3.15 / Finished pattern

Dart at the Waistline and Center Front (Figure 3.16)

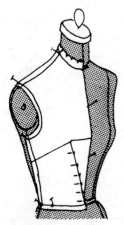

Figure 3.16 / Dart at waistline and center front

A. PREPARATION OF MUSLIN—Prepare the muslin the same way as for the basic bodice—front, except eliminate lengthwise grain lines at the apex and the princess panel (Figure 3.13).

B. DRAPING STEPS
1. Pin the muslin at the apex and center front.
2. Smooth the crosswise grain across the upper chest area, and pin at the armhole and shoulder intersection.
3. Smooth the muslin around the lower armhole, and pin at the side seam and armplate intersection.
4. Smooth the muslin on the grain and bring all the excess fullness down toward the waistline.

5. Slash the muslin below the waistline as needed in order to form a dart at the waistline and center front intersection (Figure 3.17; see finished pattern Figure 3.18).

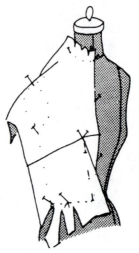
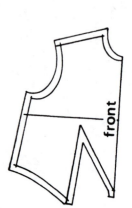

Figure 3.17 / Step B2

Figure 3.18 / Finished pattern

The French Dart (Figure 3.19)

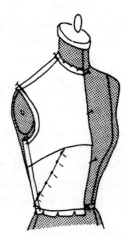

Figure 3.19 / French dart

A. PREPARATION OF MUSLIN—Prepare the muslin the same way as for the basic bodice—front, except eliminate lengthwise grain lines at the apex and the princess panel (See Figure 3.13).

B. DRAPING STEPS
1. Pin the muslin at the apex and center front.
2. Smooth the crosswise grain across the upper chest area, and pin at the armhole and shoulder intersection.

3. Smooth the muslin around the lower arm-hole, and pin at the side seam and arm-plate intersection.
4. Smooth the grain across the midriff sec-tion, slashing the muslin below the waist-line in order to achieve a flat fit.
5. Smooth downward at the side seam, bringing all fullness into the lower area of the side seam, and pin the dart into place (Figure 3.20; see finished pattern Figure 3.21).

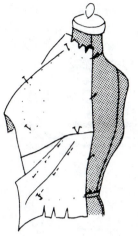
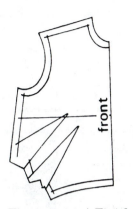

Figure 3.23 / Step B4

Figure 3.24 / Finished pattern

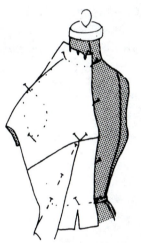
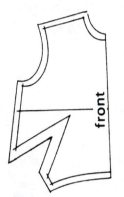

Figure 3.20 / Step B3

Figure 3.21 / Finished pattern

The Flange Dart (Figure 3.25)

Figure 3.25 / Flange dart

The Double French Dart (Figure 3.22)

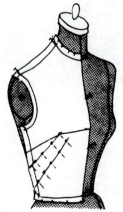

Figure 3.22 / Double French dart

Drape the same way as for the French dart except the fullness is divided into two parallel darts, approximately 1 inch apart. The vanishing points of the two darts are located about 1 inch from the apex of the bustline (Figure 3.23; see finished pattern Figure 3.24).

A. PREPARATION OF MUSLIN—Prepare the muslin the same way as for the basic bodice—front, except eliminate the lengthwise grain lines at the apex and the princess panel (See Figure 3.13).

B. DRAPING STEPS
1. Pin the muslin at the apex and center front.
2. Smooth the crosswise grain at the upper chest area, and pin at the armhole and shoulder intersection.
3. Smooth the grain across the midriff sec-tion, slashing muslin below the waistline in order to achieve a flat fit. Pin at the waistline and side seam intersection.
4. Smooth the muslin on grain and bring all excess fullness up toward the intersection of the shoulder and the armhole. Pin at side seam and armplate intersection.

5. Pin the flange dart into place, following the same method used for the basic bodice shoulder dart. This dart is often not stitched and forms a pleat (Figure 3.26; see finished pattern Figure 3.27).

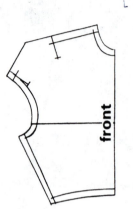

Figure 3.26 / Step B5

Figure 3.27 / Finished pattern

The Neckline Dart (Figure 3.28)

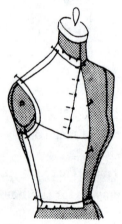

Figure 3.28 / Neckline dart

A. PREPARATION OF MUSLIN—Prepare the muslin the same way as for the basic bodice—front, except eliminate lengthwise grain lines at the apex and the princess panel (See Figure 3.13).

B. DRAPING STEPS

1. Pin the muslin at the apex and center front.
2. Smooth the grain across the midriff section, slashing the muslin below the waistline in order to achieve a flat fit. Pin at the waistline and side seam intersection.

3. Smooth the muslin on the grain and bring all the excess fullness up toward the shoulder. Pin at the side seam and armplate intersection.
4. Smooth the muslin up around the armhole, and pin at the armplate and shoulder intersection.
5. Smooth along the shoulder, and pin at the neckline and shoulder intersection.
6. Slash for the neckline, and bring all the fullness toward the center front and neckline intersection; pin dart at center front and neckline intersection. This dart may be divided into two or more shallow darts, using the same method as for the double French dart (Figure 3.29; see finished pattern Figure 3.30).

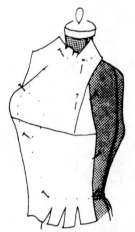
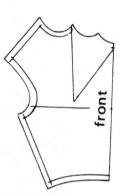

Figure 3.29 / Step B6

Figure 3.30 / Finished pattern

The Bustline Dart at Center Front (Figure 3.31)

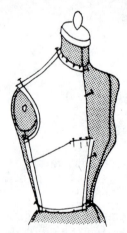

Figure 3.31 / Bustline dart at center front

1. Pin the muslin at the apex and center front above the bustline level.

2. Smooth the crosswise grain across the upper chest area, and pin at the armhole and shoulder intersection.
3. Smooth the muslin around the lower armhole, and pin at the side seam and armplate intersection.
4. Smooth the muslin on the grain and bring all the excess fullness down toward the waistline. Pin at the side seam and waistline intersection.
5. Slash the muslin below the waistline as needed in order to bring all the fullness to the center front. Pin at the waistline and center front intersection.
6. Form a horizontal dart from the apex to the center front. The grain will be bias at the center front below the bustline level. If desired, the opposite effect can be achieved by beginning draping below the bustline (Figure 3.32). The bustline dart at center front may be used to achieve close body fit between the breasts (See finished pattern Figure 3.33).

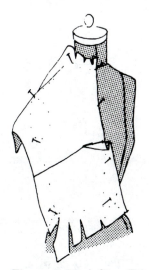

Figure 3.32 / Step B6

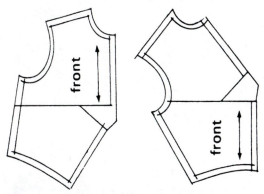

Figure 3.33 / Finished pattern

The Armhole Dart (Figure 3.34)

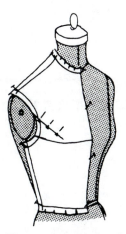

Figure 3.34 / Armhole dart

1. Pin the muslin at the apex and center front.
2. Smooth the crosswise grain across the upper chest area, and pin at the armhole and shoulder intersection.
3. Smooth the grain across the midriff section, slashing the muslin below the waistline in order to achieve a flat fit. Pin at the waistline and side seam intersection.
4. Smooth the muslin on the grain and bring all the excess fullness into the armhole. Pin at the side seam and armhole intersection.
5. Pin the armhole dart into place at any desired point in the armhole curve (Figure 3.35; see finished pattern Figure 3.36).

Figure 3.35 / Step B5

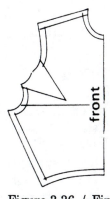

Figure 3.36 / Finished pattern

Pleats, Dart Tucks, and Gathers

Dart fullness may also be absorbed in the form of pleats, dart tucks, or gathers.

Pleats

Pleats are not stitched but are folded and placed into position. Pleats, used to replace darts, are usually not pressed down so that they will fall softly (Figure 3.37).

Figure 3.37 / Pleats

A. MARKING

1. Crossmark both sides of the pleat at the seam.
2. Crossmark both sides of the pleat 1 inch from the seam line. This crossmark does not indicate stitching but helps to retain the direction of the pleat (Figure 3.38).

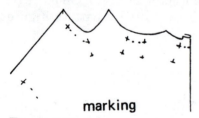

marking

Figure 3.38 / Steps A1–2

B. TRUEING

1. Remove the muslin from the dress form carefully, *leaving the pleat pinned together.*
2. True the seam line and add seam allowance.
3. Cut away excess muslin.
4. Remove pins and connect the crossmarks to indicate the shape of the pleat.

5. Draw an arrow inside the pleat to indicate the direction of the fold (Figure 3.39).

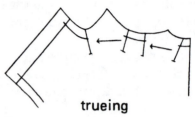

trueing

Figure 3.39 / Steps B1–5

Dart Tucks

Dart tucks are similar in shape to darts but are stitched only partway to the vanishing point (Figure 3.40).

Figure 3.40 / Dart tucks

A. MARKING

1. Crossmark both sides of the dart tuck at the seam.
2. Crossmark both sides of the dart tuck at the point where the stitching will terminate (Figure 3.41).

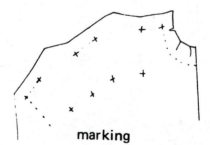

marking

Figure 3.41 / Steps A1–2

B. TRUEING

1. Remove the muslin from the dress form carefully, *leaving the dart tuck pinned together.*
2. True the seam line, and add seam allowance.
3. Cut away excess muslin.
4. Remove pins and connect crossmarks to indicate the shape and length of the dart tuck.
5. Draw an arrow inside the dart tuck to indicate the direction of the tuck (Figure 3.42).

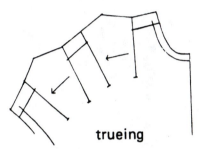

Figure 3.42 / Steps B1–5

Gathers

A running stitch holds excess fullness evenly as the thread is pulled. When draping for gathers, the dart fullness is evenly distributed, wherever desired, and held in place with style tape pinned over the muslin (Figure 3.43).

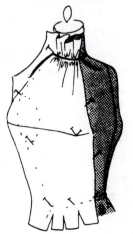

Figure 3.43 / Gathers

A. MARKING

1. Dot the gathers along the edge of the style tape at ½ inch intervals.
2. Crossmark at the beginning and at the end of the gathers.

3. Indicate the measured length of the finished gathered section in the seam allowance (Figure 3.44).

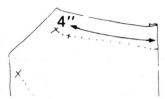

Figure 3.44 / Steps A1–3

B. TRUEING

1. Remove style tape.
2. Connect the dots with the French curve, blending the dots into a smooth continuous line.
3. Sew a double running stitch, one on the seam line and the other ¼ inch into the seam allowance (Figure 3.45).

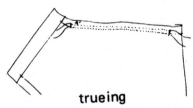

Figure 3.45 / Steps B1–3

4. Draw up the thread to the indicated finished length so that the effect of the gathering can be clearly seen (Figure 3.46).

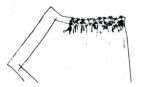

Figure 3.46 / Step B4

Neckline Variations

Various necklines may be draped by pinning style tape over the muslin on the dress form in any desired shape. The shape of the neckline may also be taped directly on the dress form before the bodice is draped. Style tape can be shifted easily

until pleasing proportions are achieved, eliminating any unnecessary markings. For examples, see the various styles illustrated (Figure 3.47).

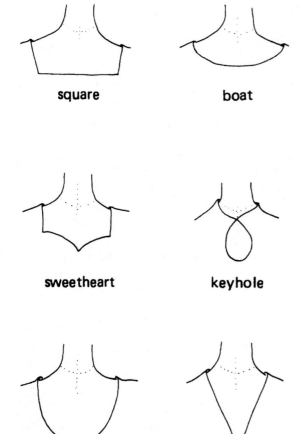

square

boat

sweetheart

keyhole

scoop

V neckline

Figure 3.47 / Neckline variations

A. DRAPING STEPS

1. Tape neckline—Continue style tape from the front to the back in a smooth line so that the entire neckline will be perfectly coordinated.
2. Drape the muslin bodice over the tape, if tape has been pinned directly on the dress form.
3. Mark the position of the neckline tape on the muslin with dots; crossmark the shoulder and neckline intersections.
4. Remove the muslin from the dress form and true the neckline.
5. Add the seam allowance and trim away excess muslin.

6. Place finished muslin on the dress form and check the fit. Sometimes lowered necklines do not lie flat after muslin has been trimmed away. If this is so, adjust the shoulder seam to eliminate excess ease.

B. LOWERED BACK NECKLINES

1. For a slightly lowered back neckline, the neckline dart must be retained to eliminate any gap (Figure 3.48).

Figure 3.48 / Slightly lowered back neckline

2. For a very low scooped neckline, the shoulder or neckline dart is eliminated. Wherever the waistline dart extends into the neckline, the dart must be shortened and reduced in width so that it ends well below the neckline (Figure 3.49).

Figure 3.49 / Low scooped back neckline/steps B2(a–b)

a. Slash muslin from the center back toward the dart at the level where the dart meets the neckline.

b. Shift excess width into the center back seam, retaining the straight grain at the center back (Figure 3.49).

The Halter

A halter is a bodice that bares the shoulders and is suspended from the neck. It usually wraps around the neck and may be fastened at the back neckline with a bow, a knot, buttons, or hooks. Some halters have a band around the back neckline and fasten in front. The front neckline of a halter can be designed in various shapes. Many halters are fitted close to the body (Figure 3.50).

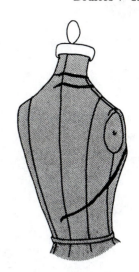
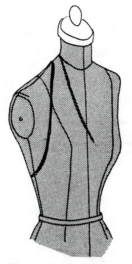

Figure 3.51 / Step A1

2. Determine the dart location and direction of grain. Minimize stretch by placing the straight grain in the direction that must fit closest to the body. This could be either the underarm edge or the neckline. If the front of the halter wraps around the neck, allow enough muslin at the straight grain to reach to the center back at the neckline and for a bow or tie, as desired. Otherwise, preparation of muslin is the same as for dart manipulation.

B. DRAPING STEPS
 1. Drape the front of the halter within the taped outline the same way as the previously described dart manipulation variations (Figure 3.52).

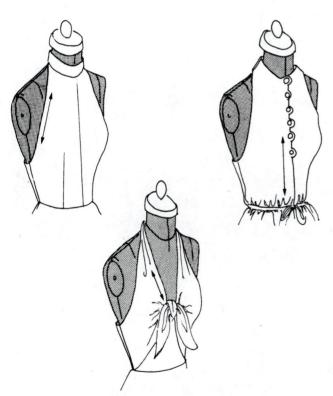

Figure 3.50 / Halter variations

A. PREPARATION OF MUSLIN
 1. Tape the front and back outline, and the basic style lines of the halter on the dress form (Figure 3.51).

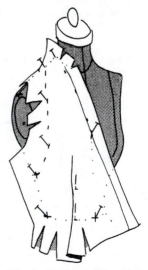

Figure 3.52 / Step B1

2. For halters that wrap around the neck, the muslin must be carefully slashed and cut away in the shoulder area exposing the shoulder.

3. To drape the lower section of the back, begin with the straight grain at center back and smooth on the grain toward the side seam slashing the waistline to keep the muslin flat and smooth. A dart is not necessary (Figure 3.53).

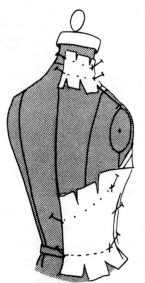

Figure 3.53 / Steps B2–3

4. If the front of the halter does not drape around the neck, a separate piece with the grain straight at the center back must be draped within the taped outline.

5. See the finished pattern (Figure 3.54).

Figure 3.54 / Finished pattern

The Surplice Front

The surplice is a bodice that wraps to one side. Both sides of the front are usually cut alike and overlap. A surplice bodice may be draped softly or fitted with darts. It may be designed as a separate blouse or joined to skirt or slacks. If it is a blouse, it may be finished with a tie that wraps around the waist (Figure 3.55).

Figure 3.55 / Surplice variations

A. PREPARATION OF MUSLIN
 1. Tape the surplice neckline on the dress form.
 2. The straight grain edge of the muslin must be long enough to reach from the shoulder and neckline intersection to the waistline plus 8 inches.
 3. The crossgrain edge should measure approximately 20 inches.
 4. Block and press the muslin.

B. DRAPING STEPS

1. Fold over 2 inches at the straight grain for the facing, and place the muslin on the dress form so that the folded edge follows the taped surplice line. Pin the surplice line at the shoulder and waistline intersections.

2. Fit the surplice bodice by smoothing excess fullness into darts, dart tucks, pleats, or gathers as desired, following the dart manipulation techniques described earlier. Additional draped fullness may be brought into the surplice wrap by lifting the muslin from below the waistline and pinning as desired (Figure 3.56).

3. Because the surplice waist is an asymmetric design, the center front must be carefully indicated with crossmarks at the neckline and waistline before the muslin is removed from the dress form.

4. See the finished pattern (Figure 3.57).

Figure 3.56 / Steps B1–2

Figure 3.57 / Finished pattern

Armhole Variations

Various armholes may be draped by pinning style tape over the muslin on the dress form. For sleeveless styles, the ease at the side seam need not be as wide as for a set-in sleeve. The amount of ease depends on the styling and the fabric. The armhole is usually dropped a minimum of ½ inch. The amount that the armhole can be dropped for styling purposes is not limited (Figure 3.58).

typical sleeves

squared

cut away

Figure 3.58 / Armhole variations

Waistline Variations

Waistlines may be lowered or raised from the normal position on the dress form. The desired position of the waistline is indicated with style tape on the front and back of the dress form before draping (Figure 3.59).

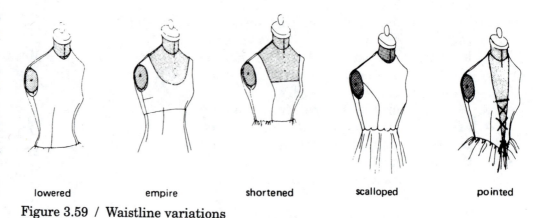

lowered empire shortened scalloped pointed

Figure 3.59 / Waistline variations

The Princess Bodice

The princess bodice is fitted with seams rather than darts. The fitting seam has unlimited design possibilities. It can originate at any point above the bustline level and terminate at almost any point be-

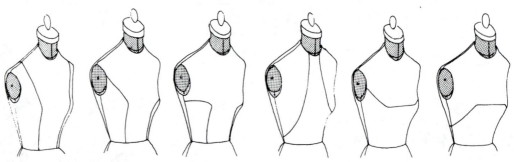

Figure 3.60 / The princess bodice

low. In order to eliminate darts, however, the fitting seam must pass within 1 inch of the apex. When designing the back of the princess waist, every effort should be made to harmonize style lines with the front (Figure 3.60).

A. PREPARATION OF MUSLIN—FRONT AND BACK

1. Pin style tape to the dress form to establish the desired princess line. Pins should be slipped through the style tape into the dress form at a shallow angle so that they can be completely inserted.
2. Tear muslin:
 a. Length—the same as for the basic bodice.
 b. Width—center front and center back panels: width at the widest point plus 4 inches; side panels: width at the widest point plus 4 inches.
3. Draw grain lines as illustrated (Figure 3.61).

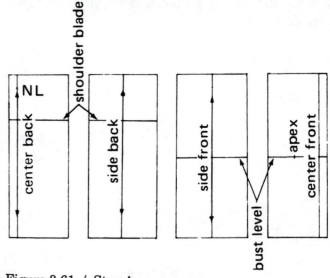

Figure 3.61 / Step A

B. DRAPING STEPS—FRONT

1. Pin the center front panel to the apex and center front.
2. Smooth the muslin from the center front toward the style tape, keeping crosswise grains perfectly aligned; pin along the style tape.
3. Drape the neckline.
4. Pin at the shoulder (Figure 3.62).

Figure 3.62 / Steps B1–4

5. Dot muslin along the center of the style tape and along the neckline.
6. Crossmark at the intersection of the neckline and shoulder, the shoulder and style tape, and the style tape and waistline (Figure 3.63).[1]

Figure 3.63 / Steps B5–6

[1]If the center front panel extends into the armhole area, dot the armhole ridge and crossmark the princess tape and armhole intersection.

7. Remove the center front panel from the dress form, and true the neckline, the shoulder, and the princess seam line. Use the ruler or French curve where necessary.
8. Allow the necessary seam allowance and trim off excess muslin (Figure 3.64).

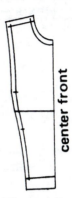

center front

Figure 3.64 / Steps B7–8

9. Replace the center front panel on the dress form, sinking pins well into the form along the princess seam.
10. Place the side front panel against the dress form so that the crosswise grain line is straight on the bustline level and the length grain is perpendicular to the floor.
11. Pin along the crosswise grain allowing the necessary ease.
12. Smooth and pin the muslin down along the straight grain line, taking a pinch at the waistline.
13. Slash the muslin below the waistline (Figure 3.65).

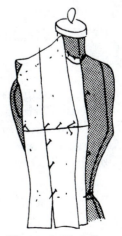

Figure 3.65 / Steps B9–13

14. Smooth the muslin over the center front panel, and pin over the trued princess seam.

15. Pin at the waistline and side seam intersection; pin at the side seam and armplate intersection.

16. Smooth the muslin up from the bustline level toward the shoulder, keeping the grains smooth. The lengthwise grain will swing toward the neckline.

17. Pin down along the princess seam toward the apex; some ease may be in the apex area.

18. Pin the shoulder and armhole.

19. Mark the shoulder, armhole, side seam, and waistline.

20. Dot the princess seam of the side panel directly over the princess seam of the center front panel.

21. Crossmark both the center front panel and the side front panel at the apex, 2 inches above the apex and 2 inches below (Figure 3.66).

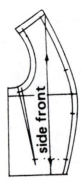

Figure 3.67 / Step B22

23. Pin the center front and side panel together, matching crossmarks.

24. Pin the front bodice to the dress form in preparation for draping the back (Figure 3.68).

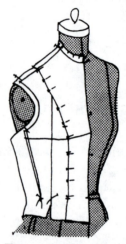

Figure 3.68 / Steps B23–24

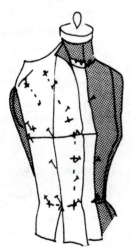

Figure 3.66 / Steps B14–21

22. True all seam lines, adding the necessary ease at the side seam. Trim away excess muslin leaving seam allowance at the shoulder seam, princess seam, and armhole. *Do not trim muslin at side seam* (Figure 3.67).

C. DRAPING STEPS—BACK

1. Pin the center back panel at the center back and at the shoulder blade level grain line. Allow the necessary ease along the shoulder blade area.

2. Smooth the muslin from the center back toward the style tape, keeping the crosswise grain perfectly aligned; pin along the style tape.

3. Drape the neckline.

4. Pin at the shoulder, placing necessary pinches for ease. If the shoulder is divided by the princess seam, one pinch is placed in the center back panel, and one

pinch is placed in the side back panel
(Figure 3.69).[2]

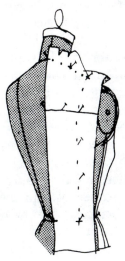

Figure 3.69 / Steps C1–4

5. Mark and true the center back panel the
same way as the center front panel (Figure 3.70).

Figure 3.70 / Step C5

6. Replace the center back panel on the
dress form the same way as the center
front, before draping the side back.

7. Place the side panel on the dress form so
that the crosswise grain line is in line
with the center back at the shoulder blade
level, and the length grain is centered in
the princess panel.

[2]If the princess seam extends into the shoulder, the back
shoulder dart is not necessary. When the princess seam origi-
nates in the armhole area or lower, a neckline or shoulder
dart may be necessary to maintain correct grain alignment.

8. Pin along the shoulder blade grain line,
allowing the necessary ease.

9. Pin the lengthwise grain line at the waist-
line, slashing the muslin below the waist-
line, and taking a pinch for ease.

10. Smooth the muslin over the center back
panel, and pin over the trued princess seam.

11. Smooth the muslin up toward the shoul-
der, and pin into place.

12. Pin the side seams together at the arm-
plate and waistline intersections. Grains
should be balanced.

13. Mark the back side panel the same way as
the front; crossmark the princess seam at
the shoulder blade level and 3 inches be-
low (Figure 3.71).

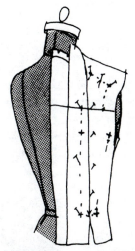

Figure 3.71 / Steps C6–13

14. True all seam lines; add seam allowance and
trim away all excess muslin (Figure 3.72).

Figure 3.72 / Step C14

15. Pin the princess waist together before
trueing the waistline. Check the fit on the
dress form.

16. See the finished pattern (Figure 3.73).

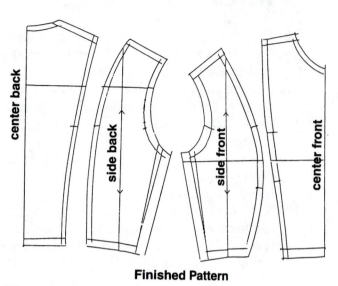

Figure 3.73 / Step C16

The Boned Bodice

The boned bodice is usually used as a foundation to hold up strapless dresses, gowns with off-the-shoulder necklines or one-shoulder styling, and also some loosely draped garments requiring special support (Figure 3.74).

Figure 3.74 / Various uses of the boned bodice

Although originally consisting of whale bones, the "bones" today are usually made of flexible plastic or flat wire coils. They are encased in pockets made of bias strips of fabric or enclosed in the seam allowance, which is folded back to form the pocket. The boning can be inserted in the center front, side seams, and princess seams of the bodice or be placed in pairs, over the breast, approximately 2 inches from the apex.

The boned bodice must be made in a firm fabric. When necessary, interfacing can be used to give additional support. The pattern for the boned bodice, however, is usually draped in muslin. The seams of the boned bodice front follow the princess seams of the dress form and a seam is at the center front. If the boned bodice back is low-cut, which is usual, no seams or darts are necessary in this area. Although the boned bodice pattern is initially draped on the dress form, the muslin must be fitted on a live model to achieve the close fit that is required.

Because the boned bodice serves as a foundation for the finished garment, it must be completed; that is, stitched in the finished fabric and placed on the dress form before the shell is draped. The shell of the finished garment can then be designed over the foundation in an infinite variety of shapes. Draped folds and gathers can float loosely or can be subtly attached to the foundation with invisible hand stitches. Of course, the finished bodice may also be closely fitted over the boned bodice using darts or seams (Figure 3.75).

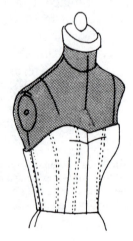

Figure 3.75

Boned Princess Bodice

A. PREPARATION OF MUSLIN

 1. Tape the outline of the boned bodice on the dress form.

 2. Tear muslin:

 a. Front

 (1) Length—measure the length of each panel as taped on the dress form and add 4 inches.

 (2) Width—measure the width of each panel at the widest point and add 3 inches.

 b. Back

 (1) Length—measure the height of the taped back at the underarm and add 4 inches.

 (2) Width—width at the widest point plus 3 inches.

 3. On the center front panel, draw a straight grain guide line 3 inches from the torn edge.

 4. To determine the bustline level, measure the distance from the upper edge of the taped bodice to the apex plus 1 inch. On the muslin center front panel, draw a cross grain line at the bustline level.

 5. Draw remaining grain lines as illustrated (Figure 3.76).

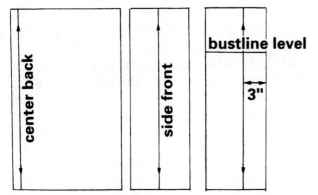

Figure 3.76 / Preparation of muslin

B. DRAPING STEPS

 1. Position the muslin center front panel on the dress form so that the straight grain line is perpendicular to the floor and in the center of the panel, and the cross grain line touches the apex. Pin at the apex.

 2. Smooth the grain up to the taped upper edge of the bodice and pin at princess line and at center front.

 3. Smooth the grain down to the waistline and pin. Slash the muslin on the grain line below the waistline.

 4. Pin the waistline at the princess line and center front.

 5. Pin the center front from the waistline to below the curve of the breast. The center front will be slightly off grain.

 6. At the bust-level cross grain line, pick up any excess muslin and form a horizontal dart from the center front to within ½ inch of the apex. Use at least ¼ inch dart pickup.

 7. Pin the muslin to the princess line below the apex.

 8. Dot the muslin along the princess seam, the upper and lower edges of the bodice, and center front; crossmark all intersections; mark bustline dart (Figure 3.77).

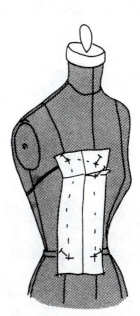

Figure 3.77 / Steps B1–8

 9. Remove the center front panel from the dress form and true dart, center front, and princess seam.

 10. Pin the dart. Allow 1 inch seam allowance at the center front and princess seam, and trim off excess muslin.

 11. Replace the center front panel on the dress form, sinking the pins well into the form along the princess line.

 12. Place the side front panel against the dress form so that the crosswise grain is straight on the bustline level and the length grain is perpendicular to the floor.

13. Pin the grain into place, taking a pinch at the waistline.
14. Slash the muslin below the waistline.
15. Smooth the muslin up to the taped upper edge of the bodice and over the center front panel; pin at the upper edge and over the trued princess seam. Some ease may be in the apex area.
16. Pin at the waistline and side seam intersection.
17. Mark all seams and intersections of the side front panel.
18. Crossmark both the center front panel and the side front panel at the apex, 2 inches above the apex and 2 inches below (Figure 3.78).

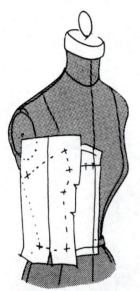

Figure 3.78 / Steps B9–18

19. True the princess seam and side seam. Leaving 1-inch seam allowances, trim away excess muslin.
20. Pin the center front and side panels together matching the crossmarks.
21. Pin to the dress form in preparation for draping the back.
22. On the center back grain line, place a crossmark 1½ inches down from the upper torn edge.
23. Position the muslin on the dress form with the crossmark pinned to the center back at the taped upper edge of the bodice.
24. Pin at the center back and waistline.
25. Smooth the muslin toward the side seam until tension appears below the waistline.

Slash muslin below the waistline at this point, and pin at the waistline and at upper edge of the bodice.
26. Repeat step 25 as often as necessary until the side seam is reached.
27. Pin the front and back together at the side seam (Figure 3.79).

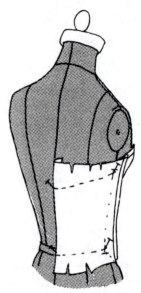

Figure 3.79 / Steps B19–27

28. Mark the upper and lower edges of the bodice, and remove from the dress form leaving the side seams pinned together.
29. Trace the front side seam to the back.
30. Trim the excess muslin from the back side seam, and pin the seam before trueing the upper and lower edges of the bodice.

C. FITTING—Because most dress forms are not shaped exactly like a nude body, the boned bodice that functions as a foundation garment must be fitted on a live model. To prepare the bodice for fitting, it must be duplicated for the left side so that a complete garment can be basted together.
1. Separate all the pieces.
2. Press all the pieces without steam to eliminate the possibility of shrinkage.
3. Trace to blocked muslin that has been prepared with the necessary grain lines for the left side of the body.
4. Cut out the left side.

5. Baste the entire bodice together. A machine-basting stitch may be used for this purpose.

6. Fit the bodice close to the body on the live model. Make any necessary adjustments. The bodice will probably have to be taken in at the bustline area and at the upper edge of the bodice.

7. See the finished pattern (Figure 3.80).

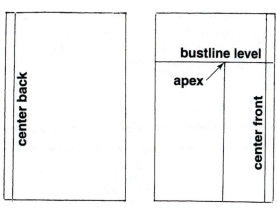

Figure 3.81 / Steps A2–6

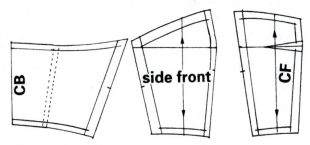

Figure 3.80 / Finished pattern

Boned One-Piece Bodice

A. PREPARATIION OF MUSLIN

1. Tape the outline of the boned bodice on the dress form.
2. Tear muslin:
 a. Front
 (1) Length—measure the length of the bodice on the dress form and add 4 inches.
 (2) Width—measure the width at bust level and add 3 inches.
 b. Back
 (1) Length—measure the height of the taped back at the underarm and add 4 inches.
 (2) Width—width at the widest point plus 3 inches.
3. On the front muslin, draw a straight grain guide line 1 inch from the lengthwise torn edge.
4. To determine the bustline level, measure the distance from the upper edge of the taped bodice to the apex plus 1 inch. On the muslin front, draw a cross grain line at the bustline level.
5. On the dress form, measure the distance from the apex to the center front.
6. On the muslin cross grain line, mark the position of the apex and draw the remaining grain lines as illustrated (Figure 3.81).

B. DRAPING STEPS

1. Pin the muslin to the dress form at the apex and center front below the bust.
2. Position the muslin so that the cross grain is straight across the dress form; pin into place along the cross grain line from the apex to the side seam.
3. Smooth the straight grain in the center of the princess panel down and pin into place at the waistline. Slash the princess panel grain line below the waistline.
4. Pin the muslin to the side seam and waistline intersection.
5. Pin the dart pickup from the waistline to the apex, keeping the apex grain line at the center of the dart (Figure 3.82).

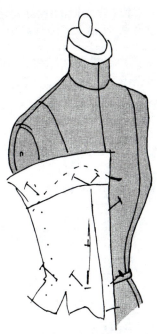

Figure 3.82 / Steps B1–5

6. Form a horizontal dart from the apex to the center front. The grain will be bias at the center front above the dart.

7. Mark both darts; dot along the upper and lower edges and crossmark all intersections (Figure 3.83).

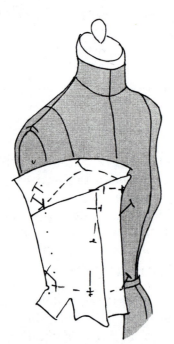

Figure 3.83 / Steps B6–7

8. Remove the bodice front from the dress form; true and pin both darts; true side seam and trim muslin leaving 1-inch seam allowance.

9. Pin the bodice front to dress form and drape bodice back the same as for the boned princess bodice (See page 50, steps 22–30).

10. Prepare the bodice for fitting (see page 50).

11. See the finished pattern (Figure 3.84).

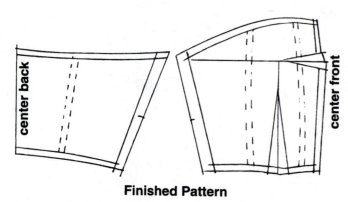

Finished Pattern

Figure 3.84 / Step B11

Cowls

Originally, the word *cowl* was used to describe the hooded garments worn by monks. Today, a cowl is any part of a garment that is draped in horizontal, loosely draped bias folds. These softly curved folds form the characteristic cowl neckline. Blouses with high cowls fill in the necklines of suits and coats, and at the other extreme, low alluring cowls are used for evening wear. Cowls can be placed at the front or the back of the bodice. They can be used to softly drape the armhole, and at various times in fashion history, they have been used to give shape to skirts and trousers. The folds of a cowl may fall casually or be very precisely placed (Figures 3.85 and 3.86).

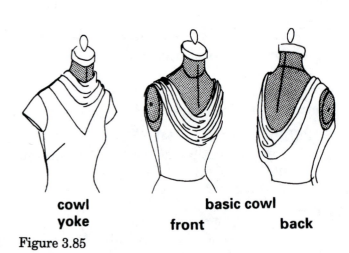

cowl yoke **basic cowl**
 front **back**

Figure 3.85

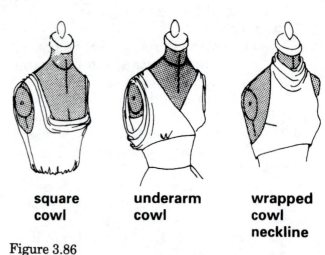

square cowl **underarm cowl** **wrapped cowl neckline**

Figure 3.86

Garments that are designed with cowls are usually made in soft fabrics. Weights may vary

from filmy, airy chiffon to heavy crepes. Each fabric will influence the flow of the cowl drape to such a degree that it is recommended that all cowls be draped directly in the fabric of the garment rather than in muslin (see Draping in Fabric, page 212). Fabric used for cowls needs the same or similar draping quality on both the lengthwise and crosswise grain. Otherwise, matching the draped folds on both sides of the cowl will be extremely difficult. Because the fabric of the cowl curves horizontally around the neckline, the armhole, or other area of the figure where it may be used, both sides of the cowl must be draped simultaneously. When a garment is designed with loose neckline cowls in both the front and back, the cowls should be draped over a fitted bodice and attached at the shoulders.

The Basic Cowl

A. PREPARATION OF FABRIC

1. Measurements: A 30-inch square is adequate for a bodice with a normal waistline. If the cowl is part of a bodice with a lowered waistline or a garment cut without a waistline seam, the square must be cut proportionately larger. On the other hand, a smaller square will be sufficient for a yoke cowl.

2. To draw a true bias across the square of fabric, fold the fabric into a right triangle and gently crease along the fold. To prevent stretching the bias, pat the fabric in the direction of the straight grain. Unfold the fabric and draw the bias line as indicated by the crease (Figures 3.87 and 3.88).

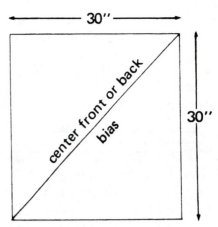

Figure 3.88 / Step A2 open

B. DRAPING STEPS

1. On the dress form, indicate the depth of the desired neckline with a pin. Necklines may be high or lowered to any degree of décolletage. For a high cowl, place the pin directly on the neckline of the dress form.

2. At the shoulder seams of the dress form, indicate the desired width of the neckline (Figure 3.89).

3. Turn back a corner of the fabric square for facing as illustrated. The bias folded edge, which will be used for the neckline, must be long enough to reach around the pins located on the dress form and provide at least 2 inches extra at the shoulders (Figure 3.90).

Figure 3.89 / Steps B1–2

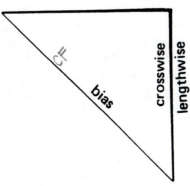

Figure 3.87 / Step A2 folded

Figure 3.90 / Step B3

4. Place muslin against the dress form, holding the center of the cowl under the pin and pinning the neckline at both shoulders. Let the neckline fall gently. *Do not stretch or pull fabric.* As the fabric falls against the body, a cowl drape will form. If the neckline is high, the cowl drape will be shallow, and more depth is usually added by lifting additional fabric toward the shoulders. If the neckline is lowered, the initial cowl drape may be adequate, but more folds can be achieved by lifting the fabric as previously mentioned. As the fabric is lifted to form additional draped folds, the center of the cowl indicated on the fabric must be kept directly in line with the center front or center back of the dress form. Keeping the center of the cowl in line is achieved by carefully lifting the same amount of fabric on both sides (Figure 3.91).

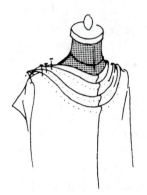
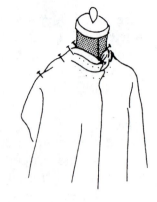

Figure 3.92 / Step B5

6. Drape the rest of the garment as desired. If the cowl drapes are sufficiently deep, additional darts or other means of fitting the bodice may not be needed. When darts are needed, they are often placed on the straight grain, forming a French dart. As the garment is fitted, *smooth only with the lengthwise or crosswise grain* to prevent stretching or pulling (Figures 3.93 and 3.94).

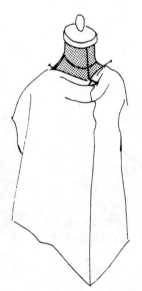

Figure 3.91 / Step B4

5. Form gathers or folds at the shoulders to accommodate additional drapes. Gathers will give a soft, casually draped appearance, while folded fabric will hold the drape in place for a more controlled look (Figure 3.92).

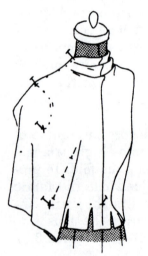

Figure 3.93 / Step B6 Figure 3.94 / Step B6

7. Mark only one side of the draped cowl.
8. Leaving any pleats and/or tucks pinned, remove the cowl bodice from the dress form. (Before removing pins, see page 38 for trueing pleats and gathers.)
9. True all markings. Raise the waistline ¼ inch at the center front to allow the bias to stretch. When one-half the cowl has

been completely trued, fold and pin the cowl at the center, and trace the trued half to the other side (Figure 3.95).

ss bring down ¼"

Figure 3.95 / Step B9

10. Trim off the excess depth of the neckline facing, leaving approximately 3½ inches at the center front. Add seam allowances, and trim away excess fabric at armhole, side seam, and waistline.
11. Replace the cowl on the dress form to check the position of the draped folds and the fit. Make any necessary adjustments. If needed, small weights may be used to hold cowl folds or gathers in place.
12. See the finished pattern (Figure 3.96).

Figure 3.96 / Finished pattern

Cowl Variations

The Underarm Cowl

The underarm cowl is draped without a side seam. When center front or center back is draped on a crosswise grain fold, the entire bodice can be cut in one piece. Thin soft fabric is recommended for the underarm cowl in order to keep bulk under the arm to a minimum. Front and back are draped simultaneously, but only on one half of the dress form (Figure 3.97).

Figure 3.97 / Underarm cowl

Underarm cowls usually leave an extremely deep armhole. They may be draped over a fitted bodice or worn over a slip. In opaque fabrics, a triangular stay can be attached to the facing and the waistline.

A. PREPARATION OF FABRIC
1. Measurements: If there will be seams at both the center front and center back, the basic 30-inch square will be sufficient. If the center front or center back is to be cut on a crosswise grain fold, the 30-inch square must be doubled to form a 30-by-60-inch rectangle.
2. For the large rectangle, draw a line on the crosswise grain separating the two 30-inch squares. Draw another crosswise grain line 2 inches to the left of the first line.

3. Draw a bias line across one 30-inch square as illustrated (Figure 3.98).

4. On the dress form, measure the waistline from the side seam to the center front and add 3 inches. If the waistline is to be raised, measure the area of the rib cage where the bodice will join the midriff or skirt.

5. On the 30-inch fabric square, draw the waistline plus 3-inch measurement as illustrated to form another square (Figure 3.98).

6. Add 1 inch for seam allowance into the small square, and cut away excess fabric as illustrated. Slash seam allowance at the bias and waistline intersection (Figure 3.99).

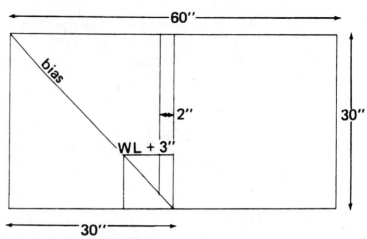

Figure 3.98 / Steps A1–5

5. Shape the neckline and pin at the shoulder (Figure 3.100).

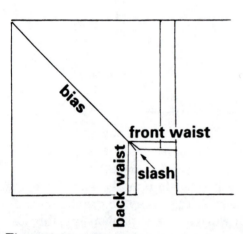

Figure 3.99 / Step A6

Figure 3.100 / Steps B1–5

B. DRAPING STEPS

1. Pin the bias and waistline intersection indicated on the fabric to the side seam and waistline intersection on the dress form. Fold and pin excess fabric temporarily to the dress form.

2. Smooth along the waistline toward the front; pin at center of princess panel.

3. Keeping grain straight, smooth up along the center of the princess panel to the bust level; pin at the bust level from the center of the princess panel to the apex.

4. From the apex, smooth fabric toward the shoulder, keeping the drawn straight grain lines parallel to the center front of the dress form; pin along the center front.

6. From the bias and waistline intersection at the side seam, smooth along the waistline toward the back; pin at the center of the princess panel.

7. Keeping the grain straight, smooth up along the center of the princess panel to the shoulder blade level, and pin.

8. Smooth with the crosswise grain along the shoulder blade level to the center back.

9. Keeping the center back on grain, pin along the shoulder blade level and center back.

10. Shape the back neckline, and pin the back and front together at the shoulder (Figure 3.101).

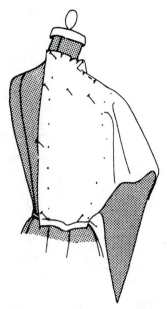

Figure 3.101 / Steps B6–10

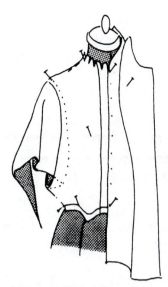

Figure 3.103 / Step B12

11. Hold the armhole extension out from the dress form, and determine the placement of the first cowl at the underarm fold. At this point, fold in the amount of fabric desired for one drape (Figure 3.102).

13. Repeat this process for as many additional cowl drapes as desired. At the shoulder, the drapes may all meet at the same point or be spaced apart. The fullness at the shoulder may also be gathered with shirring.

14. Cut away the point from the extended fabric, leaving at least 3 inches for facing (Figure 3.104).

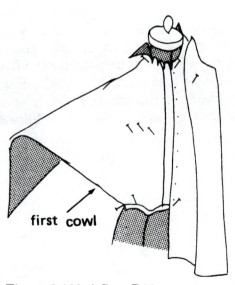

first cowl

Figure 3.102 / Step B11

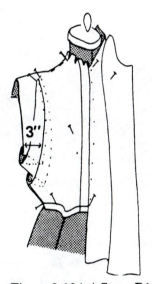

3"

Figure 3.104 / Steps B13–14

12. Bring up this fold, shaping it toward the shoulder, so that both the front and back meet at the same point. The depth of the fold will be less at the shoulder (Figure 3.103).

15. Keeping the folds at the shoulder carefully pinned together, separate the front from the back at the shoulder seam. Fold in the facing extension along the edge of the cowl, and repin the shoulder seam. If necessary, adjust or slash the facing for a better fit.

16. Fit and style the rest of the bodice as desired (Figure 3.105).

17. Mark:
 a. The center back and center front at the neckline and waistline intersections.
 b. Both sides of the underarm cowl; back and front will differ.
 c. The rest of the garment.

18. Remove from the dress form and true.

Figure 3.105 / Steps B15–16

19. If the center back or center front is draped on the fold, fold the fabric along the center fold line and pin.

20. Trace the trued half of the bodice to the other side. Leaving seam allowance, trim away excess fabric at the neckline, and center the back or center front.

21. See the finished pattern (Figure 3.106).

Figure 3.106 / Finished pattern

22. Replace the underarm cowl on the dress form to check the position of the draped cowl and the fit. Make any necessary adjustments. If needed, small weights may be used to hold the cowl folds in place.

The Wrapped Neckline Cowl

The wrapped neckline variation of the cowl has soft folds extending all around the neckline from front to back. Often used on blouses or dresses to give a scarf-like effect, it is also suitable for halters (Figure 3.107).

Figure 3.107 / Wrapped neckline

When draping a halter, tape the outline of the desired halter on the dress form before draping (See page 41).

A. PREPARATION OF FABRIC—The preparation is the same as for the basic cowl.

B. DRAPING STEPS
 1. On the dress form, indicate the depth of the desired neckline with a pin. Necklines may be high or lowered to any degree of décolletage. For a high cowl, place the pin directly on the neckline of the dress form.
 2. Turn back a corner of the fabric square for facing, as illustrated. The bias folded edge, which will be used for the neckline, must be long enough to reach around the neckline with ease and also long enough to form a knot if so desired (Figure 3.108).

Figure 3.108 / Step B2

3. Place the fabric against the dress form, holding the center of the cowl under the

pin and wrapping the neckline to the center back. Pin at the center back above the neckline. If a knot, gathers, or draped folds are desired at the center back, pin into place (Figures 3.109 and 3.110).

Figure 3.109 / Step B3 front

Figure 3.110 / Step B3 back

4. Slash carefully to the back neckline to release excess fabric. Slash precisely to the neckline and shoulder intersection (Figures 3.111 and 3.112).

Figure 3.111 / Step B4 side view

Figure 3.112 / Step B4 back

5. For a wrapped neckline cowl with a standard back, additional cowls may be draped into the shoulder seam after the back neckline has been carefully slashed (Figure 3.113).

Figure 3.113 / Step B5

6. For a halter, continue slashing into the fabric over the shoulder area to the taped outline of the halter in front. Fit the halter to the body with darts or seams. If a very bare back is desired, the halter may be fitted without a side seam (Figure 3.114).

Figure 3.114 / Step B6

7. Mark only one side of the draped cowl.
8. Remove from the dress form. Before removing the pins, see page 38 for trueing pleats and gathers.
9. When one half of the cowl has been completely trued, fold and pin the cowl at the

center, and trace the trued half to the other side.

10. Trim off the excess depth of the neckline facing. Leaving a seam allowance, trim away the excess fabric at all seams.

11. See the finished pattern (Figure 3.115).

12. Replace the cowl on the dress form to check the position of the draped folds and the fit. Make any necessary adjustments. If needed, small weights may be used to hold cowl in place.

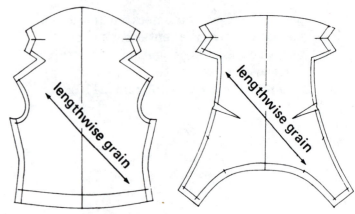

Figure 3.115 / Finished patterns

The Square Cowl with Self Stay

The square cowl is particularly well suited for a low décolletage at either the front or the back of the bodice. The characteristic stay keeps the cowl in place close to the body (Figure 3.116).

Figure 3.116 / Square cowl

A. PREPARATION OF FABRIC

1. Indicate the position of the square neckline on the dress form with style tape (Figure 3.117).

Figure 3.117 / Step A1

2. Cut a 30-inch square of fabric, and draw a true bias across the fabric. If the fabric (muslin) is marked with chalk or pencil, trace the bias line so that both sides of the fabric are marked.

3. On the dress form, measure the width and depth of the square neckline.

4. Fold the fabric square on the bias, and measure half the neckline width from the fold.

5. Draw a parallel line to the bias fold at this measurement (Figure 3.118).

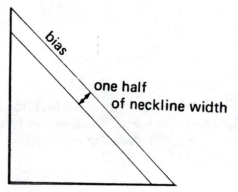

Figure 3.118 / Steps A4–5

6. Add 3 inches to the depth of the neckline measurement, and locate this measurement on a ruler. Holding the ruler on the straight grain, perpendicular to the edge of the fabric square, move it along the fabric until the point is reached where the depth of the neckline measurement and the neckline width intersect.

7. At the intersecting point, draw a line perpendicular to the folded bias, as illustrated (Figure 3.119).

Figure 3.119 / Steps A6–7

8. Slash along the grain line from the edge of the fabric to the intersecting point (Figure 3.120).

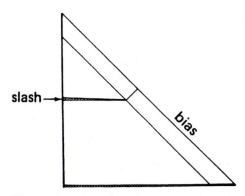

Figure 3.120 / Step A8

9. Open the fabric square and let the stay fall down, creating a bias fold along the width of the neckline (Figure 3.121).

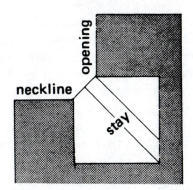

Figure 3.121 / Step A9

B. DRAPING STEPS

1. With the stay against the body, pin the neckline slash points to the corners of the square neckline taped on the dress form.

2. Pin the center front of the stay at the waistline, and slash the stay below the waistline in order to achieve a smooth fit.

3. After slashing the stay below the waistline, fit the stay close to the body as illustrated (Figure 3.122). A bustline dart, taken on the grain, will eliminate any extra bulk in the midriff area.

4. Drape and mark only one half the stay (Figure 3.122).

Figure 3.122 / Steps B1–4

5. Let the cowl drop and bring up the shoulder sections. Fold under ¼-inch seam allowance at the slashed edge, and pin the neckline as taped on the dress form (Figure 3.123).

Figure 3.123 / Step B5

6. At center front, fold in the amount of fabric desired for the first drape, and mold this fold around the square neckline to the shoulders. Pin it into place at each shoulder seam. At the shoulder, the cowl fold should lie flat against the body. Additional folds may be draped as desired. As the fabric is lifted to form additional folds, the center of the cowl indicated on the fabric must be kept directly in line with the center of the dress form (Figure 3.124).

Figure 3.124 / Step B6

7. Drape the rest of the garment as desired. If the cowl folds are sufficiently deep, additional darts or other means of fitting may not be needed. When darts are needed, they are often placed on the straight grain, forming a French dart. As the garment is fitted, *smooth only with lengthwise or crosswise grain* to prevent stretching or pulling.

8. Mark only one side of the draped cowl (Figure 3.125).

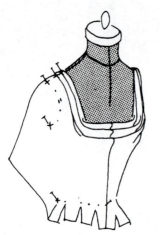

Figure 3.125 / Steps B7–8

9. Remove from the dress form. Before removing the pins, see page 38 for trueing pleats and gathers. Transfer the stay markings to the same side of the fabric as the cowl markings.

10. When one half of the cowl and stay has been completely trued, fold and pin the cowl and stay at the center, and trace the trued half to the other side.

11. Leaving a seam allowance, trim away excess fabric at the armhole, side seam, and waistline of both stay and cowl.

12. See the finished pattern (Figure 3.126).

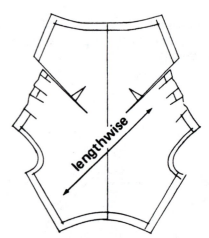

Figure 3.126 / Finished pattern

13. Place the cowl on the dress form to check the position of the draped cowl and the fit. Make any necessary adjustments.

Twists

A twist in fashion design is created when fabric is twisted or looped, forming a focal point from which draped folds radiate. Soft, drapable fabrics such as chiffon, jersey, or crepe are suitable for this type of design. Twists are used in all types of garments, ranging from formal evening gowns to intimate apparel and swimsuits. Several types of twists are described in this section.

The Butterfly Twist

The butterfly twist is cut in one piece. The result is a flat twist that is relatively simple to cut. It works particularly well in soft, thin fabrics

that can be fluted and draped over a foundation (Figure 3.127).

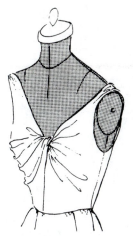

Figure 3.127 / Butterfly twist

A. PREPARATION OF MUSLIN

1. Cut a 30-inch square of fabric (Figure 3.128).

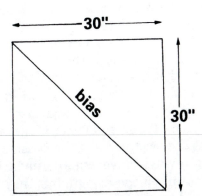

Figure 3.128 / Step A1

2. Fold the square on the bias grain and fold again.
3. Slash on the double bias fold to within 3 inches of the center point (Figure 3.129).

Figure 3.129 / Steps A2–3

B. DRAPING STEPS

1. Fold back 1 inch at both sides of one slash for the neckline seam allowance (Figure 3.130).

Figure 3.130 / Step B1

2. Gather the connecting bias area at the center of the square and twist around so that the right side of the fabric is on top on both sides with the twisted knot in the center (Figure 3.131).

Figure 3.131 / Step B2

3. Pin the neckline at the shoulders as desired.
4. Smooth and drape the folds of the bodice as desired forming gathers, tucks, or pleats that can be draped into the shoulder, side seam, or waistline. Some of the fullness can also be absorbed into the center front seam.

5. Mark and true one side of the bodice only. Trace to the other side (Figure 3.132).

Figure 3.132 / Steps B3–5

6. Repin and place on the dress form to check fit.
7. See the finished pattern (Figure 3.133).

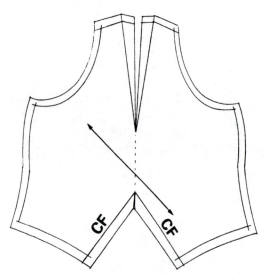

Figure 3.133 / Finished pattern

The Two-Piece Bias Twist

The two-piece bias twist consists of two pieces of fabric, cut on the true bias and looped together to form a knot. This type of twist can be used in various areas of the garment: at the shoulder, the bust, the back of the bodice, or the midriff. It is also effective in one-shoulder designs. The

smaller section of the twist can be replaced with a chain, cord, or strap (Figure 3.134).

Figure 3.134 / Two-piece bias twist

A. PREPARATION OF MUSLIN

1. Tape the outline of the design on the dress form.
2. Determine the measurements for the true bias muslin pieces.
 a. Length—measure the length of fabric needed to reach the twist loop; double that measurement, and add 6 inches.
 b. Width—estimate the width of the twist section at the widest point; divide in half, and add seam allowances.
3. Cut the two pieces of the twist. They may not always have equal dimensions, depending on the design, but they must always be cut on the true bias (Figure 3.135).

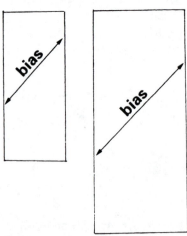

Figure 3.135 / Steps A2–3

B. DRAPING STEPS

1. Loop the two sections of the twist together, and pin the center seams, leaving enough opening at the loop to allow the twist to drape gracefully. Crossmark and clip the seam allowances at the loop opening. Pin the seam allowance together on the wrong side of the fabric.

2. Pin the twist to the dress form shaping the folds of the twist and smoothing the muslin to fit the form. Work carefully, smoothing the muslin in the direction of the grain. The bias will let the fabric mold to the figure. If necessary, the center seam of the twist sections can be adjusted to enhance the fit (Figure 3.136).

Figure 3.136 / Steps B1–2

3. Mark all seams, and remove the bodice from the dress form.
4. True seams, and leaving seam allowances, cut away the excess muslin.
5. Pin the bodice together and place it on the dress form to check the fit and make any necessary corrections.
6. See the finished pattern (Figure 3.137).

The Neck-Yoke Twist

The neck-yoke twist consists of two sections: the neck yoke and the lower section, which loops around it creating a twist. When designed with a high neckline, this type of twist is very effective as a suit blouse. The neck yoke can also be replaced with a band, a chain, or a cord when the twist is designed as a halter (Figure 3.138).

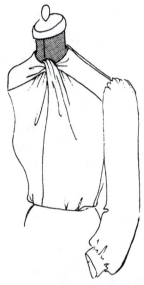

Figure 3.138 / Neck-yoke twist

A. PREPARATION OF MUSLIN

1. Neck yoke:
 a. Length—20 inches
 b. Width—7 inches
2. Lower section:
 a. Length—36 inches
 b. Width—15 inches
3. On the neck yoke:
 a. Fold back 1½ inches on the lengthwise grain for a neckline self-facing.
 b. Draw a crosswise grain line at the center of the yoke (Figure 3.139).

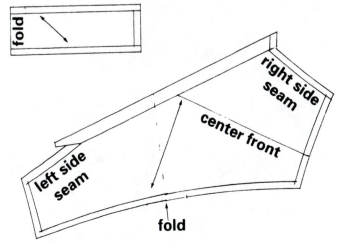

Figure 3.137 / Finished pattern

Figure 3.139 / Step A3

4. On the lower section:
 a. Draw a crosswise grain line at the center of the section (Figure 3.140).

lengthwise grain

lower section

Figure 3.140 / Step A4(a)

b. Fold the muslin on the crosswise grain line and measure in 6 inches from the edge on the fold.
c. Connect the 6-inch mark to the lower corner as illustrated (Figure 3.141). Trace this line to the other side of the muslin.
d. Leaving a 1-inch seam allowance, cut away the excess muslin. This seam will be the center front seam (Figure 3.141).

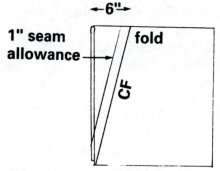

Figure 3.141 / Steps A4(b–d)

B. DRAPING STEPS
 1. On the dress form, determine the shape of the neckline, and place a pin at neckline and center front.
 2. Hook the center cross grain line of the neckline yoke under the pin at center front, and pin the neckline edge of the yoke

to the shoulder on both sides. If necessary, slash into the muslin to shape the lower edge of the yoke. Use style tape to shape the yoke line and mark (Figure 3.142).

Figure 3.142 / Steps B1–2

3. Leaving both sides of the lower section folded together, pin the center front seam to the dress form with the fold at the neckline.
4. Drape folds or gathers to be looped over the yoke at the neckline. Pin into place (Figure 3.143).

Figure 3.143 / Steps B3–4

5. Smooth the lower section on the grain toward the armhole and the side seam and determine the placement of the seam that will join the yoke to the lower section. Fold the lower section on the seam line and pin into place.

6. Fit the bodice as desired, working carefully in the direction of the grain.

7. On the center front seam, crossmark the beginning of the loop through which the yoke will be draped, approximately 1½ to 2 inches from the upper edge. The size of the loop depends on the width of the finished yoke and the thickness of the fabric (Figure 3.144).

Figure 3.144 / Steps B5–7

8. Crossmark both the yoke and lower section at the yoke seam where the loop begins, approximately 1½ inches from the center front.

9. Mark the rest of the yoke seam, the armhole, the side seam, any fitting darts or folds, and the waistline.

10. Remove the muslin from the dress form and true all seams. Leaving seam allowances, trim away all excess muslin. Clip into seam allowances at all twist crossmarks.

11. Pin the bodice together, matching all crossmarks. Place the bodice on the dress form and check fit.

12. See the finished pattern (Figure 3.145).

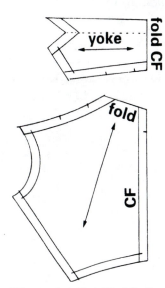

Figure 3.145 / Finished pattern

The Bust Twist

For the bust twist, two pieces of muslin are looped together between the breasts to form a twist (Figure 3.146).

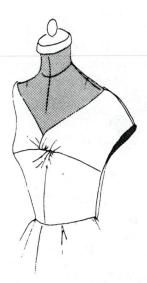

Figure 3.146 / Bust twist

A. PREPARATION OF MUSLIN
1. Tear muslin:
 a. Length—32 inches
 b. Width—20 inches
2. Fold in 1½ inches on the lengthwise grain. This fold will form the neckline

self-facing and the center front seam allowance.

3. Draw a crosswise grain line at the center of the muslin (Figure 3.147).

Figure 3.147 / Steps A1–3

B. DRAPING STEPS

1. Locate the twist point between the breasts with a pin.
2. Pin the cross grain line at center front of the muslin to the dress form 1 inch beyond the twist point.
3. Pin the upper part of the center front edge of the muslin to the shoulder forming the neckline.
4. Pin the lower part of the center front edge of the muslin to the waistline.
5. Drape small folds of muslin at the cross grain line toward the twist, and pin at the center front.
6. Slash the cross grain line to the center front of the dress form. *Do not cut into the twist folds.* This line will create an upper section and a lower section of the bodice (Figure 3.148).
7. Working with the grain, smooth the

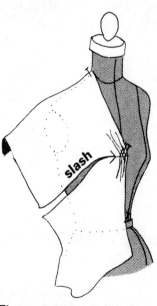

Figure 3.148 / Steps B1–6

upper section toward the shoulder, armhole, and side seam. Smooth the lower section toward the waistline and side seam.

8. Pin the upper and lower sections together forming a seam that flows from the twist to the side seam, absorbing the excess muslin as desired. Clip into the seam allowance where necessary.
9. Mark the seam to within 1 inch from center front; crossmark at this point, leaving an opening for the twist loop. Insert additional crossmarks in the seam near the apex. Mark the rest of the bodice (Figure 3.149).

Figure 3.149 / Steps B7–9

10. Remove the muslin from the dress form. True all seams. Leaving seam allowance, cut away excess muslin.
11. Duplicate the bodice for the other side by tracing the muslin.
12. Pin both sides of the bodice together, looping the twist at the center front.
13. Replace on the dress form, and check fit.
14. See the finished pattern (Figure 3.150).

Figure 3.150 / Step B14

4
Skirts

Variations of the Basic Skirt

The One-Piece Basic Skirt

It is possible to drape the basic skirt without a side seam. The shaped section of the side seam above the hipline then becomes a dart, and the skirt is usually seamed together at the center back. If the skirt is designed with a front closure, the seam can also be at center front. The matching of plaids or horizontal stripes becomes automatic in the one-piece skirt. This is a decided advantage in many cases (Figure 4.1).

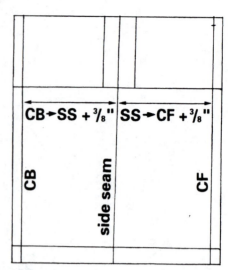

Figure 4.2 / Steps A1–6

Figure 4.1 / One-piece basic skirt

A. PREPARATION OF MUSLIN

1. Tear muslin:
 a. Length—skirt length plus 4 inches
 b. Width—width from center front to center back at the widest point of the hip area plus 2¾ inches
2. Draw a lengthwise grain line for center front and center back 1 inch from the torn edge of the muslin.
3. Measure down 2 inches from the top edge of the muslin at the center front and crossmark for the waistline.
4. Measure down 7 inches from the waistline to establish the standard hipline.
5. On the hipline, indicate with a crossmark the hip level measurement from center front to side seam plus ⅜ inch for ease, and indicate the side seam location with a lightly drawn lengthwise grain line.
6. Indicate the hem level 2 inches up from the lower edge of the muslin (Figure 4.2).

B. DRAPING STEPS

1. Drape the front and back the same way as for the basic skirt.
2. At the intersection of the side seam and waistline, pin the excess muslin together. Pin a dart from the waistline to hipline following the shape of the hip curve (Figure 4.3).

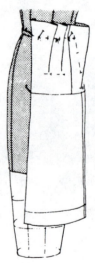

Figure 4.3 / Steps B1–2

C. MARKING

1. Mark the front and back the same way as for the basic skirt.
2. At the side seam dart, mark both sides of the pins.

D. TRUEING

1. True front and back the same way as for the basic skirt.

2. True the side seam dart by placing the hip curve so that the curved edge follows the hipline dots and touches the crossmarks at the waistline and the vanishing point at the hip level.

3. See the finished pattern (Figure 4.4).

Figure 4.4 / Finished pattern

The Tapered Skirt

A recurring theme in fashion is the slim, tapered skirt silhouette that is narrower at the hem than at the hipline. If the hem of this skirt falls below the knee, it must have a slit or a pleat to provide walking ease. This pleat is usually incorporated into a center back seam (Figure 4.5).

Figure 4.5 / Tapered skirt

A. PREPARATION OF MUSLIN—Prepare the muslin the same way as for the basic skirt, but mark ½ inch inside the side seam at the hem level, and connect this mark to the side seam grain line at the hipline. The tapered line becomes the new side seam (Figure 4.6).

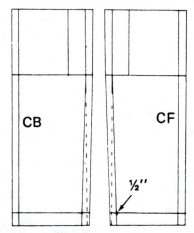

Figure 4.6 / Step A

B. DRAPING, MARKING, AND TRUEING—Drape, mark, and true the same way as for the basic skirt. Pleats, tucks, or gathers may be used instead of darts to style the excess fullness at the waistline. To mark and true pleats, tucks, or gathers, see pages 38–39. See finished pattern (Figure 4.7).

Figure 4.7 / Finished pattern

The Eased Skirt

The eased skirt is easy and comfortable. It flares slightly at the side seam without disturbing the grain of the rest of the skirt (Figure 4.8).

Figure 4.8 / Eased skirt

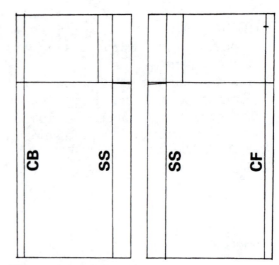

Figure 4.9 / Steps A1–9

A. PREPARATION OF MUSLIN

1. Measure the dress form the same as for the basic skirt.
2. Tear muslin (separate pieces for front and back):
 a. Lengthwise grain—the desired length of the skirt plus 4 inches.
 b. Crosswise grain—the distance from the center front to side seam at the hip level plus 5 inches.
3. Draw the grain line for center front and center back 1 inch from the lengthwise grain torn edge.
4. Measure down 2 inches from the top edge of the muslin at center front.
5. Measure down 7 inches from the waistline crossmark to establish the standard hipline.
6. Measure down 9 inches from the top edge of the muslin for the back hipline. Draw a crosswise grain line at this point.
7. On the hipline of the skirt front, indicate with a crossmark the hip level measurement from center front to side seam plus ⅜ inch for ease. Repeat from the center back to the side seam on the skirt back.
8. Draw a lengthwise grain guide line for both the front and back of the side seam at this point.
9. On both the front and back hipline, measure 2 inches in from the side seam toward the center; from this point, draw a lengthwise grain line to the upper edge of the muslin (Figure 4.9).

10. Clip into the side seam at the hipline level and pin the side seam of the front and back skirt together from the hipline down, as illustrated (Figure 4.10).

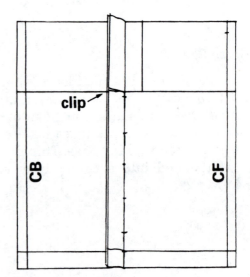

Figure 4.10 / Step A10

B. DRAPING STEPS

1. Turn under 1-inch allowance at center front and center back. At center front, pin indicated waistline mark to the tape.
2. Pin at the center front and hipline.
3. Drape the muslin so that the hipline is straight across the dress form, leaving the lower skirt hanging smoothly without any diagonal pull; distributing ease evenly, pin across the hipline from the center front to center back to prevent the muslin from sagging.

4. Smooth both the front and back lengthwise grain line near the side seam up to the waistline; be sure to avoid any diagonal pull; pick up a pinch and pin to the waistline.

5. Pin the side seam of the front and back skirt together from the hipline over the curve of the hips to the waistline.

6. Keeping the side seam grain lines pinned together from the hipline to the lower edge of the skirt, add a gentle flare as desired.

7. Remove grain line pins to check the amount of side seam flare. If necessary, adjust flare making sure that grain alignment is not disturbed.

8. Fit the waistline, using darts, tucks, or gathers (Figure 4.11).

5. See the finished pattern (Figure 4.12).

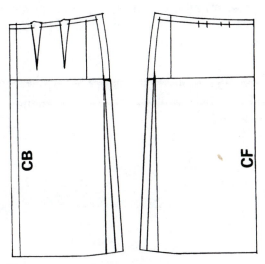

Figure 4.12 / Finished pattern

Figure 4.11 / Steps B1–8

C. MARKING AND TRUEING

1. Mark the waistline with darts the same as for the basic skirt. See pages 38–39 for tucks or gathers.

2. At the side seam, mark both sides of the pins above the hipline. Below the hipline, mark only the last pin at the lower edge of the skirt.

3. Remove the skirt from the dress form and while the skirt front and back are still pinned together, true the side seam using the skirt curve above the hipline and a long ruler from the hipline to the hem. Trace the side seam from front to back. Add a seam allowance at the side seam and trim away excess muslin.

4. True darts at the waistline same as for the basic skirt. True tucks or gathers as described on pages 38–39.

The Dirndl Skirt

The dirndl skirt is a straight skirt cut with extra fullness that is gathered into the waistline. When excessive fullness makes gathering difficult, small overlapping, unpressed pleats may be used (Figure 4.13).

The width of the skirt is dictated by the design of the garment and is often influenced by the width of the fabric. If the fabric is wide enough, the skirt may be planned using a full width for the front and a full width for the back.

Figure 4.13 / Dirndl skirt

For example: All-around width desired—80 inches; width of fabric—45 inches (Figure 4.14).

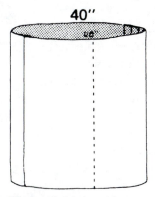

40"

Figure 4.14

When additional fullness is desired and the fabric is not wide enough to cut the skirt in just two pieces, the skirt may be cut in three pieces with a seam at each side of the front and a seam at center back. It is usually desirable to avoid a seam at center front.

For example: All-around width desired—110 inches; width of fabric—45 inches (Figure 4.15).

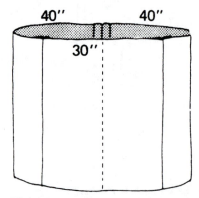

Figure 4.15

The hem width for a dirndl skirt can vary. If the skirt is to be light and airy, a rolled or edge-stitched hem is best. On the other hand, hem widths, especially on better garments, may range from 3 to 5 inches. For lightweight fabrics, extremely wide hems are often allowed because they add a certain weight causing the skirt to hang better.

A. PREPARATION OF MUSLIN

1. Estimate the desired width of the skirt.
2. Tear the muslin for front and back:
 a. Length—length of skirt plus 1½ inches plus hem
 b. Width—one quarter of the desired width for the front and one quarter of the desired width for the back plus seam allowances
3. Draw the center front grain lines.
4. On the grain line, crossmark 1½ inches down from the upper edge of the muslin.
5. Draw a crosswise grain line at hip level.
6. Draw the side seam on both front and back.
7. Draw the center back grain line (Figure 4.16).

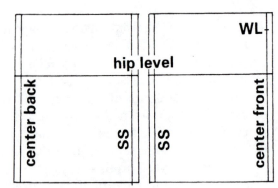

Figure 4.16 / Steps A1–7

B. DRAPING STEPS

1. Tape the hipline on the dress form.
2. On muslin, pin the side seam or side front seam together.
3. Pin the waistline and hipline at the center front to the dress form.
4. Pin the muslin at the hipline and side seam.
5. Pin the muslin at the hipline and center back, and evenly divided along the hip level.
6. Using style tape, or ¼-inch elastic if desired, hold in the extra fullness at the waistline. Distribute the fullness evenly, keeping the hip level grain line in line with the corresponding tape on the dress form. If desired, the skirt fullness may be arranged in clusters or in any way that a special silhouette may be achieved (Figure 4.17).

Figure 4.17 / Steps B3–6

7. Mark and true the gathers or pleats at the waistline. Crossmark at the side seam (see pages 38–39).

8. Mark and true the hem. The hem of a straight dirndl skirt should be on grain.
9. Stitch the gathers and adjust the fullness to fit the skirt on the dress form. Use crossmarks on the waistline of the bodice (or on the waistband, if designing a separate skirt) to fix the fullness in place.

The Dome Skirt

The dome skirt is a variation of the dirndl. The fabric is stiffened or must have a stiff crisp hand, giving the skirt a clearly defined shape. The fullness in a dome skirt is dictated by the desired silhouette and the stiffened hemline (Figure 4.18).

Figure 4.18 / Dome skirt

Depending on the fabric and desired effect, the dome skirt may be cut on the crosswise grain as well as on the lengthwise grain. When a dome skirt is cut on the crosswise grain, the center front can be cut on a fold and the center front seam is eliminated.

For extreme dome silhouettes, it may be necessary to place padding in the hipline. Ruffled, boned, or wired petticoats may also be used. The skirt is then draped *over* these supports (Figure 4.19).

hip pad ruffled petticoat wire hoops

Figure 4.19

A. PREPARATION OF MUSLIN

1. Tear muslin:
 a. Length—length of finished skirt plus 5 inches plus desired hem allowance
 b. Width—full width of muslin
2. Draw the center back grain line.
3. On this grain line, crossmark 5 inches down from the upper edge of the muslin for the waistline.
4. Draw a crosswise grain line at the hip level.
5. The muslin is stiffened by basting a width of nylon net to the back of the muslin (Figure 4.20).

Figure 4.20 / Steps A1–5

B. DRAPING STEPS

1. Tape the hipline to the dress form.
2. Pin the muslin center back to the dress form at the waistline and hipline.
3. Holding the muslin away from the dress form at the desired width, pin the center front to the dress form. The hip level grain line should correspond to the hip tape on the dress form (Figure 4.21).

Figure 4.21 / Steps B2–3

4. Using style tape or ¼-inch elastic, if desired, hold in extra fullness at the waistline. Unpressed pleats, gathers, or darts may be used alone or in combination, depending on the desired effect. Extra width is shaped at the side seam area by gently drawing out the muslin from beneath the style tape at the waistline. The angle of the pleats, gathers, and/or darts at the waistline also contributes to the shape of the dome skirt.

5. Pin center front:
 a. For a center front fold, a perfect lengthwise grain must be maintained.
 b. Drape a center front seam slightly off grain. Certain fabrics, such as woven silks, cottons blends, and most synthetics tend to pucker when long seams are stitched on the straight grain.
 c. For a more exaggerated silhouette, the center back, the center front, or both may be lifted and thrown off grain (Figure 4.22).

Figure 4.22 / Steps B4–5

6. Mark and true the waistline and center front. Crossmark at the side seam.
7. Replace the muslin on the dress form, adjust the length, and mark the hem. If the center front and/or center back seams have been draped off grain, the hem will also be slightly off grain at each side of the seams. If necessary, replace the hem with a facing.

The Gored Skirt

The gored skirt is shaped with seams, and it may be designed with a slim or flared silhouette. When the skirt is flared, the flares may be placed high or low, permitting unlimited styling possibilities. This skirt usually has six gores (Figure 4.23).

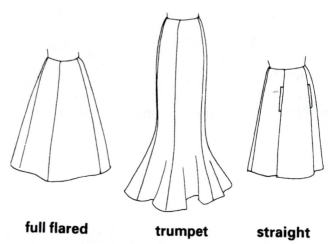

full flared **trumpet** **straight**

Figure 4.23 / Six-gore skirt

The gored skirt need not flare uniformly at every seam. The flare may be varied to achieve specific effects, such as a flare at the sides with the front and back relatively flat, an exaggerated back flare, or the flare concentrated in the front and back with relatively straight side seams.

With the addition of a center front seam and a center back seam, the six-gore skirt becomes an eight-gore skirt (Figure 4.24).

Figure 4.24 / Eight-gore skirt

A. PREPARATION OF MUSLIN
 1. On the dress form, indicate the hip level with style tape.

2. Tape the location of each gore seam from the waistline to the hip level.
3. Tape the level, from center front to center back, where the skirt will begin to flare out (Figure 4.25).

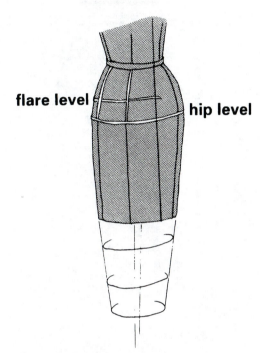

Figure 4.25 / Steps A1–3

4. Tear the muslin for the front and back:
 a. Length—length of skirt plus 2 inches plus hem
 b. Width:
 (1) Center front and center back panels—width at widest point plus desired amount of flare plus 2 inches.
 (2) Side panels—width at widest point plus 2 times the desired amount of flare plus 2 inches
5. Draw the lengthwise grain line for the center front and center back 1 inch from the torn edge.
6. Draw a lengthwise grain line in the center of each side panel.
7. On the center front grain line, crossmark 2 inches down from the upper edge of the muslin for the waistline.
8. From this point measure down 7 inches for the hip level, and draw the crosswise grain hipline across all panels.
9. At the hipline of the dress form, measure the distance from the center front and

center back to the gore seam. Add ¼ inch for ease, and on the muslin, indicate this distance from the center front and center back on the hipline. From this point, draw a grain line from the hipline to the hem.
10. At the hipline of the dress form, measure the distance from the side seam to the gore seam on both the front and back side panels. Add ¼ inch for ease, and on the muslin side panels, indicate this width centered on the hipline of each panel. From these points, draw the grain lines from the hipline to the hem (Figure 4.26).

Figure 4.26 / Steps A5–10

11. Pin all panels together on the gore seam grain lines from the hipline to hem (Figure 4.27).

Figure 4.27 / Step A11

B. DRAPING STEPS

1. Pin the center front and center back of the muslin to the dress form at the hipline and waistline.
2. Pin along the hipline from the center front to center back, distributing the ease (Figure 4.28).

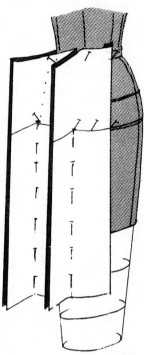

Figure 4.28 / Steps B1–2

3. Smooth the center grain line of side panels to the waistline and pin, taking a pinch for ease.
4. Pin the side and center panels together along the gore seam lines. Slash the muslin beyond the seam, where necessary.
5. Making sure that the ease is maintained in the entire hip area, pin the side seam together above the hipline.
6. Pin the desired width of all flares from the hem to the flare level taped on the dress form. Remove the pins along the grain lines of all seams to check the width of the

skirt. Make any necessary adjustments. The grains should balance in the flare area (Figure 4.29).

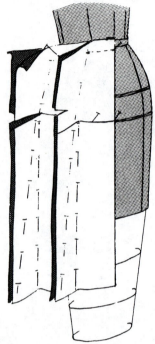

Figure 4.29 / Steps B3–6

C. MARKING AND TRUEING

1. Dot the waistline and crossmark all seams.
2. Remove the skirt from the dress form, and mark both sides of the pins at all seams.
3. While seams are still pinned together, true seams, using the skirt curve above the flare level and a long ruler along the flares. Blend any points at the flare level into a smooth seam line.
4. Trace all seams to the other side, and while the seams are still pinned together, add the seam allowance and trim away all excess muslin. Place notches into the seam allowance.
5. Separate pieces and repin the seams' matching notches.

6. True the waistline; add the seam allowance and trim away excess muslin.
7. See the finished pattern (Figure 4.30).

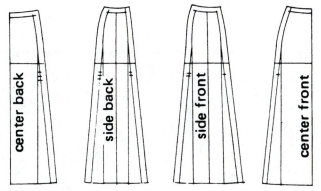

Figure 4.30 / Finished pattern

8. Replace the skirt on the dress form and adjust the length. Even length is achieved by measuring the distance from the floor to the hem every few inches along the lower edge of the skirt (Figure 4.31).

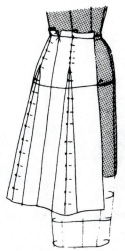

Figure 4.31 / Finished muslin pinned together

The Flared Skirt

The flared skirt borrows its silhouette from the fabric of which it is made. Knits, chiffons, and crepes give a softly mobile flow to the flared skirt. On the other hand, a more defined shape results when firmer fabrics such as crisp cottons and closely woven woolens are used. Other elements affecting the silhouette of the flared skirt are the number and fullness of the flares in the skirt and the position of the grain. There are three major areas for the placement of the lengthwise grain:

• Straight grain at the side seam (Figure 4.32).

Figure 4.32 / Finished pattern

• Straight grain at the center front (Figure 4.33).

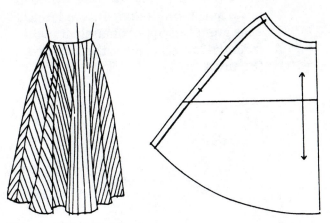

Figure 4.33 / Finished pattern

• Straight grain centered on each panel (Figure 4.34).

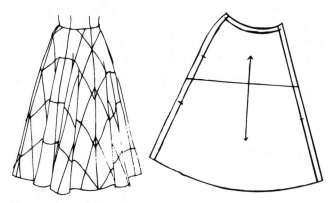

Figure 4.34 / Finished pattern

The width of the skirt and the placement of flares are carefully controlled in draping. You should estimate how many flares are desired and where they will be placed. Flares may be evenly distributed or concentrated at the front, the back, or at the sides of the skirt. With pins, mark the number and placement of flares at the waistline of the dress form.

Front Skirt

2" hem

A. PREPARATION OF MUSLIN 25
1. Tear muslin:
 a. Length—length of finished skirt plus 5 inches plus desired hem allowance
 b. Width—full width of muslin
2. Draw a lengthwise grain line:
 a. For a flared skirt with the straight grain at the **side seam,** draw a lengthwise grain line approximately 3 inches from the left selvage for the side seam (Figure 4.35).

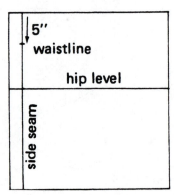

Figure 4.35 / Steps A1, 2(a), 3, and 4

b. For a flared skirt with the straight grain at the **center front,** draw a lengthwise grain line approximately 3 inches from the right selvage for the center front (Figure 4.36).

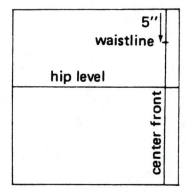

Figure 4.36 / Steps A1, 2(b), 3, and 4

c. For a flared skirt with the straight grain at the **princess line,** draw a lengthwise grain line at the center of the muslin (Figure 4.37).

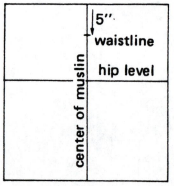

Figure 4.37 / Steps A1, 2(c), 3, and 4

3. On this grain line, indicate the waistline level with a crossmark 5 inches down from the upper torn edge.
4. At hip level, 7 inches down from the waistline crossmark, draw a crosswise grain line.

B. DRAPING STEPS FOR THE FLARED SKIRT WITH THE STRAIGHT GRAIN AT THE SIDE SEAM
1. Hold the side seam grain line against the side seam of the dress form, and pin

at the hipline and at the lower edge of the torso.

2. Smooth along the hipline, keeping the grain straight, and pin at the hipline directly under the first flare point indicated on the waistline.

3. Smooth the lengthwise grain up to the waistline, and pin directly over the pin at the first flare point.

4. Place a pinch at the waistline, following the principle of the basic skirt, and pin at the side seam and waistline intersection.

5. Slash muslin above the first flare point to within ¼ inch of the waistline (Figure 4.38).

straight grain side seam

Figure 4.38 / Steps B1–5

6. Release the muslin and drop the grain in order to form the desired flare. Flares should be limited in width so that they retain their feeling of fullness. When a flare is excessively deep, it will form a flat fold.

7. Pin the muslin to the dress form at the lower torso just beyond the completed flare.

8. Carefully retaining the position of the grain between flares, smooth along the *straight grain* to the next flare point. *Do not stretch the bias grain at the waistline.*

9. Repeat the method as described in steps 5 to 8 until the desired number of flares have been draped and center front is reached.

10. Pin the center front at the waistline and lower torso (Figure 4.39).

Figure 4.39 / Steps B6–10

C. DRAPING STEPS FOR THE FLARED SKIRT WITH THE STRAIGHT GRAIN AT CENTER FRONT

1. Pin the straight grain at the center front at the waistline, hipline, and edge of torso.

2. Smooth the crosswise grain along the hipline until aligned under the first flare point at the waistline. Smooth the grain up to the waistline, and pin directly over the pin at the first flare point.

3. Continue using the same method as for the skirt with the straight grain at the side seam (steps B5 to B8). At the curve of the hip area, be especially careful to allow enough ease over the fullest part of the

hip, easing in at the waistline if necessary (Figure 4.40).

straight grain at center front

Figure 4.40 / Steps C1–3

D. DRAPING STEPS FOR THE FLARED SKIRT WITH THE STRAIGHT GRAIN CENTERED ON EACH PANEL

1. Slash the lengthwise grain line above the indicated waistline to within ¼ inch of the waistline crossmark.
2. Pin the straight grain to the dress form, centered between the center front and the side seam at the waistline and the hip level.
3. Work from the straight grain line toward the side seam and the center front, using the same method described above. Both the side seam and center front seam will be on the bias (Figure 4.41).

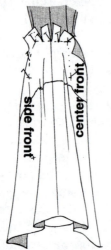

straight grain at center of panel

Figure 4.41 / Steps D1–3

E. MARKING

1. Crossmark at the side seam and waistline.
2. Dot the side seam from the waistline to the hipline; place a crossmark 7 inches below the waistline and at the edge of the torso if the side seam is on the bias.
3. Dot the waistline.
4. Crossmark the intersection of the waistline and center front.
5. Mark center front at the edge of the torso if the center front is on the bias.

F. TRUEING

1. Add additional width at the bias seams at the lower torso to compensate for the lengthwise stretch that occurs in all long bias seams. The amount of width added will depend on the fabric. For muslin, add ½ inch (Figure 4.42).

Figure 4.42 / Step F

2. True the bias seam by connecting the crossmark at the waistline with the extended mark at the lower torso. When the bias seam is at the side seam and the skirt is very full, it may be necessary to straighten a dip that can occur in the hip area.
3. Connect the dots at the waistline, squaring off a short area at the side seam and center front.
4. Add seam allowances and trim away excess muslin.

Back Skirt

A. PREPARATION OF MUSLIN—Prepare the muslin the same way as for the front skirt, but do not draw lengthwise grain lines before draping.

B. DRAPING STEPS

1. Pin the front skirt over the muslin that has been prepared for the back skirt, matching the crosswise grain at the hipline.

2. Trace the side seam of the front skirt onto the back muslin. Add seam allowance and trim away excess muslin (Figures 4.43, 4.44, and 4.45).

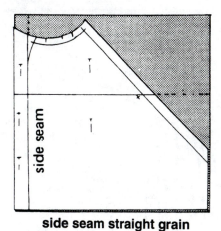

side seam straight grain

Figure 4.43 / Steps B1–2

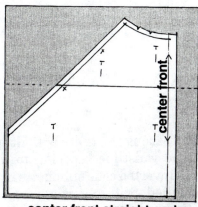

center front straight grain

Figure 4.44 / Steps B1–2

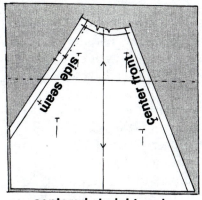

centered straight grain

Figure 4.45 / Steps B1–2

3. Pin the side seam of the front and back skirt together.

4. Replace the skirt on the dress form, pinning the front skirt into position. Check the side seam, making sure that it hangs straight from the waistline (Figure 4.46).

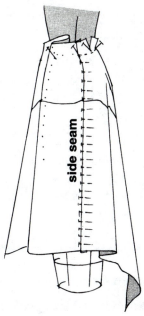

Figure 4.46 / Step B4

5. Drape the back skirt using the same method to achieve flares as in the front skirt. Back and front flares should harmonize and combine to form a well-balanced skirt. In order to achieve this balance, it is sometimes necessary to adjust the side seam of the back skirt above the hipline. Center front and center back grains need not necessarily be identical.

6. Mark and true the center back and waistline of the skirt (Figure 4.47).

7. Allow the necessary seam allowance, and trim off excess muslin.

Figure 4.47 / Step B6

8. Place the skirt on the dress form and adjust the length. Even length is achieved

by measuring the distance from floor to hem every few inches along the lower edge of the skirt. Cut off excess muslin leaving hem allowance as desired.

9. See the finished pattern (Figure 4.48).

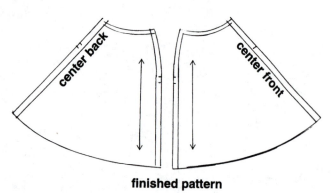

finished pattern

Figure 4.48 / Step B9

Variations of the Flared Skirt

Pleats in the Flared Skirt

Add pleats where desired along with the flares. Pleats in a flared skirt are usually deeper at the hemline so that they flow in harmony with the flares (Figures 4.49 and 4.50).

Gathers in the Flared Skirt

Add extra fullness at the waistline between flares. The effect will be similar to a dirndl skirt, but it is not necessary to have as much gathering at the waistline to achieve a graceful swing at the hem (Figures 4.51 and 4.52).

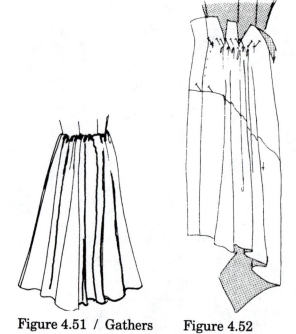

Figure 4.51 / Gathers Figure 4.52

The Peg Skirt and the Sarong Skirt

Peg skirts and sarong skirts are both draped with fullness at the waistline tapering to a narrow hemline. This inverted cone silhouette may be extreme or modified. Stiff fabrics will enhance the characteristic peg shape, whereas soft clinging fabrics result in a draped, almost Grecian effect.

There are two methods of draping peg or sarong skirts.

1. The skirt draped with a side seam is usually more modified, with extra fullness radiating from the side seam and concentrated in the upper part of the skirt. The center front of the peg skirt may be cut on the fold, and the hemline remains on grain (Figure 4.53).

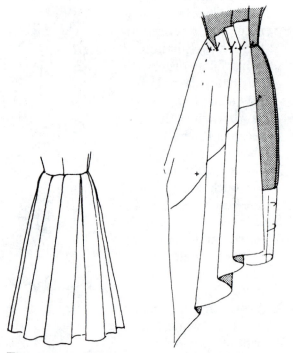

Figure 4.49 / Pleats Figure 4.50

Figure 4.53 / With side seam

2. The more extreme type of pegged skirt is usually draped without a side seam. In most cases, the straight grain is placed at the center back with the front skirt falling on the bias. When the straight grain is at the center front, the back will be on the bias. In some cases, such as the true hobble skirt, the straight grain may be placed at the side seam, and then both the center front and center back will fall on the bias (Figure 4.54).

Figure 4.54 / Without side seam

The sarong skirt is characteristically wrapped to the side with an uneven hemline. When a sarong skirt is draped with a side seam and a basic back, draping proceeds from the side seam for the draped right side of the skirt. The left side, which is wrapped underneath, is usually draped flat in order to eliminate bulk (Figure 4.55).

Figure 4.55 / Sarong

Peg Skirt with Side Seam— Front

A. PREPARATION OF MUSLIN

1. Tear muslin:
 a. Length—2½ inches plus length of the finished skirt plus hem allowance
 b. Width—one half width of muslin
2. Draw the center front grain line 1 inch from the lengthwise grain torn edge.
3. On this grain line, crossmark 2½ inches down from the upper edge of the muslin for the waistline.
4. Draw a crosswise grain line 9 inches down from the waistline, the widest part of the hip.
5. On this line, indicate with a crossmark the hip level measurement from center front to side seam plus ⅜ inch for ease.
6. Draw a straight grain line down from the hip level crossmark to the lower edge of the muslin (Figure 4.56).

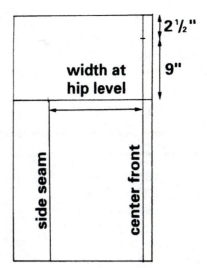

Figure 4.56 / Steps A1–6

B. DRAPING STEPS

1. Pin the muslin to the center front at the waistline, hipline, and lower edge of torso.
2. Pin the side seam at the point where the peg draping will begin, usually somewhere between the hipline and the lower edge of the torso. Below this point, the skirt should fall straight with ease, the same as a basic skirt. Pin at the lower edge of the torso.
3. Slash from the outer edge of the muslin to the pin at the side seam where the peg draping is to begin (Figure 4.57).

Figure 4.57 / Steps B1–3

4. Lift the muslin from the pin and arrange the extra fullness formed at the waistline. Unpressed pleats, gathers, or tucks may be used depending on the desired effect.

5. Repeat the pin-and-slash procedure at the side seam as often as necessary to achieve the fullness desired at the waistline.

6. Style tape or ¼-inch elastic may be used to hold in the fullness at the waistline. To create a puffed effect, draw out the muslin from beneath the style tape (Figure 4.58).

Figure 4.58 / Steps B4–6

7. Mark and true the draped area of the side seam, blending the upper curve with the straight grain at the lowest slash.

8. Mark and true the waistline (See pleats, tucks, and gathers, page 38).

9. Leaving the seam allowance, trim away excess muslin at the side seam and waistline.

10. See the finished pattern (Figure 4.59).

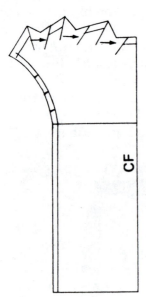

Figure 4.59 / Finished pattern

Sarong Skirt with Side Seam—Front

Because the sarong skirt is an asymmetric design, both sides have to be draped.

A. PREPARATION OF MUSLIN

1. Tear muslin:
 a. Left side
 (1) Length—1½ inches plus length of the finished skirt plus hem allowance
 (2) Width—one half width of muslin
 b. Right side
 (1) Length—4 inches plus length of the finished skirt plus hem allowance
 (2) Width—three quarters width of muslin

2. On the left side of the skirt:
 a. Draw the center front grain line 6 inches from the lengthwise torn edge of the muslin.
 b. Indicate the waistline and all grain lines the same as for the basic skirt (Figure 4.60).

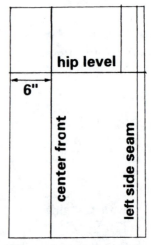

Figure 4.60 / Steps A1–2

3. On the right side of the skirt:
 a. Draw a straight grain guide line for the side seam 3 inches from the torn edge of the muslin.
 b. Draw crosswise grain line at the hip level 11 inches down from the upper torn edge of the muslin (Figure 4.61).

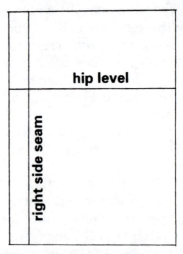

Figure 4.61 / Step A3

B. DRAPING STEPS

 1. Left side:

 a. Pin the center front at the waistline and hipline.

 b. Smooth the muslin to the side seam and drape the left side darts same as basic skirt.

 c. Smooth the muslin on the right side of the center front to the princess line; temporarily, pin the waistline dart into place.

 d. Mark the side seam from the waistline to the hipline where it should blend smoothly into the side seam grain line.

 e. Mark the left side waistline and darts the same as the basic skirt.

 f. True the left side of the skirt. Fold on the center front grain line and trace the waistline and first dart to the underlap (Figure 4.62).

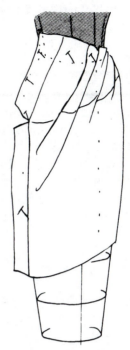

c. Shape the fullness into unpressed pleats or gathers (Figure 4.63).

Figure 4.63 / Step B2(a–c)

d. Mark and true. See the finished pattern (Figure 4.64).

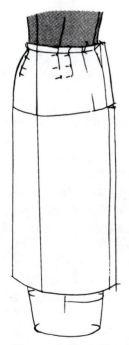

Figure 4.62 / Step B1(a–f)

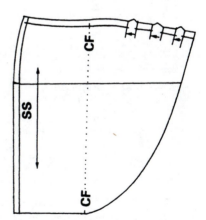

Figure 4.64 / Finished pattern

 2. Right side:

 a. Pin the side seam at hip level and at the lower edge of torso.

 b. Drape the sarong by lifting the muslin and bringing the fullness into the upper part of the opposite side seam or the waistline. It may be necessary to slash into the muslin at the right side seam, same as for the peg skirt, to achieve the desired draping effect.

Skirt Back for Peg or Sarong Skirt with Side Seam

A. PREPARATION OF MUSLIN

 1. Measure the dress form the same as for the basic skirt.

 2. Tear muslin:

 a. Lengthwise grain—the desired length of the skirt plus 4 inches

b. Crosswise grain—the distance from center back to side seam at the hip level plus 4 inches

3. Draw the grain line for the center back 1 inch from the lengthwise grain torn edge.

4. Measure down 9 inches from the waistline crossmark to establish the hip level. Draw a crosswise grain line at this point.

5. On the hipline, indicate with a crossmark the hip level measurement from the center back to side seam plus ⅜ inch for ease.

6. Draw a lengthwise grain guide line for the side seam at this point.

7. On the hipline, measure 2 inches in from the side seam toward the center; from this point, draw a lengthwise grain line to the upper edge of the muslin (Figure 4.65).

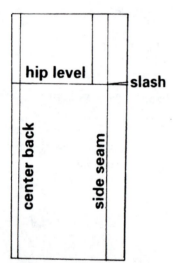

Figure 4.65 / Steps A1–7

B. DRAPING STEPS

1. Turn under 1-inch allowance at center back.

2. Pin at the center back and hipline; smooth muslin up to the waistline, and pin into place.

3. Drape muslin so that the hipline is straight across the dress form, leaving the lower skirt hanging smoothly without any diagonal pull; distributing ease evenly,

pin across hipline from center back to side seam to prevent muslin from sagging.

4. Smooth the lengthwise grain line near the side seam up to the waistline; be sure to avoid any diagonal pull; pick up a pinch and pin to the waistline.

5. Drape the waistline darts, same as basic skirt back (Figure 4.66).

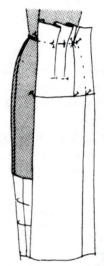

Figure 4.66 / Steps B1–5

C. MARKING AND TRUEING

1. Mark the waistline and darts the same as for the basic skirt.

2. At the side seam, crossmark the waistline and side seam intersection; dot the hip curve from waistline to hipline.

3. Remove the skirt from the dress form and true the side seam using the skirt curve above the hipline.

4. Add the seam allowance at the side seam and trim away excess muslin.

5. True darts at the waistline the same as for the basic skirt.

6. Pin the skirt back to the skirt front; replace the skirt on the dress form and check the fit; make any necessary adjustments. The side seam may have to be tapered to achieve the desired silhouette. For a sarong skirt, trace any side seam adjustment to the left front of the skirt (Figure 4.67).

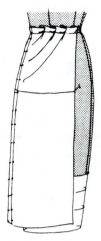

Figure 4.67 / Step B6

7. Adjust the length and mark the hem. For a peg skirt with a side seam, the hem is usually on the grain and can be easily turned up. The curved hem of some sarong skirts can either be edge stitched or finished with a facing.

Peg or Sarong Skirt Without a Side Seam

A. PREPARATION OF MUSLIN
 1. Tear muslin:
 a. Length—3 inches plus length of finished skirt plus 6 inches
 b. Width—full width of muslin
 2. Draw the center back grain line.
 3. On this grain line, crossmark 3 inches down from the upper edge of the muslin for the waistline.
 4. Draw a crosswise grain line 7 inches down from the waistline at hip level (Figure 4.68).

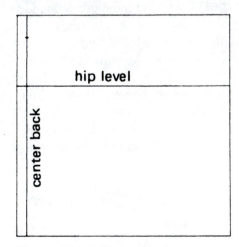

Figure 4.68 / Steps A2–4

B. DRAPING STEPS
 1. Pin center back at the waistline, hipline, and torso (Figure 4.69).

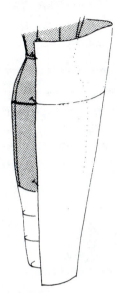

Figure 4.69 / Step B1

2. Holding the upper edge of the muslin, bring the muslin around the dress form to the front, letting the upper edge stand away from the body at the waistline. Raise the muslin at center front, letting lower edge taper closer to the body. The center front will then be on the bias grain. Sufficient width must be maintained at the lower edge for freedom of movement. Pin the muslin to the dress form at the center front (Figure 4.70).

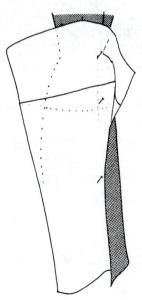

Figure 4.70 / Step B2

3. Style tape or ¼-inch elastic may be used to hold in the fullness at the waistline. Unpressed pleats, gathers, or tucks may be arranged to achieve various effects. If desired, the back of the skirt may be smoothly fitted with darts and all fullness concentrated in the front, which is particularly desirable for a sarong skirt. To create a puffed effect, draw out the muslin from beneath the style tape. When the peg or sarong skirt is draped without a side seam, the draped fullness may flow beyond the side seam area into the back skirt (Figures 4.71, 4.72, and 4.73).

6. See the finished pattern (Figure 4.74).

Figure 4.74 / Finished patterns for peg and sarong skirts without side seams

7. Replace the skirt on the dress form and adjust the hem. If the peg shape is extreme, the lower edge will be off grain and can only be edge stitched or finished with a facing.

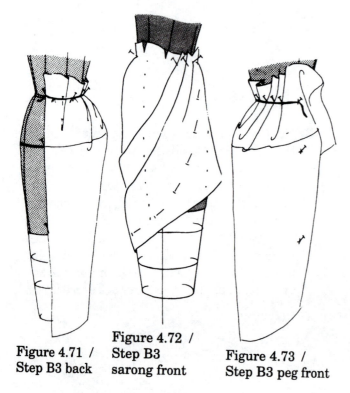

Figure 4.71 / Step B3 back

Figure 4.72 / Step B3 sarong front

Figure 4.73 / Step B3 peg front

4. Mark and true the waistline and center front for the peg skirt. For the sarong skirt, crossmark the center front, and mark and true the left side of the skirt.

5. Trim off any excess muslin, leaving the seam allowance.

Pleated Skirts

The use of pleats can give skirts graceful fullness in motion, but at rest, pleated skirts retain a smooth, slim silhouette. The fullness in a pleated skirt is controlled. Pleats can be folded in many different ways for various effects. Pleats may be spaced evenly all around the skirt, arranged in clusters, or used singly at seams. Pleats may be crisply pressed or fall in soft unpressed folds.

The types of pleating most often used in skirts are side pleats, box pleats, accordion pleats, and sunburst pleats. Side pleats and box pleats may be stitched down from the waistline to the hip for a smooth, controlled effect or they may be shaped without stitching over the hip area and left open.

Pleated skirts are usually pleated by the professional pleater. Professional methods are essential if pleats are to remain permanently pressed. To

prepare skirts for the pleater, determine the length and width desired in the finished skirt, add the hem and necessary seam allowances, and cut rectangular pieces of fabric for the front and the back of the skirt according to these measurements. Before a skirt can be sent to the pleater, all but one seam should be sewn, and the hem must be finished. This method is used for side-, box-, and accordion-pleated skirts. The sunburst-pleated skirt is cut like a circular skirt (Figures 4.75, 4.76, and 4.77).

accordion pleats sunburst pleats

Figure 4.75

Figure 4.76 / Side pleats

Figure 4.77 / Box pleats

After pleating, pleated skirts should be placed on the dress form in order to determine the exact waistline shape. This shaping can be done with style tape or narrow elastic tape (Figures 4.78 and 4.79).

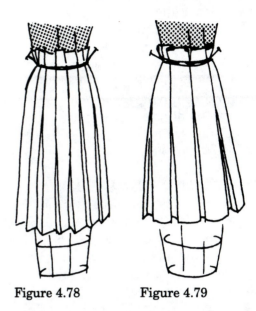

Figure 4.78 Figure 4.79

When a professional pleater is not available, box- or side-pleated skirts can be draped so that the resulting pattern indicates the position and width of the pleats. The markings can then be transferred to the fabric, and the pleats are basted and pressed into place. This process is not difficult, but it is time-consuming.

Side- or Box-Pleated Skirts

To drape and pleat a side- or box-pleated skirt, determine the spacing of the pleats and the depth of each pleat as desired. A fuller effect is achieved by moderately shallow pleats spaced closely together rather than by deep pleats spaced further apart. Deeper pleats (more than 2 inches) remain folded and the fullness is lost. Very shallow pleats (¾ inch or less) save fabric but will not hold their shape. Side pleats are usually spaced fairly close together, while box pleats may be spaced further apart. The number of pleats in an all-around pleated skirt is determined by the distance between pleats and the hip measurement of the finished skirt.

For example: If the hip measurement of the skirt is 36 inches and pleats are spaced 1½ inches apart, 24 pleats will be in the finished skirt. If these pleats will be 1 inch deep, 2 inches have to be added for each pleat to the width of the skirt, totaling 48 inches for pleats in addition to the 36 inches required for the finished hip measurement. The sweep of the entire skirt will then total 84 inches (Figures 4.80 and 4.81).

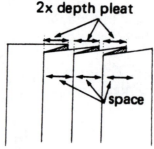
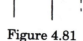

Figure 4.80

Figure 4.81

A. PREPARATION OF MUSLIN

1. Measure the hip circumference from the center front to the center back at the widest point and add 1 inch for ease. Divide this measurement in half for the front and the back of the skirt.
2. Tear muslin for the front and back:
 a. Length—length of skirt plus 1½ inches plus hem
 b. Width—front or back measurement determined in step 1 plus the amount of extra fabric needed for the pleats in one quarter of the skirt plus 2 inches

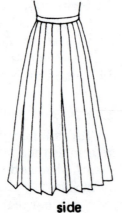

side

Figure 4.82

For example: For a skirt with side pleats (Figure 4.82), 1 inch deep, 1½ inches apart, measuring 36 inches at the hipline, 6 pleats will be in each quarter. Each 1-inch pleat will require 2 inches of extra fabric. Therefore, each quarter of the skirt will measure as follows:

9 inches hip measurement
12 inches for pleats
2 inches for seam allowances

23 inches—total

For a skirt with box pleats (Figure 4.83), 1½ inches deep on each side of the box, 3 inches apart, measuring 36 inches at the hipline, 3 pleats will be in each quarter. Each complete box pleat will require 6 inches of extra fabric. Therefore, each quarter of the skirt will measure as follows:

9 inches hip measurement
18 inches for pleats
2 inches for seam allowances

29 inches—total

3. Draw the center front grain line.
4. On the grain line, crossmark 1½ inches down from the upper edge of the muslin.
5. Draw a crosswise grain line at hip level.
6. Draw the side seam in both the front and back.
7. Draw the center back grain line (Figure 4.84).

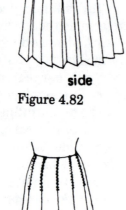

box

Figure 4.83

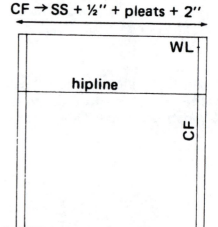

Figure 4.84 / Steps A3–7

CF → SS + ½″ + pleats + 2″

WL

hipline

CF

8. Pin-baste the side seam together as illustrated (Figure 4.85).

Figure 4.85 / Step A8

9. Open the fabric, with seam allowance and pins underneath.

10. To mark the muslin for a *skirt with side pleats:*
 a. Begin at the side seam by marking the depth of a pleat at each side of the side seam.
 b. Next to the depth of the pleat mark, measure the distance of the space between the pleats and the mark.
 c. Next to the spacing mark, measure two times the depth of the pleat.
 d. Repeat these measurements, alternating the spacing and the depth of the pleat pickup, to the center front and the center back of the skirt (Figure 4.86).

11. To mark the muslin for a *skirt with box pleats:*
 a. Space pleats so that the side seams are hidden inside a pleat, as illustrated (Figure 4.87).
 b. Repeat as for side pleats, steps 10a to 10d.

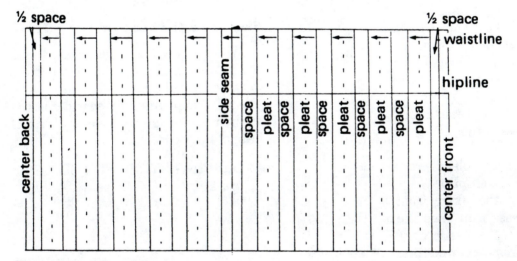

Figure 4.86 / Step A10

Figure 4.87 / Step A11

12. Draw a grain line to the hem at each pleat mark.
13. Press and pin pleats from hipline to hem.

B. DRAPING STEPS

1. Pin the center front and center back of the pleated skirt to the dress form.
2. Pin along the hipline, keeping the grain straight (Figure 4.88).
3. Adjust the pleats to fit the waistline by taking in even amounts at each side of the pleat pickup so that the center of each pleat remains on grain. Be sure that the overall grain remains straight in the hip area of the skirt. The additional pickup on each pleat will be less at the center front, but every effort should be made to keep the spacing of pleats as uniform as possible. Pin pleats down as they are fitted over the hip area.
4. Using style tape, mark the waistline (Figure 4.89).
5. Mark each pleat from waistline to hipline.
6. Remove the skirt from the dress form. True the waistline, and true each pleat from the waistline to hipline.
7. Leaving seam allowance, trim away excess muslin at the waistline (Figure 4.90).

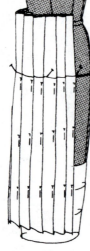

Figure 4.88 / Steps B1–2

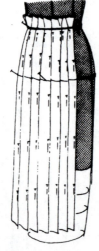

Figure 4.89 / Steps B3–4

side pleats

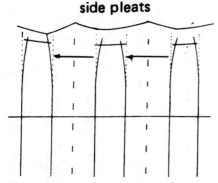

Figure 4.90 / Steps B6–7

Kick Pleats and Inverted Pleats

Kick pleats and inverted pleats are generally used to give walking ease to an otherwise straight skirt. A kick pleat is a simple side pleat inserted at the center back or center front. It is most often used at the center back of a basic skirt. An inverted pleat is a single box pleat usually placed at the center front (Figure 4.91).

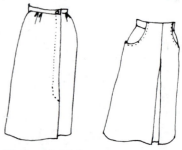

Figure 4.91

To drape these pleats, fold the muslin at the center front or center back according to the type and the depth of the desired pleat, before the skirt is draped.

Pleats Inserted in an Off-Grain Seam

When a pleat is to be inserted in an off-grain seam, as in a gored skirt or a princess dress, it may be draped as a side pleat or as an inverted pleat. These pleats may be wider at the hem than at the upper edge in harmony with the general flare of the skirt.

A. DRAPING STEPS FOR SIDE PLEATS (Figure 4.92)

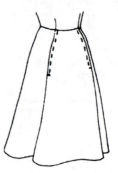

Figure 4.92 / Side pleats

1. Add the fabric for the depth and shape of the desired pleat after the flare has been established at the seam.
2. After the skirt has been trued and the seam pinned together to the top of the pleat, fold the pleat in the direction desired and pin into place along the upper edge.

3. See the finished pattern (Figure 4.93).

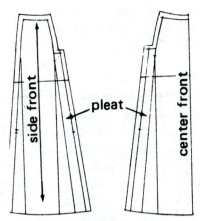

Figure 4.93 / Finished pattern

B. DRAPING STEPS FOR A SIMPLE IN-VERTED PLEAT—This pleat will have a seam showing at the center (Figure 4.94).

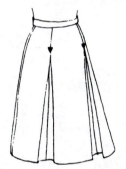

Figure 4.94 / Inverted Pleats

1. Add enough fabric to form a complete pleat on each side of the seam.
2. Pin the seam at the center of the pleat together.
3. Fold the pleat at each side of the seam into place, and pin along the upper edge of the pleat.
4. See the finished pattern (Figure 4.95).

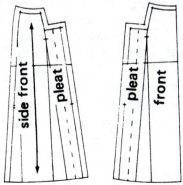

Figure 4.95 / Finished pattern

C. DRAPING STEPS FOR A TWO-PIECE INVERTED PLEAT—This pleat will have no seam showing at the center, but it will have seams at the inside folds of the inverted pleat (Figure 4.96).

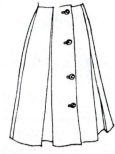

Figure 4.96

1. Add enough fabric to form the depth of each pleat at each side of the seam.
2. Remove from the dress form and cut a piece of fabric for the inside of the pleat by tracing the shape of the pleat extension at each side of the seam onto a folded piece of muslin.
3. Leaving a seam allowance, trim excess fabric from the seam extensions and the insert (Figure 4.97).

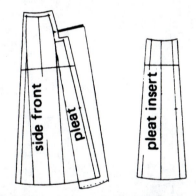

Figure 4.97 / Steps C2–3

4. Pin the insert to the pleat extensions at the long seams and shape the top of the pleat as illustrated (Figure 4.98).
5. Pin to the skirt along the upper edge of the pleat (Figure 4.98).

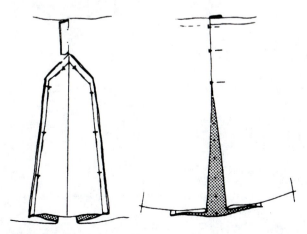

Figure 4.98 / Steps C4–5

The Skirt with a Built-Up Waistline

Most skirts may be designed with a built-up waistline. When they are separate, these skirts are finished with a facing instead of the usual waistband. Exceptions are flared skirts and those that are designed with a dartless hip yoke. However, these skirts may also be designed without a waistband and finished with a facing, but they will have to end at the normal waistline or below. The lower edge of the facing for a built-up waistline skirt ends at the normal waistline. The skirt should be interfaced above the normal waistline so that it is held firmly in place. Because there is no waistband, the zipper or button closure must extend to the upper edge of the skirt (Figure 4.99).

2. Tear the muslin following the instructions for the type of skirt that is to be developed, but add the height of the skirt extension above the normal waistline to the lengthwise grain measurement.
3. Draw the center front lengthwise grain line 1 inch from the torn edge.
4. On the lengthwise grain line, mark the upper edge of the skirt 2 inches down from the upper edge of the muslin.
5. On the dress form, measure the distance from the taped upper edge of the skirt to the standard waistline.
6. Mark the standard waistline and hip level on the center front grain line; draw a cross grain line at the hip level (Figure 4.100).

Figure 4.100 / Steps A3–6

B. DRAPING STEPS
1. Pin the center front at the upper edge of the skirt, the standard waistline, and the hipline.
2. Drape the skirt as desired:
 a. In a skirt with a side seam, extend the darts to the upper edge. Darts will be deepest at the standard waistline. Darts may also be released below the standard waistline forming tucks or soft pleats. Leave adequate ease in the skirt above the waistline to accommodate the facing and the interfacing. The amount of ease will depend on the thickness of the finished fabric.

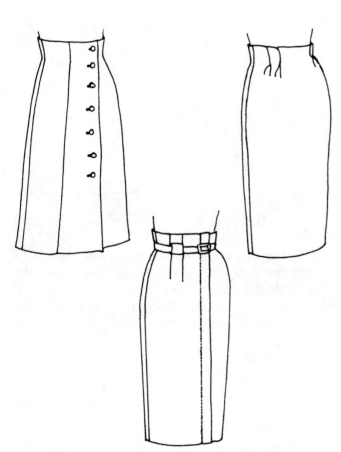

Figure 4.99 / Built-up waistline skirt variations

A. PREPARATION OF MUSLIN
1. Tape the new, built-up waistline onto the dress form.

b. In a gored skirt, extend and shape the gores above the standard waistline (Figure 4.101).

Figure 4.101 / Steps B1–2

3. Mark and true, following the instructions for the skirt style being draped as given in the applicable section of this chapter.

4. To develop the facing, pin together all seams and/or darts except the side seam; trace the skirt outline above the standard waistline.

5. See the finished pattern (Figure 4.102).

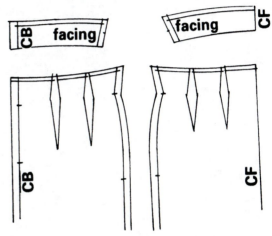

Figure 4.102 / Finished pattern

5

Pants

Pants, trousers, slacks—whatever we call them—have become a staple in virtually every woman's wardrobe. They are worn everywhere at any time of the day or night. They may cling to every curve of the body, or they may be straight and tailored. For evening or loungewear, they are often full and flowing. They may be shaped like a skirt: pegged, tapered, or flared. Pants may be long, or they may stop short at any length (Figure 5.1).

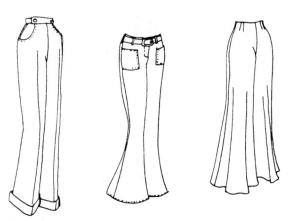

Figure 5.1 / Pants

A bifurcated pants form is essential for draping pants or trousers. These forms may have legs shaped only to the knee, or they may be full length with legs that are realistically molded to the ankle. The full-length forms are preferable because they give a better sense of proportion, permitting the designer to consider the length as well as the width of the legs. When no pants form is available, pants must be drafted from measurements (Figure 5.2).

Figure 5.2 / Pants form

Basic Straight Trousers

A. PREPARATION OF MUSLIN

1. Tape the hipline on the pants form.
2. Tear muslin for both front and back:
 a. Length—desired length of trousers plus 2 inches plus hem or cuff allowance; *for a cuff,* allow 2 times the finished cuff plus hem
 b. Width—19 inches
3. On the pants form, determine the length of the crotch by holding the L-square so that the short end passes between the legs at the highest possible point and the long end rests against the center front of the torso. The measurement that is then indicated on the L-square at the waistline is the crotch length including 1¼ inches of ease. This ease is the average amount of ease used in straight, comfortable trousers. More closely fitted pants have less crotch ease, usually ¾ inch; and loosely fitted pants, such as pajamas, may have more ease allowed (Figure 5.3).

Figure 5.3 / Step A3

4. On the muslin front, draw a lengthwise grain line for the center front 4 inches from the torn edge.

5. On the muslin back, draw a lengthwise grain line for the center back 6 inches from the torn edge.
6. On the center front and center back grain lines, mark down from the upper edge 2 inches for the waistline intersection.
7. Draw a crosswise grain line on the front and back 7 inches down from the 2-inch waistline mark for the hipline.
8. Draw a crotch level grain line below the hipline at the correct distance from the waistline (Figure 5.4).

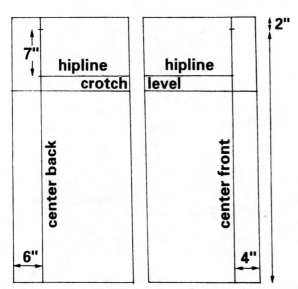

Figure 5.4 / Steps A4–8

9. Establish the *crotch extensions* on the crotch level cross grain line:
 a. Front—one quarter of the distance from the center front to the side seam at the hip level (Figure 5.5)

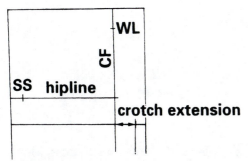

Figure 5.5 / Step A9(a)

b. Back—one half the distance from the center back to the side seam at the hip level (Figure 5.6)

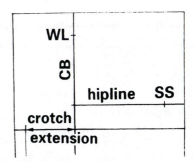

Figure 5.6 / Step A9(b)

10. At the crotch extensions, drop straight grain lines parallel to the center front and center back.
11. On the center back grain line, mark the half-way point between the waistline and the crotch level.
12. At the center back and waistline intersection, measure up ¼ inch and in ¾ inch; from this point, connect a diagonal line to the half-way mark on the center back grain line.
13. At the intersection of the center back and the crotch level, draw a diagonal line 2 inches long (Figure 5.7).

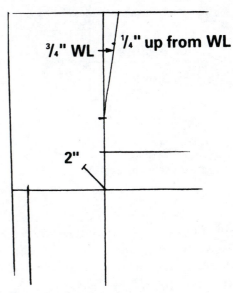

Figure 5.7 / Steps A10–13

14. Place the French curve so that it touches the center back at the half-way mark, the diagonal line, and the crotch level; draw the back crotch curve as illustrated (Figure 5.8).

crotch level

Figure 5.8 / Step A14

15. At the intersection of the center front and the crotch level, draw a diagonal line 1½ inches long.
16. Placing the French curve so that it touches the center front at the hipline, the diagonal line, and the crotch level, draw the front crotch curve (Figure 5.9).

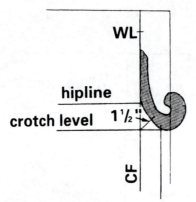

WL

hipline

crotch level 1½"

CF

Figure 5.9 / Steps A15–16

17. Add seam allowance at the crotch curve, and trim away excess muslin; clip into the seam allowance at the curve at frequent intervals.

B. DRAPING STEPS

1. Before placing the muslin on the form, overlap the front and back muslin at the inseam, pin the front and back crotch points together, and pin along the inseam to the ankle (Figure 5.10).

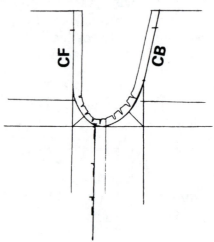

CF CB

Figure 5.10 / Step B1

2. On the pants form, pin the center front and center back at the waistline and the hipline (Figure 5.11).

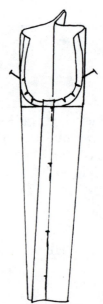

Figure 5.11 / Step B2

3. Pin both the front and back along the hipline, leaving adequate ease.

4. Pin the front and back together at the hipline and side seam intersection (Figure 5.12).

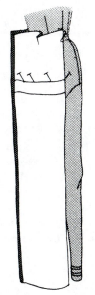

Figure 5.12 / Steps B3–4

Figure 5.13 / Finished pattern

5. For both the front and back, keeping the lengthwise grain straight in the center of the princess panel, smooth up from the hipline to the waistline, and pin at the waistline with a pinch for ease.

6. Pin the back and front together at the side seam from the crotch level to the waistline.

7. Fit the waistline with darts, pleats, or gathers as desired. The center front grain line may be shifted slightly off grain for a smoother fit.

8. Maintaining the balanced grain, pin the leg sections together at the side seam tapering slightly, if desired. The inseam may also be tapered to correspond.

9. Mark the side seam, the inseam at the ankle, the waistline, and darts, or pleats.

10. Remove the trousers from the form and true.

11. Leaving seam allowances, trim away excess muslin at the waistline, side seam, and inseam.

12. Pin the trousers together at the side seam and inseam. Replace the trousers on the pants form; check the fit and make any necessary adjustments.

13. See the finished pattern (Figure 5.13).

Fitted, Tapered, Pegged, or Flared Pants

Pants can be shaped to fit the body in infinite ways. They may fit closely around the derriere and upper leg and then fall straight and slim to the ankle; they may be full and pegged at the waistline and then tapered to fit closely at the ankle; or they may flare out in varying degrees from any point on the leg.

A. PREPARATION OF MUSLIN—For a closer fit around the derriere, follow the instructions for basic trousers, with the following exceptions:
1. Reduce the crotch ease to ¾ inch.
2. Reduce the back crotch extension by ¾ inch.
3. At the center back and waistline intersection, measure in 1¼ inch, and up ¼ inch (Figure 5.14).

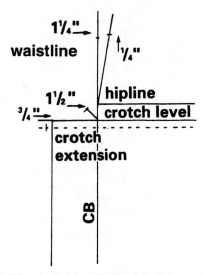

Figure 5.14 / Steps A1–3

4. From this point, draw a diagonal line to the hipline and center back intersection.
5. Reduce the diagonal line at the crotch level and center front to 1½ inches (Figure 5.15).

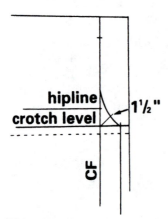

Figure 5.15 / Steps A1–5

B. DRAPING STEPS—Draping steps are the same as for basic trousers, except that less fullness will be at the waistline. The front dart can be totally eliminated, especially when the pants are designed with classic pants pockets. The back dart will be very shallow.

C. VARIATIONS

1. *For tapered pants:*
 a. Let the muslin fall in toward the ankle and taper the side seam and inseam with a straight line (Figure 5.16).

Figure 5.16 / Step C1(a)

b. See the finished pattern (Figure 5.17).

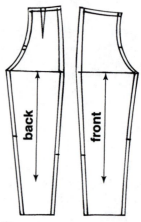

Figure 5.17 / Finished pattern

2. *For pegged pants* (Figure 5.18), add fullness at the waistline and in the hip area as follows:

Figure 5.18 / Peg pants

a. Determine the position of the lowest drape at the side seam; place a pin at that point, and slash from the outer edge of the muslin to the pin.
b. Lift the muslin from the pin and arrange the extra fullness formed at the waistline. Unpressed pleats, gathers, or tucks may be used depending on the desired effect.
c. Repeat the pin-and-slash procedure at the side seam as often as necessary to achieve the fullness desired at the waistline. The back of the pants may be

left plain, or it may be pegged using the same draping procedure as in the front.

d. Style tape or ¼-inch elastic may be used to hold in the fullness and help mark the waistline. To create a puffed effect, draw out muslin from beneath the style tape.

e. See the finished pattern (Figure 5.19).

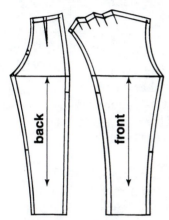

Figure 5.19 / Finished pattern

3. *For fitted pants with straight, slim legs:*

a. Let the back muslin taper toward the knee. At the knee area, slash the muslin at the back inseam, and pin both the inseam and side seam on the grain from the knee area down (Figure 5.20).

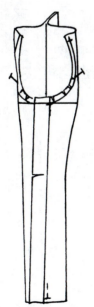

Figure 5.20 / Step C3(a)

b. See the finished pattern (Figure 5.21).

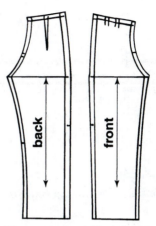

Figure 5.21 / Finished pattern

4. *For fitted pants with flared legs:*

a. Let the back muslin taper toward the knee. At the point where the flare is to begin (this point may be at the knee or above or below), slash into the muslin at the front and back side seams and at the inseams, and shape the leg with the amount of flare desired (Figure 5.22).

Figure 5.22 / Step C4(a)

b. See the finished pattern (Figure 5.23).

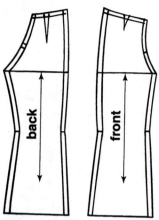

Figure 5.23 / Finished pattern

5. *For all variations:*
 a. Mark the side seam, inseam, center front adjustment, and waistline.
 b. Remove the pants from the form and true all markings. Side seams and inseams should be blended into a smooth curve wherever necessary.
 c. Leaving the seam allowance, trim away all excess muslin.
 d. Pin the pants together, and replace on the form; check fit and make any necessary adjustments.

Divided Skirts

Pants that fit and fall like a skirt and yet have the convenience and comfort of pants are used for evening, lounge-, and sportswear. When the division at the crotch is hidden with pleats, they are called *culottes* (Figure 5.24).

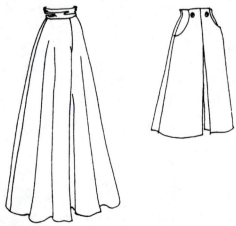

Figure 5.24 / Culottes

A. PREPARATION OF MUSLIN
 1. Tear muslin:
 a. Length—the same way as for basic trousers; when flares are desired, add 5 inches to the length above the waistline
 b. Width—a full width of muslin for the front and a full width for the back
 2. Mark the grain lines the same way as for basic trousers; when flares are desired, mark the waistline 5 inches down from the upper edge of the muslin (Figure 5.25).

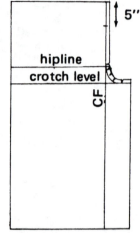

Figure 5.25 / Step A2

B. DRAPING STEPS— Steps 1 and 2 are the same as for basic trousers. Drape the rest of the garment following the directions for the type of skirt desired.
 1. *For culottes,* arrange an inverted pleat at the center front and the center back. If desired, pleats may also be arranged to overlap at the center front and the center back (Figure 5.26).

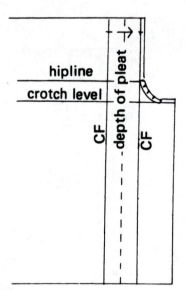

Figure 5.26 / Step B1

 2. *For full-flared pants,* additional flare should be added at the inseam for a balanced look.

Jumpsuits

All-in-one garments, combining bodice and trousers, are a neat, easy, and comfortable dressing solution. Jumpsuits are ideal protective clothing because they cover the body completely. This coverage is especially true when the wrist and ankle openings of the jumpsuit fit snugly and the closure consists of a zipper under a flap. It is therefore no wonder that jumpsuits are worn by astronauts and welders, as well as skiers, speed skaters, and divers (Figure 5.27).

Figure 5.27 / Jumpsuits

There are two kinds of jumpsuits. Those jumpsuits used for protection are usually designed to fit closely to the body. These garments must be designed in stretchable fabric to fit and move like a second skin. When jumpsuits are to be cut in conventional woven fabrics, they must be designed with a considerable amount of extra ease in all directions so that they permit comfortable movement. Because loosely draped and/or elasticized jumpsuits are so comfortable and easy to wear, they are also used for loungewear and play clothes.

A. PREPARATION OF MUSLIN
1. Tear muslin:
 a. Length for front and back—the distance from the neck band to the ankle plus 6 inches

 b. Width:
 (1) Front—the distance from the center front to the side seam at the bust level plus 6 inches
 (2) Back—the distance from the center back to the side seam at the hipline plus 9 inches
2. On the muslin, draw the lengthwise grain for the center front 4 inches from the torn edge; for center back 7 inches from the torn edge.
3. On the center front, mark down 4 inches from the upper edge for the neckline.
4. Pin the center front of the muslin to the form at the neckline and chest.
5. Smoothing on the grain across the chest, locate, pin, and mark the position of the apex.
6. From the apex, smooth the muslin down and mark the waistline and hip levels.
7. Remove the front muslin from the form and draw the cross grain lines at the bust, waistline, and hip levels.
8. On the back muslin, draw the cross grain lines at the same levels as on the front muslin.
9. On the back and front, draw a cross grain line for the crotch level with at least 2 inches of ease allowed if the jumpsuit is to be cut in a conventional woven fabric (See page 100, step 3). If a higher, closer fitting crotch is desired, the fabric used must have a considerable amount of vertical stretch (Figure 5.28).

Figure 5.28 / Steps A1–9

10. Establish the crotch extensions on the crotch level grain line:
 a. Front—one quarter of the distance from the center front to the side seam at hip level
 b. Back—one half the distance from the center back to the side seam at hip level
11. At the intersection of the center back and the crotch level, draw a diagonal line 2 inches long.
12. Place the French curve so that it touches the center back, the diagonal line, and the crotch level. Draw the back crotch curve as illustrated in Figure 5.29.
13. At the intersection of the center front and the crotch level, draw a diagonal line 1½ inches long.
14. Placing the French curve so that it touches the center front at the hipline, the diagonal line, and the crotch level, draw the front crotch curve (Figure 5.29).
15. Add seam allowance at the crotch curve, and trim away excess muslin; clip into the seam allowance at the curve at frequent intervals.

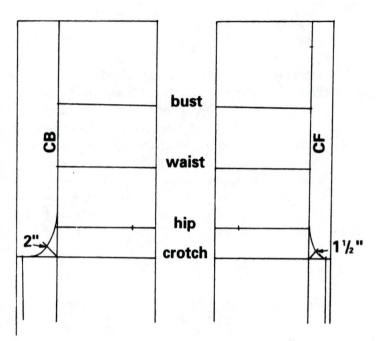

Figure 5.29 / Steps A10–14

B. DRAPING STEPS
 1. Before placing the muslin on the form, pin the front and back crotch seams together. Overlap the seam allowance.
 2. Pin the center front and center back to the form at the hipline and waistline; pin the front at the apex and then pin the center front at the neckline; pin the center back temporarily at the neckline.
 3. For a smooth front and slightly bloused back, drape the bodice front, manipulating darts so that the fullness falls down to the waistline. The side seams above the waistline will be longer than the side seams on the form, providing extra length for the back of the jumpsuit. This extra length or blousing in the back is needed for comfortable sitting and bending (Figure 5.30).

Figure 5.30 / Steps B2–3

4. Take in the width at the waistline as desired, using darts, tucks, elastic, draw string, or simply a belt (Figure 5.31).

Figure 5.31 / Step B4

5. When using fabrics with sufficient vertical stretch, conventional crotch ease will work, and the grain in both the front and back of the jumpsuit may be balanced.

6

The Midriff and Yokes

Yokes are relatively small, flat sections of the garment that serve a decorative, and frequently functional, design purpose. When the flat section is placed at the waistline, it is a midriff. Functionally, yokes can hold in gathers or pleats, or the seam joining the yoke to the garment can be used to fit the garment to the body.

The Fitted Midriff

For a fitted midriff, muslin is draped close to the body, without darts above the waistline (Figure 6.1).

Figure 6.1 / The fitted midriff

A. PREPARATION OF MUSLIN

1. Tape the seam lines of the fitted midriff onto the dress form. The back should continue in a harmonious line with the front.
2. Tear muslin for back and front:
 a. Length—height of the midriff plus 5 inches
 b. Width—width at the widest point plus 3 inches
3. Draw a grain line for center front and center back 1 inch from the length grain torn edge (Figures 6.2 and 6.3).

Figure 6.2

Figure 6.3 / Steps A1–4

4. On the center front grain line, place a crossmark 1½ inches down from the upper torn edge.

B. DRAPING STEPS

1. Place the muslin on the dress form with the crossmark pinned to the center front at the taped upper edge of the midriff.
2. Pin at the center front and waistline.
3. Smooth the muslin toward the side seam until tension appears below the waistline. Slash the muslin below the waistline at the tension point, and pin at the waistline and upper edge of the midriff.
4. Slash the muslin above the midriff if necessary.
5. Repeat steps 3 and 4 as often as needed until the side seam is reached.
6. In order to accommodate extra fullness in the skirt or bodice, the midriff should be draped with the necessary ease (Figure 6.4).

Figure 6.4 / Steps B1–6

7. Mark and true all seam lines. Crossmark at side seams.
8. Add the necessary seam allowance, and trim away excess muslin.
9. Drape the back following the same procedure as for the front.
10. See the finished pattern (Figure 6.5).

Figure 6.5 / Finished pattern

The Bodice Yoke

Bodice yokes, molded to the body without darts, may be used in the front or the back of the upper part of the bodice (Figure 6.6).

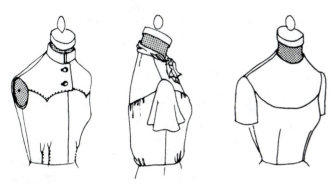

Figure 6.6 / Yokes

A. PREPARATION OF MUSLIN

1. Tape the desired yoke shape onto the dress form. If both front and back yokes are used on the same garment, proportions should harmonize (Figure 6.7).

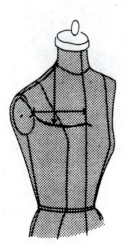

Figure 6.7 / Step A1

2. Determine the placement of the grain. To maintain a uniform appearance of the garment, the grain position in the yoke should be the same as for the rest of the garment. Uniform grain position is especially important for napped fabrics, twills, or satin weaves. For a contrasting effect, which may be desirable in stripes or plaids, crosswise or bias grain may be used for the yoke.

3. On the dress form, measure the amount of muslin needed for the crosswise grain and lengthwise grain at the widest and longest points of the yoke, respectively. Add at least 3 inches to each measurement, and tear the muslin accordingly.

For example: Muslin needed for the yoke illustrated:

Width—7 inches plus 3 inches = 10 inches
Length—6 inches plus 3 inches = 9 inches

4. Draw a grain line for the center front or center back 1 inch from the torn edge of the muslin.
5. Crossmark for the neckline 4 inches down from the upper edge on the center front for a front yoke and 3 inches down from the upper edge on the center back for a back yoke (Figure 6.8).

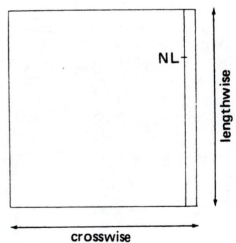

Figure 6.8 / Steps A2–5

B. DRAPING STEPS

1. Place the muslin onto the dress form with the crossmark pinned to the neckline at the center front or center back.
2. Pin the yoke along the center front or center back to the lower edge as taped on the dress form.
3. Drape the neckline.

4. Smooth the grain across the upper chest area or across the back, and pin at the armhole and shoulder intersection. (If a deep back yoke extends below the shoulder blade line, the back shoulder seam and/or armhole will have more ease than usual.)
5. Pin along the taped lower edge of the yoke.
6. Mark and true the yoke outline (Figure 6.9).

Figure 6.11 / Shirt yoke

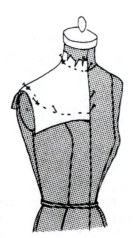

Figure 6.9 / Steps B1–6

7. Trim away excess muslin leaving necessary seam allowance.
8. See the finished pattern (Figure 6.10).

Figure 6.10 / Finished pattern

The Shirt Yoke

The classic shirt is cut with a back yoke that extends into the shoulder area of the front bodice; thus the shoulder seam in its usual position is eliminated. The shirt yoke is usually cut with the center back on the crosswise grain (Figure 6.11).

A. PREPARATION OF MUSLIN

1. Tape the desired yoke shape onto the dress form. For a one-piece yoke, the front shoulder seam should extend from the neckline to the armhole anywhere between the normal shoulder seam and not lower than the midpoint of the armplate (Figure 6.12).

Figure 6.12 / Step A1

2. Tear muslin:
 a. Lengthwise grain—the distance across the widest point of the back yoke plus 5 inches
 b. Crosswise grain—the distance from the back tape to the front tape at the lowest point plus 5 inches
3. Draw a center back grain line 1 inch from the torn edge at the left side of the muslin.
4. Measure the distance from the neck to the tape at the center back; add 1 inch and crossmark the muslin for the neckline intersection as illustrated.

5. At ½ inch above this mark, cut away a rectangular piece of muslin. The rectangle should measure 1½ inches in from the center back and extend to the upper edge of the muslin (Figure 6.13).

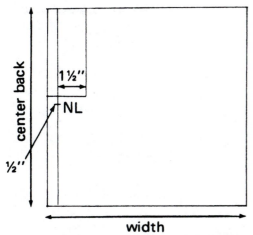

Figure 6.13 / Steps A2–5

B. DRAPING STEPS

1. Pin the center back at the neckline and lower edge.
2. Drape the muslin flat around the neckline, slashing as necessary until the muslin lies smoothly over the shoulder and reaches the front tape of the yoke. The front of the yoke will fall on the bias. If the back of the yoke is lower than the shoulder blade line, considerable ease may be at the lower edge of the yoke. Extra ease may be a desirable feature in a shirt, and it sometimes eliminates the need for gathers or pleats in the shirt back (Figures 6.14 and 6.15).

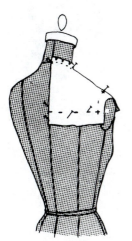

Figure 6.14 / Steps B1–2 back

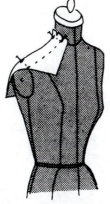

Figure 6.15 / Steps B1–2 front

3. Mark and true. Crossmark the neckline and armhole intersections at the normal shoulder seam line.
4. Trim away excess muslin, leaving seam allowances.
5. See the finished pattern (Figure 6.16).

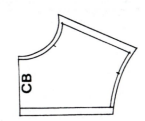

Figure 6.16 / Finished pattern

The Hip Yoke

The hip yoke is the smoothly fitted section of slacks or skirts extending from the waistline to the hip area. If the hip yoke is cut no lower than the hip bone, darts are eliminated, resulting in an unbroken area below the waist. The hip yoke can be styled to achieve various effects. The lower skirt or slacks may be straight, gathered, gored, pleated, or flared (Figure 6.17).

Figure 6.17 / Hip yokes

A. PREPARATION OF MUSLIN

1. Tape the seam lines of the hip yoke onto the dress form. The back should continue in a harmonious line with the front.

2. Tear the muslin for back and front:
 a. Length—length of the hip yoke at the deepest point plus 4 inches
 b. Width—width of the hip yoke at the widest point plus 4 inches

3. Draw a grain line for the center front 1 inch from the lengthwise grain torn edge.

4. On the center front grain line, place a crossmark 3 inches down from the upper torn edge (Figure 6.18).

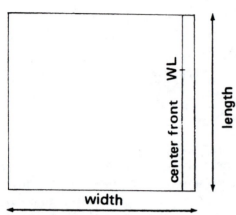

Figure 6.18 / Steps A3–4

B. DRAPING STEPS

1. Place the muslin on the dress form with the crossmark pinned to the center front at the waistline of the hip yoke.

2. Pin the lower edge of the hip yoke at the center front.

3. Smooth the muslin toward the side seam until tension appears above the waistline. Slash the muslin above the waistline at this point, and pin at the waistline. Be-

cause the muslin is slashed above the waistline, the grain at the waistline will drop so that the hip yoke fits smoothly over the hip. Place a pinch for ease at the waistline of the hip yoke as slashing and smoothing proceed. Ease must also be maintained at the lower edge of the hip yoke. If the hip yoke extends below the hipline, the resulting slight flare provides necessary ease (Figure 6.19).

Figure 6.19 / Steps B1–3

4. Mark and true all seam lines.

5. Add the necessary seam allowance, and trim away excess muslin.

6. Drape the back following the same procedure as for the front.

7. See the finished pattern (Figure 6.20).

Figure 6.20 / Finished pattern

7

Collars

As collars are draped, the designer has complete freedom to experiment. The shape and size of the collar can be controlled and evaluated in proportion to the rest of the garment in the process of development. The completed or partially completed bodice muslin must be placed onto the dress form before draping the collar. Collars should always be draped over the neckline of the garment.

The Mandarin Collar

The mandarin collar, derived from the traditional Chinese costume, provides a neat and tailored finish for the neckline. Basically, it is a fitted, raised band with the two rounded sides meeting at center front. Sometimes the sides of the collar are straight, they may be spaced apart, or they may overlap for closing. Although the true mandarin may be as high as 3½ inches, modern versions rarely exceed 2½ inches in height and may be much narrower (Figure 7.1).

Figure 7.1 / Mandarin collar

A. PREPARATION OF MUSLIN

1. Tear muslin:
 a. Length—12 inches
 b. Width—4 inches
2. Draw a grain line for the center back 1 inch from the short torn edge at the left side of the muslin.
3. Draw a grain line ½ inch from the lower edge (Figure 7.2).

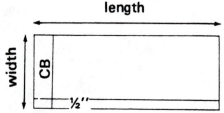

Figure 7.2 / Steps A2–3

B. DRAPING STEPS

1. Pin the center back of the muslin strip to the center back of the dress form above the neckline, with the ½-inch extension below the neckline (Figure 7.3).

Figure 7.3 / Step B1

2. Smooth the muslin around the neck, clipping into the ½-inch extension at the neckline and maintaining ease at the upper edge. Keep the straight grain at the neckline for approximately 1½ inches.
3. Continue smoothing and clipping around the neckline, dropping the grain as necessary to shape the collar to the neck but still maintaining adequate ease at the upper edge until the center front is reached. The grain will have dropped approximately ½ inch at the center front.
4. Mark the height and shape the front of the collar as desired. Style tape may be used to determine the most pleasing shape before marking. If the collar is to be cut with the outer edge on the fold, straight grain must be maintained.
5. Crossmark at the shoulder seam, and dot the neckline (Figure 7.4).

Figure 7.4 / Steps B2–5

6. True the collar, and trim away excess muslin, leaving seam allowances.

7. See the finished patterns (Figures 7.5 and 7.6).

Figure 7.5 / Finished pattern

Figure 7.6 / Finished pattern

The Band Collar

The band collar is very similar to the mandarin collar except that it is cut on the fold at the center front, and the neck opening is at the back of the garment. Edged with lace, the band collar is typical of the Victorian look. Untrimmed, it is a popular smooth finish for the neckline (Figure 7.7).

Figure 7.7 / Band collar

A. PREPARATION OF MUSLIN

1. Tear muslin:
 a. Length—11 inches
 b. Width—4 inches
2. Draw a grain line for the center front 1 inch from the short torn edge at the right side of the muslin.
3. Draw a grain line ½ inch from the lower edge (Figure 7.8).

Figure 7.8 / Steps A2–3

B. DRAPING STEPS

1. Pin the center front of the muslin strip to the center front of the dress form above the neckline, with the ½-inch extension below the neckline.
2. Smooth the muslin around the neck, clipping into the ½-inch extension at the neckline and maintaining ease at the upper edge. Keep the straight grain at the neckline for approximately ¼ inch (Figure 7.9).

Figure 7.9 / Steps B1–2

3. Continue smoothing and clipping around the neckline, using the same method as for the mandarin collar until the center back is reached. The grain will have dropped approximately 1½ inches at center back.
4. Mark the height of the collar as desired.
5. Crossmark at the shoulder seam, and dot the neckline (Figure 7.10).

Figure 7.10 / Steps B3–5

6. True the collar and trim away excess muslin, leaving seam allowances.
7. See the finished pattern (Figure 7.11).

Figure 7.11 / Finished pattern

The Convertible Collar

The convertible collar may be worn open or closed as illustrated. Cut on the straight grain, it has a relatively high stand that is somewhat reduced when the collar is cut on the bias. The straight grain convertible collar is used to achieve a tailored look and is especially popular for the shirtwaist (Figure 7.12).

Figure 7.12 / Convertible collar

A. PREPARATION OF MUSLIN
1. Tear muslin:
 a. Length—12 inches
 b. Width—6 inches
2. Draw a grain line for the center back 1 inch from the short torn edge at the left side of the muslin.
3. Draw a grain line ½ inch from the lower edge (Figure 7.13).

Figure 7.13 / Steps A2–3

B. DRAPING STEPS
1. The neckline development for the convertible collar is the same as that for the mandarin collar. (See draping steps B1 through 3, page 116).
2. Fold the collar over to the desired height of the stand at center back.
3. Clip into the outer edge of the collar so that it rests on the shoulder at the desired

width. The stand gradually decreases until it disappears at the center front.
4. With style tape, determine the desired shape of the collar and mark the collar outline at the outer edge of the style tape. The outer edge of the collar may not be on the straight grain. If the collar is to be cut with the outer edge on the fold, the straight grain must be maintained (Figures 7.14 and 7.15).

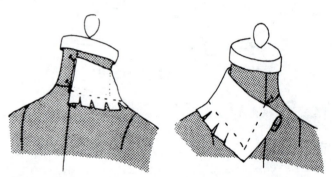

Figure 7.14 / Steps B2–4 back Figure 7.15 / Steps B2–4 front

5. Crossmark at the shoulder seam, and dot the neckline.
6. True the collar and trim away excess muslin, leaving seam allowances. Trace the neckline to the right side of the collar.

C. THE UNDERCOLLAR
All collars must be faced. The facing for a collar is called the *undercollar,* and it is designed to let the upper collar roll smoothly without pull and also to prevent the outer edge seam from showing. To achieve this effect, the undercollar is always cut somewhat smaller than the upper collar. When working in muslin, ⅛ inch less at the outer edges usually is sufficient. In heavier fabrics, such as woolens or velvets, a greater difference in dimensions will be required. On the other hand, a collar designed in a thin fabric such as organza may require an undercollar measuring only ⅟₁₆ inch less than the upper collar.

Cutting the undercollar on the bias grain with a center back seam will add to the cost of the finished garment but usually results in a smooth roll without breaks at the roll line. Shaping the center back seam ⅛ inch in at the roll line will

permit a still better roll of the collar. When cutting the undercollar on the bias, it should be interfaced and placed onto the dress form with the upper collar in place before adjusting the outer dimensions of the undercollar.

See the finished pattern (Figure 7.16).

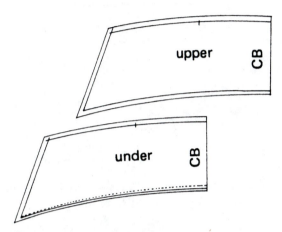

Figure 7.16 / Finished pattern

The Peter Pan Collar

The Peter Pan style is a popular, youthful collar that fits gently around the neckline. It may rest relatively flat on the shoulders or have a more decided roll. The width may vary from very narrow to quite wide, and the outer edge may assume various shapes as illustrated (Figure 7.17).

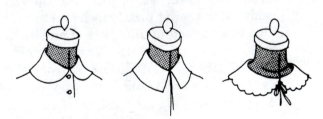

Figure 7.17 / Peter Pan collar

The simplest way to create a Peter Pan collar is to combine draping with patternmaking using the neckline of the front and back bodice patterns to create the shape of the collar neckline. The second technique relying only on draping is somewhat more complicated to execute, but it has the advantage of giving the designer better control of the roll of the collar.

Combination Method of Developing the Peter Pan Collar

A. PREPARATION OF MUSLIN

1. Tear a 12-inch square.
2. Draw a grain line for the center back 1 inch from the torn edge at the left side of the muslin.
3. Estimate the width of the collar and stand. Measure up from the lower edge the total width of the collar plus ½ inch for seam allowance and mark.
4. Remove the draped bodice from the dress form. Remove the pins from the side seam and the shoulder seam, and place the back bodice pattern over the muslin so that the center back grain line of the bodice is directly over the center back grain line of the muslin square and the seam allowance and mark are aligned.
5. Place the front bodice pattern so that the shoulder seam meets the back bodice shoulder seam at the neckline intersection and overlaps at least 1 inch at the armhole intersection. The result will be a fairly flat collar. When the overlap at the shoulder tip increases, the neckline becomes straighter and the roll of the collar becomes higher. The shoulder tip overlap can range anywhere from 1 to 3 inches (Figure 7.18).

Figure 7.18 / Steps A1–5

6. Trace the resulting neckline from the bodice pattern to the muslin. Straighten the neckline at the shoulder intersection, if necessary, and crossmark.

7. Add seam allowance at the neckline, and cut the collar along neckline. Slash into the seam allowance (Figure 7.19).

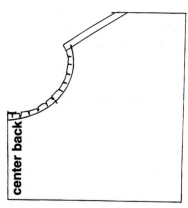

Figure 7.19 / Step A7

B. DRAPING STEPS

1. Place the collar onto the dress form over the bodice at the center back as illustrated; pin the neckline over the neckline of the bodice (Figure 7.20).

Figure 7.20 / Step B1

2. Letting collar roll over naturally, pin at center back (Figure 7.21).

Figure 7.21 / Step B2

3. Using style tape, shape the collar as desired. Slash the outer edge of muslin to the style tape to make sure the collar lies flat on the shoulders.
4. Mark the collar outline at the outer edge of the style tape (Figure 7.22).

Figure 7.22 / Steps B3–4

5. Remove from the dress form and true the collar. Add seam allowance and cut out.
6. Cut the undercollar (See pages 118–119).

The Draped Peter Pan Collar

Although somewhat more complex, this method provides more design flexibility as the collar is developed.

A. PREPARATION OF MUSLIN

1. Tear a 12-inch square.
2. Draw a grain line for the center back 1 inch from the torn edge at the left side of the muslin.
3. Estimate the width of the collar and stand. From the lower edge, measure up the width of the collar plus ½ inch and mark.
4. Cut away a rectangular piece of muslin ½ inch above this mark. The rectangle should measure 1½ inches in from the center back and extend to the upper edge of the muslin (Figure 7.23).

Figure 7.23 / Steps A2–4

B. DRAPING STEPS

1. Pin the center back at the neckline and the lower edge (Figure 7.24).

Figure 7.24 / Step B1

2. Drape the muslin flat around the neckline, slashing as necessary until the muslin lies smoothly over the shoulder and reaches the center front. The center front will fall on the bias. Trim away any excess muslin at the neckline, leaving ½ inch (Figure 7.25).

Figure 7.25 / Step B2

3. Reverse the slashed edge at the neckline so that the slashes face downward.
4. Pin the neckline of the collar to the neckline of the garment at the center back and approximately 1½ inches along the neckline toward the shoulder (Figure 7.26).

Figure 7.26 / Steps B3–4

5. Turn the collar down leaving the desired amount of roll, and pin the lower edge of the collar to the center back.
6. Maintain the roll along the neckline edge of the collar by increasing the depth of the slashes. Slash gradually and turn the collar down every so often as work proceeds to check that the desired amount of roll is maintained. The outer edge of the collar must also be slashed gradually until the collar touches the shoulder at the desired width (Figure 7.27).

Figure 7.27 / Steps B5–6

7. With style tape, determine the desired shape of the collar.
8. Mark the collar outline at the outer edge of the style tape. Dot the neckline, and crossmark at the shoulder seam (Figure 7.28).

Figure 7.28 / Steps B7–8

9. True the collar and trim away excess muslin, leaving seam allowances. Trace the neckline to the right side of the collar.
10. Cut the undercollar (See pages 118–119).

11. See the finished pattern (Figure 7.29).

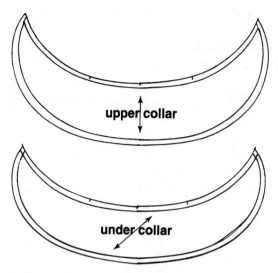

Figure 7.29 / Finished pattern

Variations Based on the Peter Pan Collar

Using the same draping technique as for the Peter Pan collar, all sorts of collars of various widths and shapes for high or low necklines can be developed (Figure 7.30).

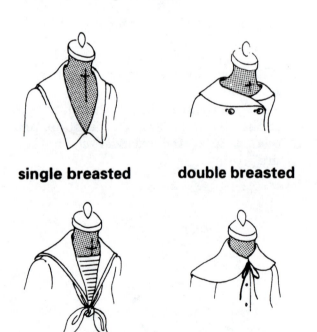

single breasted **double breasted**

the sailor collar **the cape collar**

Figure 7.30 / Peter Pan variations

A. PREPARATION OF MUSLIN

Cut a rectangle large enough to accommodate the outer edge of the collar.

For example: Sailor collar—20 inches long by 15 inches wide
Cape collar and shawl collar[1]—16 inches square

B. DRAPING STEPS
1. Determine the desired neckline.
2. Continue draping the same way as for the Peter Pan collar.

The Shawl Collar—Cut in One Piece with the Front Waist

The shawl collar has traditionally been associated with the tuxedo design of formal men's wear. This collar may be used on coats and jackets or any garment with a front opening. Its simple elegant shape may be varied by its width, length, and height of roll. The outer edge of the shawl collar may be notched to simulate the two-piece notched collar. The undercollar is always seamed at the center back, but the upper collar—cut in one piece with the facing—may be cut without a center back seam (Figure 7.31).

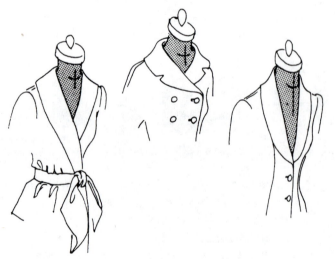

Figure 7.31 / Shawl collar

A. PREPARATION OF MUSLIN
1. Tear the muslin:
 a. Length—center front length plus 10 inches plus hem

[1]This shawl collar is cut separately and is to be distinguished from the shawl collar that is cut all in one piece with the front bodice (See the next section).

b. Width—side seam to center front at bust level plus 9 inches

2. Draw the center front grain line 6 inches from the torn edge.

3. Crossmark the neckline 10 inches down from the upper torn edge of the muslin.

4. Pin the center front of the muslin to the dress form at the neckline and the chest.

5. Smoothing on the grain across the chest, locate, pin, and mark the position of the apex.

6. Draw a crosswise grain line at the apex level.

7. Draw a lengthwise grain line parallel to the center front, indicating the width of the extension. An extension is needed at the center front for the overlap necessary to accommodate buttons and buttonholes. The width of this extension depends on the size of button used, but 1 inch is usually sufficient for lightweight dresses and blouses. Jackets and coats need a wider overlap. The shawl collar flows up from the edge of the extension (Figure 7.32).

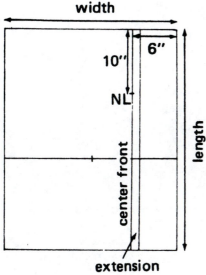

Figure 7.32 / Steps A2–7

B. DRAPING STEPS

1. Pin the muslin to the center front of the dress form at the neckline, and drape the lower part of the garment front as desired.

2. Drape the back of the garment completely before working on the front shoulder and collar.

3. Pin the back shoulder seam to the dress form by sinking pins into the seam allowance of the shoulder.

4. Drape the front shoulder over the back.

5. Leaving only the seam allowance at the shoulder, cut into the muslin from the armhole to within 1 inch of the neckline.

6. Slash carefully to the intersection of the neckline and shoulder seam as illustrated (Figure 7.33).

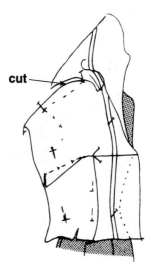

Figure 7.33 / Steps B1–7

7. Sink a pin into the dress form at the neckline and shoulder intersection (Figure 7.33).

8. Remove the pins at the center front so that the muslin may be folded back to the desired depth of the finished neckline. Place a pin at the lowered neckline as illustrated (Figure 7.34).

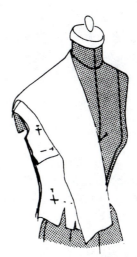

Figure 7.34 / Step B8

9. Bring the muslin around the neckline to the back. The center back will be on the bias. Pin the back neckline from the shoulder and neckline slash to the center back, maintaining an adequate seam allowance (Figures 7.35 and 7.36).

Figure 7.38 / Steps B11–12

13. Turn up the collar. If an excess fold of fabric occurs near the neckline, shape a shallow dart from the intersection of the shoulder and neckline down the front under the collar until all excess fabric is absorbed (Figure 7.39).

Figure 7.35 / Step B9

Figure 7.36 / Step B9 (cont.)

10. Fold the collar down at the desired roll line, and slash the outer edge of the collar to the desired width. The back neckline seam should be covered by the collar (Figure 7.37).

Figure 7.37 / Step B10

11. With style tape, determine the desired shape of the collar.
12. Slash to the intersection of the collar edge and extension (Figure 7.38).

Figure 7.39 / Step B13

14. Mark the front and back muslin. True and trim away excess muslin, leaving seam allowances.
15. The facing and upper collar are cut in one piece. Determine the width of the facing at the shoulder and along the center front. The minimum width at the shoulder is 1½ inches and at the waistline

2½ inches. Trace the outline of the collar edge, center back of the collar, back neckline, and shoulder seam onto another piece of muslin for the upper collar. If the upper collar is to be cut without a center back seam, the grain should be straight at the center back. The front neckline dart, if used, may not be necessary in the facing for the correct roll of the collar. Use the hip curve to draw the inside edge of the facing from the shoulder seam to waistline. To ensure the proper roll of this collar, cut the upper collar larger than the undercollar from the center back to the center front extension (See pages 118–119).

16. See the finished pattern (Figure 7.40).

Figure 7.40 / Finished pattern

17. A separate back neck facing is required (See page 200).

The Tailored Notched Collar

Frequently used on coats and jackets, the notched collar may also be used on tailored dresses and blouses. This neckline treatment involves two pieces: (1) the lapel, cut in one piece with the front of the garment, and (2) the collar, cut separately. Infinite variations may be achieved by changing the size and shape of both the lapel and the collar. Both the collar and the lapel must be interfaced in order to achieve a smoothly tailored effect (Figure 7.41).

Figure 7.41 / Tailored notched collar

A. PREPARATION OF MUSLIN

1. For the lapel:
 a. Prepare the muslin for the front of the garment as desired, adding 4 inches to the width at the center front.
 b. Draw the center front grain line 4 inches from the torn edge of the muslin.
 c. Draw the extension line for the overlap at the center front of the garment parallel to the center front grain line as illustrated in Figure 7.42 (See also page 123, step A7).

Figure 7.42 / Step A1

 d. Mark the neckline 4 inches down from the upper torn edge of the muslin at the center front.
2. For the collar: The undercollar is draped first.

a. For a narrow straight collar: Prepare a rectangle 11 by 6 inches, cut on the bias, indicating guide lines the same way as the grain lines for the convertible collar (Figure 7.43).

CB

collar—same as convertible

Figure 7.43 / Step A2(a)

b. For a wide round collar: Prepare a 12-inch square of muslin, cut on the bias, indicating guide lines the same way as the grain lines for the Peter Pan collar (Figure 7.44).

CB

collar – same as Peter Pan

Figure 7.44 / Step A2(b)

B. DRAPING STEPS

1. Drape the front and the back of the garment as desired.

2. Fold back the lapel section to the desired depth. Slash to the point at the extension where the lapel turns over. Slash to the pin at the neckline and shoulder intersection (Figure 7.45).

3. Drape the narrow straight collar the same way as for the

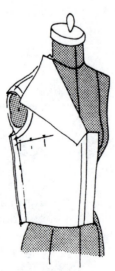

Figure 7.45 / Steps B1–2

convertible collar, and drape the wide rounded collar the same way as for the Peter Pan:

a. Mark the back neckline only to the shoulder.

b. Clip into the outer edge of the collar so that it rests on the shoulder at the desired width.

c. Let the front of the collar roll along the front neckline into the same angle as the fold of the lapel.

d. Fold the lapel over the collar as illustrated (Figure 7.46).

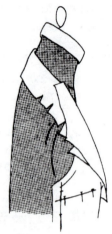

Figure 7.46 / Step B3

4. With style tape, determine the desired shape of the collar and lapel. The lapel begins at the neckline, approximately 1½ inches down from the shoulder (Figure 7.47).

Figure 7.47 / Step B4

5. Mark the outline of the lapel. Place a crossmark at the intersection of the collar and the lapel. Cut away any excess muslin from the lapel, leaving the seam allowance.

6. Mark the outline of the collar.

7. Pin the collar to the lapel from the crossmark to the neckline (Figure 7.48).

Figure 7.48 / Steps B5–7

8. Turn the collar up, and mark the neckline. Crossmark the shoulder seam and neckline intersection. Mark the roll line at the center back.
9. Pin the collar and lapel together along the front neckline (Figure 7.49).

Figure 7.49 / Steps B8–9

10. Remove the muslin from the dress form, leaving the lapel and collar pinned together.
11. Trace the neckline of the collar and lapel so that both pieces are completely marked.
12. True the outer edge of the collar and, leaving a seam allowance, trim away any ex-

cess muslin. A slight indentation at the roll line of the center back seam will permit the finished collar to roll better. At the center back, measure in ⅛ inch at the indicated roll line. Using the hip curve as illustrated (Figure 7.50), replace the straight center back with a curved line.

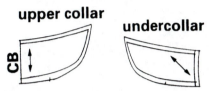

Figure 7.50 / Finished patterns

13. Cut the upper collar with the straight grain at the center back. The upper collar is cut larger than the undercollar to permit the proper roll and to hide the seam edge. The difference in size between the upper and undercollar is determined by the thickness of the fabric. For muslin, the upper collar should be cut ⅛ inch more at the outer edges.
14. Cut a facing for the lapel. The facing should extend from the shoulder along the center front. In order to permit the lapel to roll properly, the facing is cut somewhat larger than the front at the outer edges of the lapel.
15. See the finished pattern pieces (Figure 7.51).

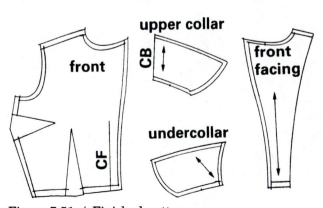

Figure 7.51 / Finished patterns

8

Sleeves

Only those sleeves that are usually developed by draping are described in this chapter. A large number of sleeves are more easily developed by flat pattern drafting and therefore have not been included here. *Unmounted sleeves,* those cut in one with the bodice, can be easily developed by draping. When a shoulder pad is desired, a raglan pad is pinned to the dress form before the sleeve is draped.

The Basic Dolman Sleeve

The dolman sleeve is the simplest of the unmounted sleeves. In its elementary form, it is a loose sleeve cut to any length in one piece with the body of the garment. Historically, this cut has been used for the traditional robes of the Near and Far East as well as for the early tunics of Western dress (Figure 8.1).

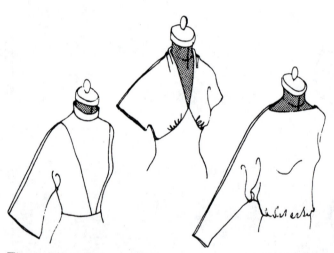

Figure 8.1 / Dolman sleeve

When a dolman is used in a garment designed without a waistline, such as a princess or a shift, the grain at the side seam must be balanced and the dolman will also automatically balance. In a waistline dress, the dolman sleeve and the side seam need not necessarily be balanced if the design does not require it. When striped fabric is used, however, the grain at the overarm and side seam should match, and the dolman should be balanced.

A. PREPARATION OF MUSLIN
1. Tear the muslin for front and back:
 a. Length—neck band to waistline plus 6 inches for a bodice; neck band to hem plus 4 inches for a garment without a waistline
 b. Width—for a short sleeve, one-half width of muslin; for a three-quarter sleeve, three-quarter width; for a full-length sleeve, the full width
2. Draw the center front and center back grain lines 3 inches from the selvage edge.
3. Prepare the front and back grain lines the same way as for the basic waist or shift (Figure 8.2).

B. DRAPING STEPS
1. Drape the front and back as desired, leaving ½-inch ease in the front armhole. For a shift or princess-type garment, maintain the straight grain at the bustline. *When the bustline grain is kept straight, the dolman will be balanced.*

Figure 8.2 / Steps A2–3, back

Steps A2–3, front

2. Pin the shoulders and side seams to-
gether, as illustrated (Figure 8.3).

Figure 8.3 / Steps B1–2

3. At the shoulder and armhole intersection,
place another pin ⅜ inch above the inter-
section. Blend pins from this raised point
along the shoulder to the original shoul-
der seam (Figure 8.4).

Figure 8.4 / Step B3

4. Hold out the muslin for the sleeve, and de-
termine the shape desired. The overarm

seam usually continues at approximately
the same angle as the raised shoulder
seam in a straight line from the raised tip
of the shoulder. The underarm seam
should be no higher than 3 inches below
the armplate; it may be lower if desired.
For a full-length sleeve, the width at the
elbow must be at least 2 inches wider
than the width at the elbow of the basic
sleeve pattern.

5. Mark the dolman sleeve outline on the
front muslin with pins.

6. Mark the rest of the garment and remove
it from the dress form, leaving the side
seam and shoulder seam pinned together
(Figure 8.5).

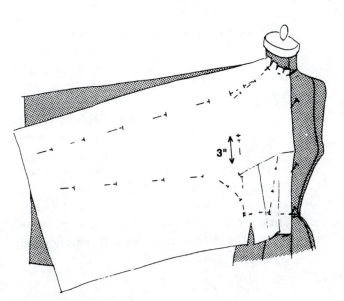

Figure 8.5 / Steps B4–6

7. Remove pins from the darts and other de-
tails, but *leave the shoulder seam, over-
arm seam, and entire underarm seam
pinned together.*

8. Place the front face down on the table and
smooth out both layers of muslin. (An
excess fold of muslin may extend from
the shoulder blades into the sleeve area.
If a fold occurs, it should be smoothed
out to taper to nothing at approximately
the elbow of the sleeve. Adjust pins, if
necessary.)

9. Pin the back and front together along the outer edges of the muslin (Figure 8.6).

Figure 8.6 / Steps B8–9

10. On the sleeve sloper, which has been folded in half, mark down ½ inch from the top of the cap at the center fold of the sleeve. Place the sleeve sloper with the fold on the overarm seam and the ½-inch mark at the raised shoulder and armhole intersection.
11. True the overarm sleeve outline. Make sure that it blends into the raised shoulder seam.
12. Mark the wrist level (or hem of sleeve) at the overarm seam; make sure the width of the sleeve is *at least* 1 inch wider than the sleeve sloper at the elbow level. Cross-mark the shoulder and armhole intersection, the elbow level, and the underarm curve (Figure 8.7).

Figure 8.7 / Steps B10–12

13. Leaving the front and back pinned together, trace the back sleeve outline to the front.

14. Separate the front and back, and true the rest of the garment.
15. Leaving the seam allowances and adequate hem at the lower edge of the sleeve, trim away any excess muslin.
16. Clip the seam allowance at the side seam and underarm seam at frequent intervals.
17. Pin the garment together and replace it on the dress form. Check the fit, paying special attention to the lower edge of the sleeve. Adjust the shape and length if necessary.
18. See the finished pattern (Figure 8.8).

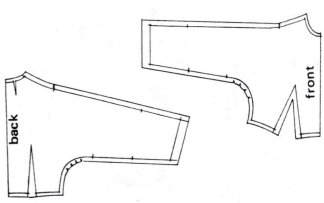

Figure 8.8 / Finished pattern

The Long Fitted Dolman Sleeve

The dolman sleeve, fitted from elbow to wrist, is a recurring feature in fashion. The pattern for this sleeve is easily achieved by combining draping with flat pattern drafting. The garment is draped, and the sleeve is drafted (Figure 8.9).

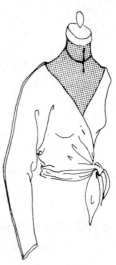

Figure 8.9 / Long fitted dolman sleeve

A. PREPARATION OF MUSLIN

1. Tear the muslin for front and back:
 a. Length—the same way as for the basic dolman sleeve
 b. Width—the full width of the muslin
2. Prepare the front and back the same way as for the basic dolman sleeve.

B. DRAPING STEPS

1. Drape the front and back as desired.
2. Raise the shoulder seam the same way as for the basic dolman sleeve.
3. Mark the approximate underarm curve of the side seam as far as the elbow with pins.
4. Mark front and back style details; cross-mark the raised shoulder and armhole intersection. Remove the muslin from the dress form, leaving the shoulder seam and side seam pinned together.
5. Place the front face down on the table and smooth out both layers of muslin. An excess fold of muslin will extend from the shoulder blade into the sleeve area. This fold should be smoothed out to taper to nothing at approximately the elbow of the sleeve. If the dolman is balanced, grains will match at the side seam.
6. Draw a crosswise grain line from the raised shoulder and armhole intersection to the opposite selvage of the muslin as illustrated.
7. Determine the overarm seam. At the wrist, the overarm seam should be within 3 inches of the crosswise grain line, which extends from the raised shoulder level (Figure 8.10).

Figure 8.10 / Steps B5–7

8. On the sleeve sloper, which has been folded in half, mark down ½ inch from the top of the cap at the center fold of the sleeve.

9. Place the sleeve sloper with the fold on the overarm seam and the ½-inch mark at the raised shoulder and armhole intersection.
10. Mark the elbow level at the overarm seam; extend the elbow line 1 inch at the underarm, making the sleeve wider.
11. Adjust the underarm curve so that it blends to the extended elbow of the sleeve sloper (Figure 8.11).

Figure 8.11 / Steps B9–11

12. Trace the overarm seam from shoulder to wrist and the underarm seam above the elbow from the back to the front.
13. Leaving the seam allowance, trim away excess muslin from the shoulder seam. Trim away excess muslin, leaving the seam allowance at the underarm. Trim muslin from the waistline to the elbow. Slash into the seam allowance at the shoulder/armhole crossmark. Leaving approximately 3 inches extra muslin along the overarm seam to the wrist level, cut away the excess muslin at the overarm seam as illustrated (Figure 8.12).

Figure 8.12 / Step B13

14. Separate the front from the back and lay it flat on the table. Overlap the overarm seam extensions of the sleeve, and pin them temporarily at the shoulder intersection and at the wrist (Figure 8.13).

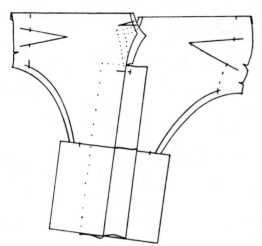

Figure 8.13 / Step B14

15. Place the opened sleeve sloper over the muslin with the elbow levels matching.
16. Mark the outline of the lower front sleeve on the muslin.
17. Slash the elbow line of the sleeve sloper from the back underarm seam to the center of the sleeve.
18. Pick up the wrist at the center of the sleeve until the desired shaping is reached.
19. Draw the outline of the lower back sleeve onto the muslin.
20. Mark the center of the sleeve at the wrist on the muslin (Figure 8.14).

21. Remove the sleeve sloper, and draw a straight line from the center of the sleeve at the wrist to the shoulder seam for the *corrected* overarm seam of the dolman sleeve.
22. Slip a piece of tracing paper, with carbon side down, between the overlapping extensions of the overarm seam, and trace the overarm seam to the lower layer of muslin (Figure 8.15).

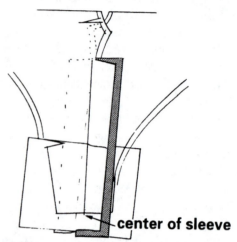

Figure 8.15 / Steps B21–22

23. Separate the front and back completely.
24. Shape the excess fullness at the back underarm seam into an elbow dart or ease. Add crossmarks at the underarm seam to keep ease in the back underarm seam concentrated at the back elbow area.
25. Finish trueing the rest of the garment.
26. Leaving the seam allowances, trim away all excess muslin.
27. Pin together and replace it on the dress form to check the style and fit.
28. See the finished pattern (Figure 8.16).

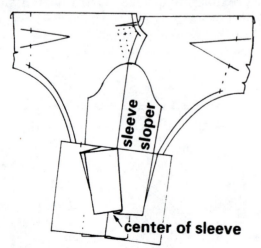

Figure 8.14 / Steps B15–20

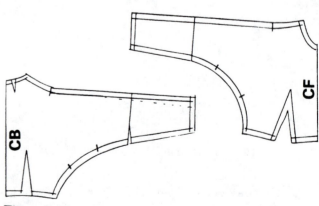

Figure 8.16 / Finished pattern

The Semi-Mounted Sleeve

The semi-mounted sleeve combines the smooth shoulder line of the unmounted sleeve with the fit of a set-in sleeve at the underarm. This sleeve is cut in one piece with the front and back of the garment, but from approximately 1 inch below the screw level of the armplate. It is set into a separate panel of the bodice. The bodice may assume various shapes, the design being limited only by the fact that it must have a seam originating at the front and back of the armhole (Figure 8.17).

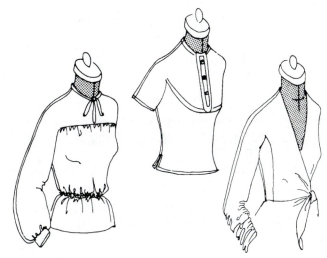

Figure 8.17 / Semi-mounted sleeve

A. PREPARATION OF MUSLIN

1. Tape the dress form with the desired style lines. A front and back seam must originate at the armhole approximately 1 inch below the screw level of the armplate, ¾ inch toward the center front and center back from the armplate. This seam at the armhole must be the same distance from the side seam at both the front and back (Figure 8.18).
2. Tear the muslin for front and back:
 a. Center front and center back panels— the same way as for the dolman sleeve, with width depending on the sleeve length
 b. Front and back underarm panels—add 5 inches to the length and width of the taped area on the dress form

B. DRAPING STEPS

1. Drape the underarm panels in the front and back.
2. Mark and true, dropping the armhole and adding width at the side seam, the same way as for the basic waist. The front and back armhole measurement should be the same.
3. Pin the side seam together and replace the finished underarm panels on the dress form. Sink pins into the form (Figure 8.19).
4. Drape the center front and center back as desired.
5. Pin and raise the shoulder seam, the same way as for the dolman sleeve.
6. Mark all style lines.
7. Mark the seam originating at the armhole directly over the underarm panel seam. Crossmark this seam at the armhole intersection. If this seam follows the princess line, add the necessary crossmarks at the apex, 2 inches above the apex and 2 inches below (Figure 8.20).

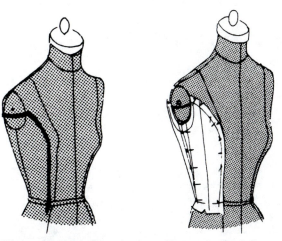

Figure 8.18 / Step A1 Figure 8.19 / Steps B1–3

Figure 8.20 / Steps B4–7

8. Remove the muslin from the dress form, keeping the shoulder seams pinned together.

9. True all style lines except the shoulder seam, which remains pinned.

10. At the underarm panel seam and armhole, pin the front and back crossmarks together.

11. Place the front and back flat on the table with the back on top.

12. Maintain the excess fold in the upper back armhole area. Let this fold slope down at a 45-degree angle and smooth out in the elbow area (Figure 8.21).

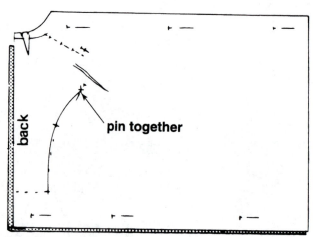

Figure 8.21 / Steps B9–12

13. Fold the sleeve sloper in half lengthwise.

14. Determine the measurement of the lower armhole from the side seam to the underarm panel crossmark.

15. Mark this measurement at the lower sleeve cap (Figure 8.22).

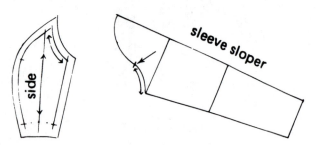

Figure 8.22 / Steps B13–15

16. Place the folded sleeve sloper on the muslin, matching armhole crossmarks and positioning the center sleeve fold on the true bias. The center sleeve fold may also be placed at a somewhat more shallow angle if a wider sleeve is desired (Figure 8.23).

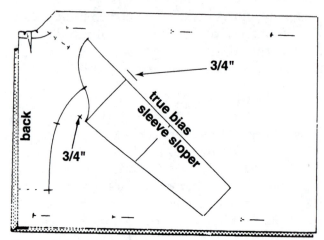

Figure 8.23 / Step B16

17. Outline the center sleeve fold from the biceps to the wrist. Extend the biceps line ¾ inch beyond the outline to make the sleeve somewhat wider at the upper arm. Blend to the wrist as illustrated. Outline the wrist and the underarm from the wrist to the elbow (Figure 8.24).

Figure 8.24 / Step B17

18. Place a mark on the muslin ¾ inch above the intersection of the biceps and underarm seam (See Figure 8.23). Using the crossmark as a pivot point, pivot the lower sleeve cap to the ¾-inch mark (Figure 8.25).

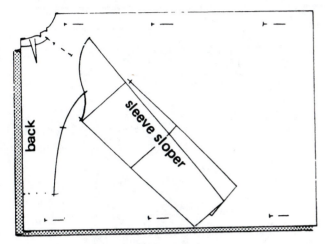

Figure 8.25 / Step B18

19. Connect the ¾-inch mark with a shallow curve to the underarm seam at the elbow.
20. True the shoulder seam.
21. Connect the shoulder seam to the center of the sleeve, using the French curve (Figure 8.26).

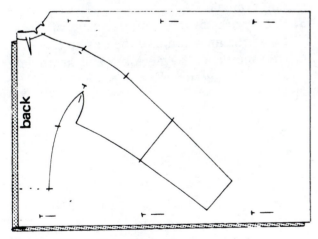

Figure 8.26 / Steps B19–21

22. Trace the back shoulder and sleeve to the front. Some ease will occur in the back shoulder seam. Crossmark the center of the sleeve seam at the tip of the shoulder and the biceps. Crossmark the elbow level at the underarm seam.

NOTE: For a long sleeve, fitted from the elbow to the wrist, follow directions for the long fitted dolman sleeve (pages 133–134).

23. Leaving the seam allowance, cut away excess muslin at the wrist and at the underarm seam to the elbow.
24. Separate the front and back, leaving a seam allowance. Cut away excess muslin on all other seams. Slash into the seam allowance to the crossmarks at the armhole.
25. Pin the underarm seam; pin the underarm panels to the front and back; pin-baste the lower armhole seam from the inside, same as for the basic set-in sleeve; pin the shoulder and overarm seam, matching the crossmarks.
26. Replace the muslin on the dress form; check the fit and make any necessary adjustments.
27. See the finished pattern (Figure 8.27).

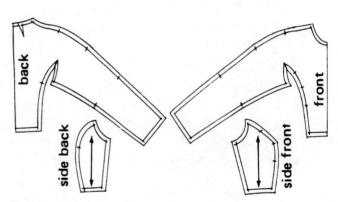

Figure 8.27 / Finished pattern

The Raglan Sleeve

The raglan sleeve is set in with a seam that extends from the underarm to the front and back neckline. This seam may be somewhat varied for different design effects. The raglan combines a smooth shoulder with the fit and hang of a set-in sleeve. It may be cut in one piece or split into two pieces with an overarm seam extending from the

shoulder. Additional ease at the underarm is often added to this sleeve, making it comfortable to wear. It is widely used for tailored garments, but it is equally popular for dresses, sportswear, and loungewear (Figure 8.28).

Figure 8.28 / Raglan sleeve

A. PREPARATION OF MUSLIN

1. Tape the desired raglan seam for both the front and back, from the point at the armhole 1 inch below the screw level and ¾ inch from the armplate toward the center front and the center back, to the neckline (Figure 8.29).

Figure 8.29 / Step A1

2. Prepare the muslin for the front and back the same way as for the basic bodice.
3. Tear the muslin for a raglan sleeve:
 a. Length—7 inches plus the length of the sleeve sloper plus 1 inch
 b. Width—width of the sleeve sloper at the biceps plus 4 inches

c. Draw a lengthwise grain line at the center of the muslin
d. Draw a crosswise grain line at the biceps level (7 inches plus cap height from the top of the muslin).
e. Draw a crosswise grain line at the elbow level (Figure 8.30).

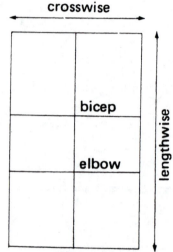

Figure 8.30 / Step A3

B. DRAPING STEPS

1. Drape the front and back as desired.
2. Mark the front and back; dot the front armhole ridge the same way as for a normal armhole.
3. Crossmark at the intersection of the taped raglan seam and the armhole.
4. Crossmark at the neckline and armhole seam intersection (Figure 8.31).

Figure 8.31 / Steps B1–4

5. Remove the muslin from the dress form, leaving the side seams pinned together, and true the front and back. Lower the armhole and add ease at the side seam, the same way as for the basic set-in sleeve. True the lower front armhole lining up the French curve with the dots at the armhole ridge. At the back armhole, let the French curve touch the armplate mark at the shoulder blade level and the raglan seam crossmark. True the raglan seam blending it into the lower armhole (Figure 8.32).

Figure 8.32 / Step B5

6. Leaving the seam allowance, trim away excess muslin.
7. Pin the front and back together at the side seam.
8. Place the sleeve sloper, face down, over the front bodice with lower armhole seams matching. Mark the crossmark at the intersection of the raglan seam and the armhole on the sleeve cap as illustrated. Repeat for the back of the sleeve cap (Figure 8.33).

Figure 8.33 / Step B8

9. Trace the sleeve sloper below the elbow level on the prepared muslin.
10. Using the crossmarks at the sleeve cap as pivot points, pivot the sleeve sloper up at each side of the biceps ½ to 1 inch. One inch will give extra ease to the sleeve.

11. With the sleeve sloper in this pivoted position, trace the lower cap onto the muslin at the front and back of the sleeve. Crossmark the sleeve cap at the pivot point (Figure 8.34).

Figure 8.34 / Steps B9–11

12. Shape the underarm seam above the elbow by connecting the raised cap with the lower underarm seam, using the hip curve.
13. Leaving the seam allowance, trim away excess muslin at the underarm and the lower cap of the sleeve. Slash into the seam allowance at the cap crossmark (Figure 8.35).

Figure 8.35 / Steps B12–13

14. Pin the underarm seams of the sleeve together. Pin-baste the underarm section of the sleeve cap into the lower armhole, the same as for the basic set-in sleeve.
15. Replace the bodice on the dress form.
16. Pin the raglan seam and armhole intersection to the tape on the dress form.

17. Hold the sleeve out at the center grain line so that it forms approximately a 45-degree angle. In that position, smooth the front of the cap extension toward the neckline, and pin along the raglan seam. Repeat for the back (Figure 8.36).

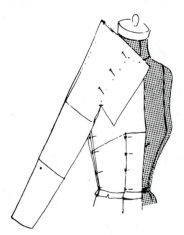

Figure 8.36 / Steps B14–17

18. Bring the front and back of the cap extension together at the shoulder seam and pin.
19. At the tip of the shoulder, place another pin ½ inch up. Blend a pinned curve from this raised point along the shoulder to the original shoulder seam.
20. From the raised shoulder seam, blend a pinned curve to the center of the sleeve grain line at approximately the middle of the cap.
21. Mark the raglan seams on the sleeve.
22. Crossmark the shoulder seam at the armhole intersection (Figure 8.37).

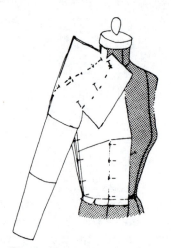

Figure 8.37 / Steps B18–22

23. Remove the muslin from the dress form, leaving the shoulder seam pinned together.
24. Leave the shoulder seam pinned together, and true the front shoulder. Trace the front shoulder to the back. True the raglan seams.
25. Leaving seam allowance, trim away excess muslin at the shoulder and raglan seams. The open shoulder seam will form a large curved dart. If desired, the raglan sleeve may be split into two pieces by cutting from the vanishing point of the large shoulder dart, along the center of the sleeve to the wrist. If the sleeve is divided into two pieces, both pieces must be traced and seam allowance added to the center of the sleeve seam.
26. Pin the shoulder dart or overarm seam together, matching the crossmarks.
27. Pin the raglan seams of the sleeve over the front and back. Pin-baste the lower armhole from the inside.
28. True the neckline, blending the line at the intersections of the raglan seams.
29. Replace the muslin on the dress form and check fit.
30. See the finished pattern (Figure 8.38).

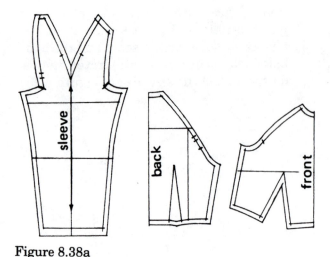

Figure 8.38a

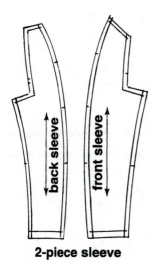

2-piece sleeve

Figure 8.38b / Finished pattern

The Kimono Sleeve with a Gusset

When a smooth unmounted sleeve is desired, without any of the bulk at the underarm of the dolman sleeve, a gusset must be inserted at the under-arm to facilitate ease in movement. The gusset is a diamond-shaped piece of fabric that is set into a slashed opening. The gusset opening, especially at the point of the slash, must be reinforced in the construction of the garment (Figure 8.39).

Figure 8.39 / Kimono sleeve with gusset

A. PREPARATION OF MUSLIN—The muslin is prepared the same way as for the dolman sleeve.

B. DRAPING STEPS

1. Drape the front and back bodice as desired.
2. Include extra ease in the front armhole; pin the side seam; and raise the shoulder seam the same way as for the dolman sleeve.
3. Mark all style lines.
4. Remove pins from darts and other details, but *leave the shoulder seam and side seam pinned together.*
5. Place the front, face down, on the table and smooth out both layers of muslin. An excess fold of muslin will extend from the shoulder blade into the sleeve area. This fold should be smoothed out to taper to nothing at approximately the elbow of the sleeve at a 45-degree angle to the back bodice. Pin both layers of muslin together.
6. True the back side seam, lowering the armhole and adding the necessary ease (Figure 8.40).

Figure 8.40 / Steps B5–6

7. On the folded sleeve sloper, mark down the top of the sleeve cap ½ inch at the center fold of the sleeve. At the underarm, mark down 1½ inches from the biceps.

Divide the cap height into thirds, and square a line across the cap at the lower third as illustrated (Figure 8.41).

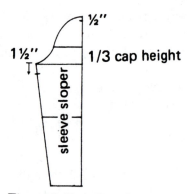

Figure 8.41 / Step B7

8. Place the folded sleeve sloper over the back muslin with the ½-inch mark at the tip of the raised shoulder and the 1½-inch mark at the underarm intersecting the side seam.
9. On the muslin, mark the lower third of the sleeve cap line with a crossmark where it touches the edge of the cap.
10. Outline the center of the sleeve fold, the underarm seam, and the lower edge of the sleeve.
11. Add ¼ inch to the center of the sleeve at the biceps level (Figure 8.42).

Figure 8.42 / Steps B8–11

12. Using the hip curve, draw the overarm seam, blending a smooth line from the shoulder to the ¼-inch extension and touching the center of the sleeve at the el-bow. Reverse the hip curve to smooth out the shoulder area of this long seam.
13. Draw the diagonal gusset line from the intersection of the underarm and side seam to the armhole crossmark.
14. Add seam allowance, measuring down ½ inch at the underarm and side seam. Connect these points with the gusset crossmark as illustrated (Figure 8.43).

Figure 8.43 / Steps B12–14

15. Trace the back shoulder and sleeve to the front. Some ease will occur in the back shoulder seam. Crossmark the center of the sleeve seam at the tip of the shoulder and the biceps. Crossmark the elbow level at the underarm seam. Trace the trued side seam and the gusset line with the seam allowance to the front.
16. Add seam allowances and trim away excess muslin.

NOTE: For a long sleeve, fitted from the elbow to the wrist, follow directions for the long fitted dolman sleeve (pages 132–134).

17. Cut the gusset by folding a 10-inch square twice on the bias, forming a 4-ply triangle (Figure 8.44).

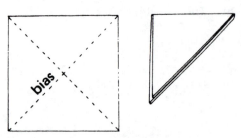

Figure 8.44 / Step B17

18. Place this folded triangle on the back muslin with one folded edge in line with the side seam and the other folded edge touching the gusset crossmark.

19. Indicate the gusset crossmark and the marked seam allowance of the gusset at the side seam on the folded triangle (Figure 8.45).

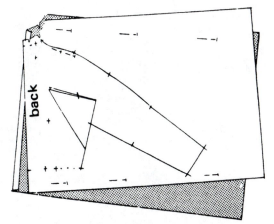

Figure 8.45 / Steps B18–19

20. Connect these marks with a straight line, and add ½-inch seam allowance.

21. Cut along the seam allowance, and trace the gusset line forming the gusset as illustrated (Figure 8.46).

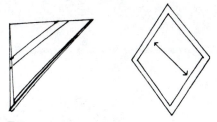

Figure 8.46 / Steps B20–21

22. Slash the diagonal gusset line on the front and back.

23. Separate the front from the back to complete trueing.

24. Leaving seam allowance, cut away excess muslin.

25. Pin the front and back together at the side seam and underarm seam.

26. Fold back the seam allowances on the gusset opening, and pin in the gusset. Although the gusset can be pinned into place, the pins are somewhat clumsy, and the gusset can best be evaluated when it is basted rather than pinned (Figure 8.47).

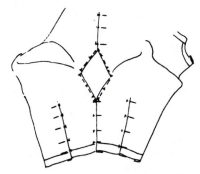

Figure 8.47 / Steps B23–26

27. Pin the overarm seam and the rest of the garment together.

28. Replace the muslin on the dress form. Check the fit and make any necessary adjustments.

29. See the finished pattern (Figure 8.48).

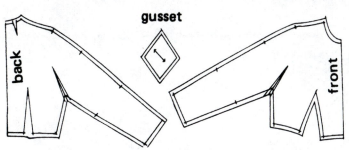

Figure 8.48 / Finished pattern

9
The Shift

One of the most comfortable and flattering shapes in fashion is the shift. Cut in one piece, without constraint at the waistline, it allows freedom of movement and camouflages the less than perfect figure. Never totally out of fashion, the shift draping technique lends itself to many variations in silhouette, extending from the body-skimming

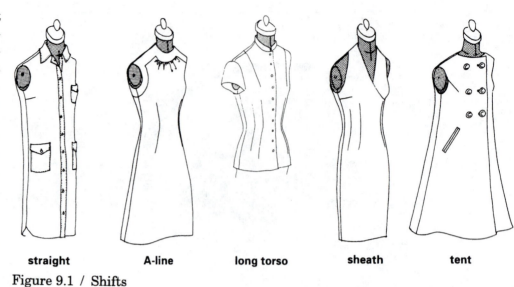

straight A-line long torso sheath tent

Figure 9.1 / Shifts

sheath, to the slightly fitted shape, the straight shift, and to the flared tent. When a defined waistline is desired, the shift can be belted. The basic technique used to drape the shift also applies to draping the fitted torso, which is a hip-length version of the sheath. Smocks, blouses, and dresses with a blouson silhouette are also developed using shift draping methods (Figure 9.1).

The Straight Shift

A. PREPARATION OF MUSLIN

1. Tape the hipline on the dress form 7 inches from the waistline.
2. Tear the muslin for the front and back:
 a. Length—4 inches plus length of finished shift at the center front plus hem
 b. Width—width at the widest point (bustline or hipline) plus 6 inches
3. Draw the center front and center back grain lines 1 inch from the torn edge.
4. On the center front, mark down 4 inches from the upper edge for the neckline.
5. Pin the center front of the muslin to the dress form at the neckline and chest.
6. Smoothing on grain across the chest, locate, pin, and mark the position of the apex.
7. Let the muslin hang freely, follow the grain down from the apex, and mark the hipline level (Figure 9.2).

Figure 9.2 / Steps A5–7

8. Remove the front muslin from the dress form and draw crosswise grain lines at the bust and hip level; draw one lengthwise grain line down from the apex and another in the center of the princess panel as illustrated (Figure 9.3).

Figure 9.3 / Step A8

9. On the back muslin, draw the hip grain line at the same level as on the front muslin.

10. Locate the shoulder blade level by pinning the muslin to the center back at the hipline and bringing it straight up to the neckline; pin at the neckline, and mark the shoulder blade level at the center back (Figure 9.4).

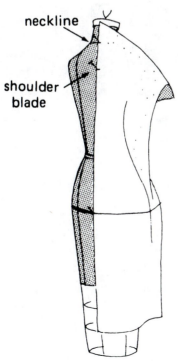

Figure 9.4 / Steps A9–10

11. Remove the back muslin from the dress form, draw in the shoulder blade level crosswise grain line, and measure and mark the position of the armplate as in the basic waist back.

12. Draw a lengthwise grain line down from the shoulder blade level to the hipline 1¼ inch from the armplate as in the basic waist back (Figure 9.5).

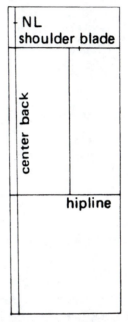

Figure 9.5 / Steps A11–12

B. DRAPING STEPS—FRONT

1. Pin the center front at the neckline and chest.

2. Pin at the apex.

3. Let the muslin fall straight down from the apex, and pin on the hipline at the princess seam and center front. Make sure the hipline on the muslin falls directly over the taped hipline on the dress form.

4. Leaving adequate ease (at least ⅜ inch at the hipline), pin the side seam at the hipline and bustline level.

5. Shape the neckline as desired.

6. Fit the shift above the bustline, using any of the various dart positions above the bustline level as discussed in dart variations on pages 35–37.

7. Mark the neckline, shoulder, armhole, and darts the same way as for the basic waist. At the side seam, crossmark

the armplate and hipline intersections (Figure 9.6).

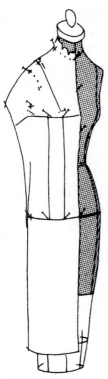

Figure 9.6 / Steps B1–7

8. Remove the muslin from the dress form, and true the neckline, shoulder, armhole and darts, the same way as for the basic waist. Connect the armplate and hipline crossmarks at the side seam, and draw a lengthwise grain line from the hipline crossmark to the lower edge of the muslin.

9. Leaving a seam allowance, trim away excess muslin at the neckline, shoulder, and armhole.

10. Replace the front on the dress form; fold back and pin the excess muslin at the side seam in preparation for draping the back (Figure 9.7).

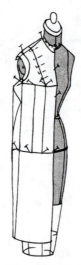

Figure 9.7 / Steps B8–10

C. DRAPING STEPS—BACK

1. Pin the center back at the neckline, shoulder blade level, and hipline.

2. Smooth across the hipline, leaving ease and keeping the hip grain line aligned with the tape on the dress form; pin the hipline at the side seam and at the lengthwise grain line.

3. Bring up the muslin so that the lengthwise grain remains straight and adequate ease is maintained across the shoulder blades; pin along the shoulder blade grain line. In the shift, this grain line may be lifted slightly near the armhole in order to maintain a cylindrical effect.

4. Making sure that the lengthwise grain remains straight, pin the back to the front at the side seam, placing one pin at the armplate and another at the hipline.

5. Drape the neckline and the shoulder. The neckline or shoulder dart is somewhat deeper on a shift than on a fitted back waist.

6. Mark the neckline, shoulder, and armhole (Figure 9.8).

Figure 9.8 / Steps C1–6

7. Keeping the side seam pinned together, remove the shift from the dress form.
8. Trace the front side seam to the back. For a set-in sleeve, drop the armhole and give additional ease at the upper side seam, blending the ease toward the traced side seam at the hipline. Use of the hip curve will help in shaping the extended side seam.
9. Leaving a seam allowance, cut away excess muslin. Clip into the side seam allowance at the waistline and hipline.
10. Complete the trueing of the neckline, shoulder, and armhole, and leaving a seam allowance, cut away any excess muslin (Figure 9.9).

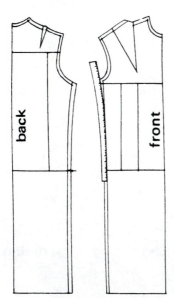

Figure 9.9 / Steps C1–10

11. Pin the shift together, and replace it on the dress form. Check the fit and mark the hem.

The Sheath

When a shift is shaped and fitted close to the body, it is a sheath; when a sheath is cut short, ending at the hipline, it becomes a long torso. The same draping technique is used for both versions (Figure 9.10).

Figure 9.10 / Sheath

A. PREPARATION OF MUSLIN—Prepare the muslin and drape the same way as for the straight shift (front and back through step C6).

B. SHAPING OF THE SIDE SEAM
1. Pin the front and back together at the side seam the same way as for the straight shift.
2. Take in the side seam at the waistline. Diagonal pull will appear in the waistline area of the front and back. Therefore, darts must be added to keep the pickup of the fabric balanced. Straight grain must be maintained at the center of the waistline darts. The pickup at the side seam and the width of the darts at the waistline will vary according to the shape of the dress form and the amount of fit desired. For a very close fit, two darts will be needed in both the front and the back of the sheath. As a closer fit is achieved, the hipline level of the muslin

will rise above the taped line on the dress form (Figure 9.11).

Figure 9.11 / Steps B1–2

3. True the darts as illustrated (Figure 9.12).

Figure 9.12 / Step B3

4. Slash into the dart pickup at the waistline before pinning the darts.
5. Slash into the seam allowance of the side seam in the curved waistline area.

The A-Line Shift

The shift with a slightly shaped side seam and moderate flare at the hem is the A-line shift (Figure 9.13).

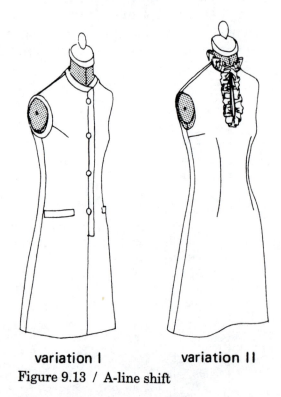

variation I variation II
Figure 9.13 / A-line shift

A. PREPARATION OF MUSLIN—Prepare the muslin and drape the same way as for the straight shift (front and back through step C6).

B. SHAPING THE SIDE SEAM
 1. Pin the front and back together at the side seam the same way as for the straight shift.
 2. Pin the side seam at the waistline to the desired shape. If a diagonal pull appears in the waistline area of the front and back, darts must be added so that the pickup of fabric at the waistline is balanced all around.

3. Up to 3 inches of flare may be added at the knee level of the side seam (Figure 9.14).
4. Blend the side seam with a gentle curve from the underarm to the hipline. For a set-in sleeve, allow the necessary ease.

The French Dart Shift

A diagonal, slightly curved dart, extending from the apex to the side seam, permits very subtle shaping in the shift. The waistline can be molded and considerable flare can be added with a minimum of seaming (Figure 9.15).

Figure 9.14 / Steps B1–3

A. PREPARATION OF MUSLIN—Prepare the muslin the same way as for the straight shift.

B. DRAPING STEPS—FRONT

1. Pin the center front at the neckline and chest.
2. Pin at the apex.
3. Let the muslin fall straight down from the apex, and pin on the hipline at the princess seam and center front, making sure that the hipline on the muslin falls directly over the taped hipline on the dress form.
4. Leaving adequate ease (at least ⅜ inch), pin at the hipline.
5. Smooth across the chest area, and pin at the armhole.
6. Drape the neckline, shoulder, and armhole.
7. Let excess muslin drop toward the hipline, forming a diagonal fold from the apex to the side seam (Figure 9.16).

Figure 9.15 / French dart shift

Figure 9.16 / Steps B3–7

8. Slash along the center of the fold from the side seam to within 2 inches of the apex.

9. Pin the slashed sides together fitting as in a French dart. If a flare is desired over the hip bone, it may be dropped from the slash before the dart is pinned (Figure 9.17).

10. Mark the slashed dart as pinned.

11. Dot the side seam above the hipline wherever the muslin touches the dress form.

12. Crossmark the side seam at the armplate, the dart intersection, and the bottom of the torso (Figure 9.18).

13. Remove the muslin from the dress form and true the neckline, shoulder, and armhole. True and pin the dart.

14. Replace the muslin on the dress form in order to drape the back.

Figure 9.17 / Steps B8–9

C. DRAPING STEPS—BACK—The draping of the back and the shaping of the side seam of the French dart shift are the same as for the A-line shift (See pages 150–151).

The Tent

The tent is a shift with flare that usually originates from the armhole. More extreme fullness can be developed by adding flares from the apex, the back neckline, or the shoulder seams (Figure 9.19).

Figure 9.18 / Steps B10–12

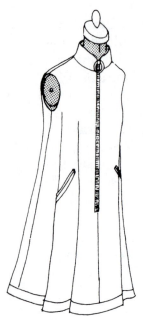

Figure 9.19 / Tent

A. PREPARATION OF MUSLIN—Prepare the muslin the same way as for the basic shift, but the width of the front and back depends on the desired width at the hemline.

B. DRAPING STEPS

1. Drape the same way as for the basic shift up to step C6 (See pages 146–148).

2. For a simple tent, add desired flare (up to 5 inches at the knee level). Connect the armhole and hem with a straight line (Figure 9.20).

3. For additional fullness, add flares from the front and back of the armhole. When draping the armhole, slash into the seam allowance at approximately the lower third of the armhole. Drop the grain at this point to form a flare the same way as in the flared skirt (See page 81).

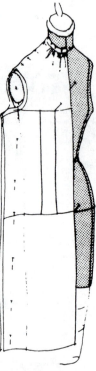

Figure 9.20 / Steps B1–2

Continue draping to the side seam, and add additional fullness at the side seam as desired (Figure 9.21).

4. Gain still more flare by eliminating the shoulder dart and letting the shift flare from the apex.

The Smock

The smock silhouette is created by adding additional fullness to the shift. This fullness is gathered or pleated into a shoulder yoke, which may be cut with or without a shoulder seam. When a deeper front yoke is desired, the yoke is cut

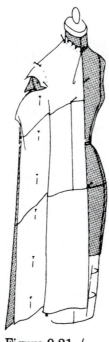

Figure 9.21 / Step B3

in two pieces. For a more classic shirt effect, the shoulder seam in its normal place is eliminated (Figure 9.22). To drape the yoke, see The Bodice Yoke and The Shirt Yoke on pages 111–113.

Figure 9.22 / Smock

The Body of the Smock

A. PREPARATION OF MUSLIN—Prepare the muslin the same way as for the basic shift, ex-

cept that 10 inches should be added to the width of both the front and the back.

B. DRAPING STEPS—Pleats, if desired, should be estimated and pressed into place before draping.

1. Pin the center front at the neckline and chest.
2. Pin at the apex.
3. Let the muslin fall straight down from the apex, and pin on the hipline at the princess seam and center front, making sure that the hipline on the muslin falls directly over the taped hipline on the dress form.
4. For gathers or tucks at the yoke, pin additional muslin into position, keeping the grain straight over the tape at the hipline (Figure 9.23).

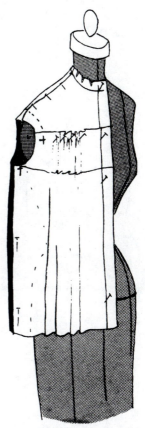

Figure 9.23 / Steps B1–4

5. Mark the yoke seam; pleats, tucks, or gathers; and armhole.
6. Drape the back following the same principles as for the front.

7. Pin and mark the side seam. The side seam is usually kept on the straight grain, but it may also flare from the armhole to the hem if desired.
8. Remove the muslin from the dress form and true all seams.
9. Add seam allowances and trim away excess muslin.
10. Replace the muslin on the dress form. Check the fit and make any necessary adjustments.

The Blouse

Blouses designed as separates or as part of a suit are usually draped following the procedure described for the basic straight shift or the smock. The standard blouse length is 7 inches below the waistline. In order to maintain a smooth distribution of fullness at the waistline, dart tucks may be used from hip to waist as illustrated (Figure 9.24).

Figure 9.24 / Blouse

The Blouson

The blouson is usually a modified tent or smock shape that is gathered into the top of a skirt at the waistline or the hipline. The blouson is allowed to blouse softly over the waist or the hips (Figure 9.25).

Figure 9.25 / Blouson

This effect cannot be achieved without some sort of independent way of holding up the skirt. When the blouson is at the waistline, the skirt can be fitted over the hips or elasticized at the waist. When the blouson is at the hipline, the garment must have an attached camisole that serves as a foundation to keep the bloused fullness of the bodice suspended.

In order to maintain the effect of soft blousing, a hip-length zipper should not be used to close the garment. Buttons or snaps are the appropriate closures for a blouson (See pages 203–206).

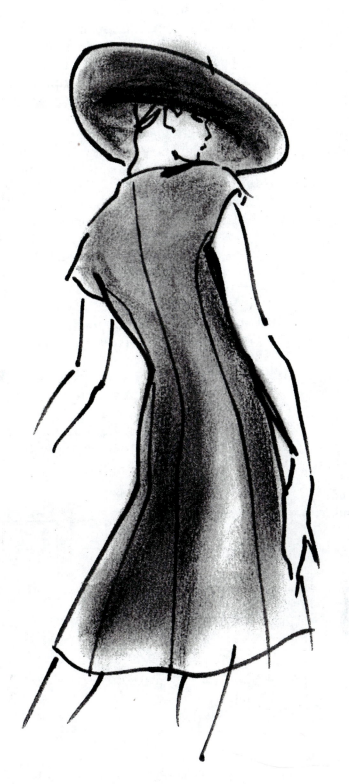

10

The Princess Dress

80 cm length + 2 cm hem + 4" = length
4 panels 2-10" wide, 2-16"

The princess dress is fitted with seams. Long gores, which may extend from shoulder to hem, can be shaped to achieve infinite variations in silhouette. Traditionally, the "princess" suggests a close-fitting bodice with a flared skirt, but the princess may also be used to develop garments with slim lines or wide, tent-like flares. The princess seam may originate at any point of the garment above the bustline, passing within an inch or so of the apex, and usually extending to the hem (Figure 10.1).

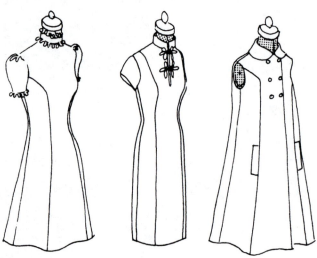

Figure 10.1 / The princess dress

Princess styling is adaptable to all sorts of garments, including loungewear, swimsuits, and dresses ranging from ball gowns to those designed for little girls' wear. Princess seaming is basic to the design of fitted jackets and coats, but the method of draping these tailored garments differs from the soft princess draping described here. The draping method for tailored apparel is described in chapter 12, "Tailored Garments."

A. PREPARATION OF MUSLIN

1. Indicate the desired princess seam line on the dress form by pinning style tape above the bustline in both the front and back.
2. Tape the hipline on the dress form 7 inches down from the waistline (Figure 10.2).

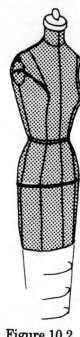

Figure 10.2 / Steps A1–2

92

3. Tear the muslin for the front and back:
 a. Length—4 inches plus length of garment plus hem.
 b. Width—center front and center back panels—10 inches; side front and side back panels—16 inches. This width is for a moderately flared princess skirt; for a very full skirt, the panels have to be cut correspondingly wider.
4. Draw lengthwise grain lines for the center front and center back.
5. Draw a lengthwise grain line in the center of each side panel.
6. On the center front, indicate the neckline 4 inches down from the upper edge.
7. Pin the center front of the muslin to the dress form at the neckline and chest.
8. Smoothing on grain across the chest area, locate, pin, and mark the position of the apex.
9. Let the muslin hang freely, follow the grain down from the apex, and mark the hipline level.
10. Remove the center front panel from the dress form, and draw a crosswise grain line at the hip level.
11. Draw a crosswise grain line at the hip level of all panels the same way as for the center front (Figure 10.3).

Figure 10.3 / Steps A4–11

B. DRAPING STEPS

1. Pin the center front at the neckline, chest, and hipline.
2. Keeping the crosswise grain straight, smooth across the chest area, and pin over the style tape.
3. Shape the neckline.
4. Pin at the shoulder.
5. Mark the neckline, shoulder, and armhole if the center front panel extends into this area, and mark over the tape at the princess seam from the shoulder or armhole to the apex (Figure 10.4).
6. Remove the center front panel from the dress form and true the neckline, shoulder, and princess seam above the apex.
7. Draw a grain line from the apex to the lower edge of the muslin.
8. Leaving seam allowance, trim away excess muslin at the neckline, shoulder, and princess seam line above the apex. Slash to the apex as illustrated (Figure 10.5).

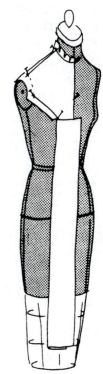

Figure 10.4 / Steps B1–5

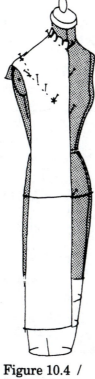

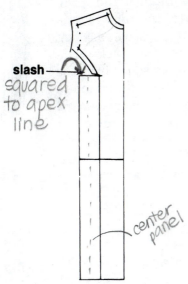

slash

squared to apex line

center panel

Figure 10.5 / Steps B6–8

9. Replace the center front panel on the dress form, pinning at the center front and at the princess seam line above the apex.
10. Fold the excess muslin below the apex toward the center front, and pin as illustrated (Figure 10.6).
11. Place the side front panel onto the dress form, aligning the hiplines and making sure that the straight grain line is in the center of the panel and perpendicular to the floor.
12. Pin along the hipline, allowing necessary ease.
13. Smooth upward along the center of the princess panel; pin along the straight grain line and at the bustline.
14. Smooth the muslin over the center front panel, and pin over the trued princess seam.
15. Leaving adequate ease, pin the side seam at the hipline and bustline level.
16. Dot the princess seam of the side panel over the princess seam of the center front panel.
17. Crossmark both the center front panel and the side front panel at the apex and 2 inches above the apex.
18. Mark the shoulder if the side panel extends to the shoulder and the armhole.
19. Crossmark the side seam at the armplate and hipline intersections (Figure 10.7).

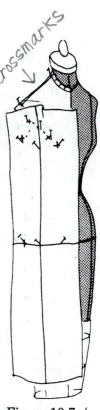

crossmarks

Figure 10.6 / Steps B9–10

Figure 10.7 / Steps B11–19

20. Remove the side front panel from the dress form; true the shoulder seam and the princess seam above the apex.

21. Connect the side seam crossmarks at the underarm and hipline with a straight line; draw a grain line from the hipline to the lower edge of the muslin.

22. Draw a grain line from the apex to the lower edge of the muslin and slash to the apex, the same way as steps 7 and 8 (Figure 10.8).

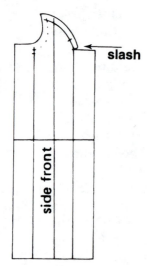

Figure 10.8 / Steps B21–22

23. Replace the side panel on the dress form, pinning the princess seam directly over the princess seam of the center front panel; sink pins at the shoulder seam and fold back excess muslin at the side seam as illustrated (Figure 10.9).

24. Pin the center back panel along the hipline.

25. Bring the center back panel straight up, and pin at the shoulder blade level and neckline.

26. Shape the neckline and pin at the shoulder. If the princess seam extends into the shoulder, the back shoulder dart is not necessary. When the princess seam originates

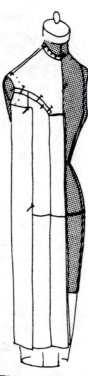

Figure 10.9 / Step B23

in the armhole area or lower, a neckline or shoulder dart may be necessary to maintain correct grain alignment.

27. Drape and pin the shoulder, leaving adequate ease.

28. Mark the neckline, shoulder, and armhole, and mark the princess line to the end of the style tape.

29. Crossmark at the end of the style tape (Figure 10.10).

30. True and replace the center back panel on the dress form the same way as the center front panel.

31. Pin the side back panel to the hipline the same way as the side front panel.

32. Bring the muslin straight up to the shoulder blade level and pin.

33. Leaving adequate ease, smooth and pin over the princess seam of the center back panel.

34. Pin the front and back side seams together at the hipline and armplate. In order to prevent excessive ease just below the back armhole, slashing into the muslin at the armplate area may be necessary. Grain at the side seam above the hipline may not be perfectly balanced (Figure 10.11).

35. Mark and true the side back panel the same way as the side front panel.

36. When all panels have been replaced on the dress form with the excess muslin below the apex extending outward, pin around the hipline with pins pointing down.

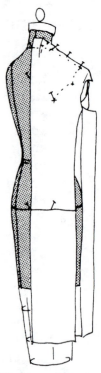

Figure 10.10 / Steps B24–29

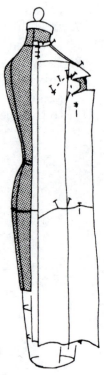

Figure 10.11 / Steps B31–34

37. Pin the princess seams and side seam from the apex level to the hem shaping the waistline and adding flare in the skirt as desired. The grain should be balanced at all seams below the hipline. Pin the seams simultaneously in order to achieve a balanced fit all around. For a nipped-in waistline, an additional dart will be needed in the waistline area of the front and back side panels.

38. Add a crossmark in the front princess seam 2 inches below the apex and in the back princess seam 3 inches below the existing crossmark (Figure 10.12).

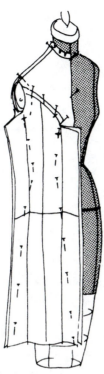

Figure 10.12 /
Steps B37–38

39. Carefully remove the princess dress from the dress form, leaving all seams pinned together. Mark, true, and trace seams, using the pins as a guide. Below the waistline, follow the curve of the hip as pinned to the flare point. A ruler may be used to straighten the seam line from the flare point (or just above the flare point) to the hem. Add crossmarks in the skirt area. Lower the armhole, and allow necessary ease in the side seam if a set-in sleeve is desired.

40. Leaving necessary seam allowance, trim away excess muslin at the princess seams and the side seam. Slash seam allowances in curved areas. Pin princess seams together, matching crossmarks.

41. True the front and back of the armhole. If the princess seams extend into the armhole, the armhole cannot be trued until the princess seams are pinned together.

42. Pin the side seam and the shoulder seam.

43. Replace the princess dress on the dress form. Check fit and mark hem.

44. See the finished pattern (Figure 10.13).

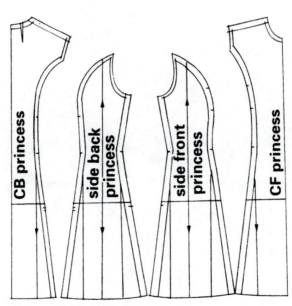

Figure 10.13 / Finished pattern

11

Sportswear
and
Casual Wear

By far, most of the clothing designed, manufactured, and worn today fits into the sportswear and casual wear category. Mass produced all over the world, the styling of this apparel is kept relatively simple, the fit is easy and comfortable, and the appeal is to a wide range of customers. Included in this category are separates for casual wear and active sports, as well as simple sleep and loungewear.

Sportswear and casual wear can be found at every price level, from inexpensive tops and pants found in numerous mail order catalogues and chain stores to designer separates sold in boutiques and better department and specialty stores. Also, this type of apparel is worn by just about everyone regardless of age or gender. Women, men, and children wear casual apparel for almost all occasions.

Both the design and manufacturing of casual apparel in this great variety of categories are similar. In each company, for each division, design development begins many months before the selling season. The vice president for design and/or the design director meet with designers and sales personnel to arrive at an overall concept for the entire line. At the concept meeting, designers usually present their ideas for the new line to the design director and the merchandisers. Certain general questions are explored and researched as a result of these meetings. Taking various factors into consideration, the group makes the broad decisions regarding colors and basic shapes for the next season. The age and general characteristics of the target customer, the season, the type of retail outlet where the merchandise is to be sold, and the price point are all taken into consideration. Also, the best-selling numbers of the previous season at both the wholesale and the retail level are reviewed (they are not always the same) and will influence the look of the line as it takes shape.

A large company usually has several divisions. Divisions may be distinguished by size range, price point, fabrication (for example, knitted or woven fabrics) or by apparel category such as active sportswear, sleepwear, or casual separates. One designer is usually in charge of design for each division. He or she will begin work on the line by selecting specific fabrics in the colors that will be featured by the company, and then sketch ideas for the coordinated groups of items to be featured and sold together. This coordination allows the customer to easily assemble complete outfits and leads to multiple sales. At this stage, the designer may make quick sketches on paper or sketch directly on a computer. Eventually, an accurate technical sketch for each piece is entered into a computer.

Next, the basic shapes of the various pieces must be determined. The shapes are best determined by draping basic body patterns for a particular group of garments on the dress form. Working directly in muslin or the actual fabric on a full-sized dress form allows the designer to determine the precise amount of fullness necessary to achieve the desired shape. Working with only flat patterns on a computer requires guesswork in estimating the amount of ease required and leads to multiple fittings before the desired shape is finally achieved. Computer firms are feverishly working on programs that will convert an accurate three-dimensional sketch automatically into a flat pattern that is ready to be cut and sewn in fabric. This conversion from a sketch to a computer-generated pattern may some day soon eliminate the draping step; but for the time being, draping is still the most efficient way to develop a new basic body.

Once the body pattern has been draped, fitted on a model, and approved, it is digitized into a computer. Variations of the design are *then* developed using flat pattern-making techniques directly on the computer.

In some companies, usually those selling better-priced apparel, a sample room where samples are sewn is part of the home office design department. Many other firms, however, prefer to have samples sewn at factories where the finished product will be produced. When samples are sewn at the factory, the designer prepares a computer sketch with patterns, fabric information, and very clear specifications for each finished sample to be made at the factory. Companies usually provide the designer with a prepared form for this purpose (Figure 11.1). This practice of off-shore prototype development may also require travel by the designer to all parts of the world, wherever factories are located, to make sure that instructions are followed and to resolve any discrepancies that might arise.

When the first sample or prototype has been completed, it is sent to the home office where it is again fitted on a model for evaluation of fit

Specification Sheet – Sweater Tops
Country _____

	Sizes	S	M	L				Style #:	Wt. Per Dz.:
A	Body Length							Proto #:	Date:
B	½ Chest 1" below Armhole							Ref #:	Factory:
C	Cross Shoulder							Fiber:	
D	Sleeve Length							Machine:	
E	Sleeve Length CB							Comments:	
F	Armhole Straight								
G	Raglan – From CB Seam								
H	Muscle 1" from Armhole								
I	Sleeve Opening								
J	Sleeve Cuff Ht.								
K	Bottom Opening								
L	Bottom Cuff Ht.								
M	Neck Wide							A. Seam to Seam	B. Inside
N	Neck Depth – Front							Imag Shld Line to	
O	Neck Depth – Back							Imag Shld Line to	
P	Neck Trim								
Q	Front Placket L/W								
R	Buttons Size /#								
S	Collar – Ht. CB								
T	Collar – at Top								
U	Pocket Width/Depth								
V	Pocket Placement	A. From Top Shld						B. From CF	
W	Shoulder Pad LxW								
X	Shoulder Pad Placement							Edge to Edge	
Y	Neck Stretch							Minimum 24" Circumference	

Figure 11.1A

Specification Sheet – Skirts
PLEASE SUBMIT _____ Size: _____

Style No.:_____ Spec. Date:_____

Description:_____ Spec. Date:_____

_____ Spec. Date:_____

_____ Spec. Date:_____

_____ Spec. Date:_____

FOB:_____LANDED:_____RETAIL:_____

FABRIC:_____

COUNTRY:_____FACTORY:_____DEPT.:_____

APPROVAL DATE:_____ORNAMENTED: YES ☐ NO ☐

Sizes					
A. Skirt Length					
B. Waist Relaxed					
C. Waist Stretched					
D. Hip 3" Down					
E. Hip 7" Down					
F. Bottom Width					
G. Hem Sweep					
H. Waistband					
I.					
J. Belt Loops					
K. Pocket Placement					
L.. Pocket Opening					
M. Pocket Length					
N.					
O.					

Figure 11.1B

Specification Sheet – Pants
PLEASE SUBMIT _____ Size: ____

Style No.:_____	Spec. Date:_____
Description:_____	Spec. Date:_____
_____	Spec. Date:_____
_____	Spec. Date:_____
_____	Spec. Date:_____

FOB:_____LANDED:_____RETAIL:_____

FABRIC:_____

COUNTRY:_____FACTORY:_____DEPT.:_____

APPROVAL DATE:_____ORNAMENTED: YES ☐ NO ☐

Sizes	S		M		L	
A. Waist relaxed						
B. Waist Stretched						
C. Waistband width						
D. Thigh at Crotch						
E. Knee 14" Down from Crotch						
F. Front Rise						
G. Back Rise						
H. Outseam						
I. Inseam						
J. Hem Opening						
K. Hem						
L. Hip 7" Down from Waist						
M. 4" up from Crotch						
N. Hip 3" Down						
O. Label Placement						
P. 2" Above Hem						
Q.						
R. Pocket Placement						
S. Pocket Opening						
T. Pocket Length						
U.						
V.						

Figure 11.1C

and the final aesthetic approval by design and merchandising people. If more adjustments are required, the prototype and instructions for changes are sent back to the factory and the entire process is repeated. Companies that work with several factories may do "double sourcing." This means that the same prototype is made up by two factories, and the factory that submits the best sample gets the work.

Eventually, as piece by piece is added, design groups are completed, the line is shown and sold to retailers, and it is ready for production. The transition from design to production has become simplified since the introduction of computers in apparel design and manufacturing. The pattern for the prototype has already been developed by the designer using a computer and is stored in the system. A computer is used to grade the pattern into the various sizes of a particular size range. The next computer task is to generate an economical cutting layout, taking into consideration the width of the fabric, the grain direction of each pattern piece, and the presence of nap or

one-way design in the fabric. Now the design is well on its way to the cutting, sewing, and finishing process of manufacturing.

This chapter describes draping methods for the various basic bodies used in this segment of the industry.

The Unstructured Drop-Shoulder Jacket

Many items of outerwear, including unstructured jackets, parkas, sweatshirts, and all sorts of other loose fitting tops in the casual wear category, are developed from the basic pattern of the unstructured drop-shoulder jacket. These garments fit easily over other layers of clothing and still have plenty of room for movement. The easy, loose fit is achieved without darts. Once the basic body has been draped, it is digitized into a computer where it serves as the foundation for the development of infinite variations using flat pattern-making methods (Figure 11.2).

Figure 11.2

A. PREPARATION OF MUSLIN

1. Tear muslin—front and back
 a. Length—34 inches
 b. Width—width at widest point (the widest point may be at the bustline or the hipline) plus 8 inches
2. Draw the center front and center back grain lines.
 a. Front—2 inches from the lengthwise torn edge
 b. Back—1 inch from the lengthwise torn edge
3. On the center front, mark down 4 inches from the upper edge for the neckline.
4. Pin the center front of the muslin to the dress form at the neckline and chest.
5. Smoothing on grain across the chest, locate, pin, and mark the position of the apex.
6. Letting the muslin hang free, follow the grain down from the apex, and mark the hipline level (Figure 11.3).

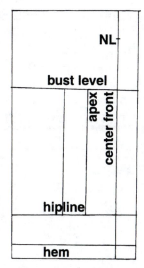

Figure 11.4 / Step A7

8. On the back muslin, draw the hip grain line at the same level as on the front muslin.
9. Below the hipline on both the front and back, draw a cross grain line 1½ inches up from the torn edge for the hemline.
10. Locate the shoulder blade level by pinning the muslin to the center back at the hipline and bringing it straight up to the neckline; pin at the neckline, and mark the shoulder blade level at the center back (Figure 11.5).

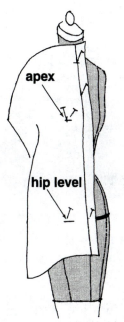

Figure 11.3 / Steps A1–6

7. Remove the front muslin from the dress form and draw the crosswise grain lines at the bust and hip levels; draw one lengthwise grain line down from the apex and another in the center of the princess panel as illustrated (Figure 11.4).

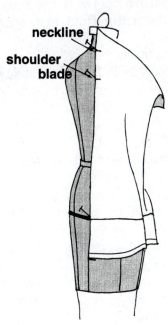

Figure 11.5 / Steps A8–10

11. Remove the back muslin from the dress form, draw in the shoulder blade level crosswise grain line, and measure and mark the position of the armplate.

12. Draw a lengthwise grain line down from the shoulder blade to the hipline 1¼ inches in toward the center back from the armplate as illustrated (Figure 11.6).

Figure 11.6 / Step A12

B. DRAPING STEPS—The unstructured jacket is usually draped over a raglan shoulder pad that has been pinned to the shoulder of the dress form. Tape the shoulder seam line and the normal armhole over the shoulder pad.

1. Pin the center front at the neckline and chest.

2. Pin at the apex.

3. Let the muslin fall straight down from the apex and pin on the hipline at the princess seam and center front, making sure that the hipline falls directly over the taped hipline on the dress form.

4. Leave adequate ease throughout (at least ⅜ inch at the hipline), and pin to the side seam at the hipline and bustline levels.

5. Shape and mark the neckline, adding ¼-inch ease evenly distributed. (This extra ease will absorb some of the extra muslin normally taken in with a shoulder dart.)

6. Keeping the cross grain straight, smooth the muslin across the chest and over the shoulder; throw all excess muslin above the bust level into ease at the arm-

hole. Pin and mark the amount of excess at the armplate at the screw level as for a dart.

7. *Control pins*—pin across the bustline and hipline controlling ease.

8. Pin and crossmark side seam at the armplate and the hipline.

9. Decide on and mark lightly the shoulder seam extension. (The shoulder seam may be extended from 1½ to 4 inches.)

10. Decide how much to lower the armhole. (The armhole may be lowered from 3 to 4½ inches.) Mark lowered armhole at the side seam (Figure 11.7).

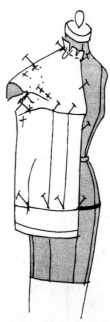

Figure 11.7 / Steps B1–10

11. Remove pins at the shoulder and side seam, *but do not remove the control pins.*

12. Drape the back the same as for the back shift (steps 1 through 4, page 148).

13. Drape the neckline with a pinch for ease, eliminating the darts at the shoulder or neckline. Shift all excess muslin into the armhole for ease. Pin and mark excess fullness at the armhole as for a dart.

14. Pin the front and back side seams together at the bust level and crossmark on both sides of the pin.

15. Pin the side seam together at the lowered underarm adding ease (at least 1½ inch). Remove the bust level pin so that

the jacket falls straight down and the desired silhouette is achieved.

16. Pin the front and back shoulder seams together extending the seams at the armhole as desired.

17. Mark the back neckline. Crossmark at the neckline and shoulder and crossmark at the shoulder seam and armhole. Transfer the bust level mark at the side seam to the back (Figure 11.8).

18. Remove the jacket from the dress form and separate the front and back (Figure 11.9).

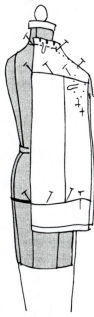

Figure 11.8 / Steps B11–17

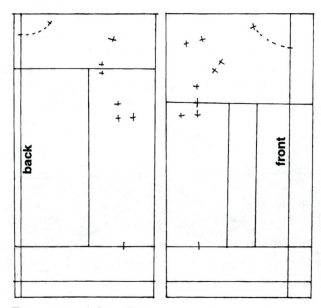

Figure 11.9 / Step B18

19. Trueing—front and back:
 a. Raise the extended shoulder seam ½ inch at the armhole; connect to the neckline with a ruler. Add seam allowance and trim away excess muslin.
 b. At the side seam and bust level crossmarks, draw grain lines down to the desired lowered depth of the armhole; from this point, on both the front and back, draw a cross grain line to the extended side seam, and drop grain guide lines to the lower edge of the jacket.

20. Back only:
 a. Determine the difference between the front and back fullness as indicated in the armhole.

 FOR EXAMPLE:
 Ease-in-front armhole—1 inch
 Ease-in-back armhole—⅜ inch
 Difference—⅝ inch

 b. Extend the back side seam at the dropped armhole the determined difference.
 c. Draw a line for the side seam from the extended underarm to the side seam guide line at the lower edge (Figure 11.10).

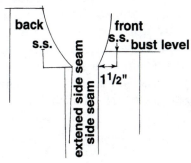

Figure 11.10 / Steps B20(a–c)

21. Armhole:
 a. True the armhole front and back with Fairgate Vary Form curve as illustrated (Figure 11.11).

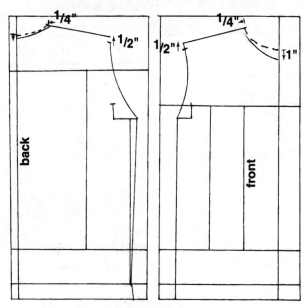

Figure 11.11 / Steps B19–21(a)

b. Pin the shoulder seam and blend the armhole seam line for a smooth, continuous curve (Figure 11.12).

Figure 11.12 / Steps B21–22

22. True the neckline, lowering it ¼ inch at the center back, ¼ inch at the shoulder seam, and 1 inch at the center front.
23. Add seam allowances and trim away excess muslin at the side seam and armhole.

NOTE: Because samples or prototypes in this category are usually completed in the factory, seam allowances must be extremely accurate and should meet the requirements of the sewing machines. The maximum seam allowance for this type of garment is ½ inch, but generally it is ⅜ inch.

The Drop-Shoulder Jacket Sleeve

The sleeve for the unstructured drop-shoulder jacket fits smoothly into the armhole. It is cut wide enough for active movement and fits easily over other layers of clothing. In addition, bulky fabrics are often used for these garments, which also require an easy fit.

SLEEVE LENGTHS FOR THE DROPPED-SHOULDER JACKET SLEEVE

Size	6	8	10	12
Underarm Length	16⅞	17¼	17⅝	18
Normal Cap Height	6⅛	6¼	6⅜	6½

A. DEVELOPING THE DROP-SHOULDER JACKET SLEEVE

1. At the center of a large sheet of paper, approximately 25 by 25 inches, draw a straight line for the center of the sleeve.
2. Square lines across the center of the sleeve line for the wrist and biceps levels.
3. Subtract the amount of shoulder-drop extension from the normal cap height.
 Example: If the normal cap height is 6¼ inches, and the shoulder extension is 2½ inches, the maximum cap height is 3¾ inches. However, cap height can be made even shorter for more lift or action.
4. Square a 1-inch line across the center of the sleeve line to indicate the top of the cap height, as calculated in step 3.
5. Measure the length of the front and back armhole following the curve. The back is usually longer than the front. Subtract ½ inch from both the back and front measurements.
6. Draw guidelines for the sleeve cap by pivoting a ruler from each side of the one-inch top of sleeve line until the end of the back and front armhole measurements hits the biceps line.
7. Square an underarm guide line from the end of the cap to the wrist level.
8. The *wrist circumference* of a jacket sleeve usually measures *10½ inches*. Measure the distance between the two underarm guide lines; determine the difference between this number and the wrist circumference. At the wrist line, measure in one-half of this difference from the underarm guide lines.
9. Connect each side of the wrist with the end of the sleeve cap using the long end of the hip curve. The center of the sleeve will have shifted toward the back at the wrist level (Figure 11.13).

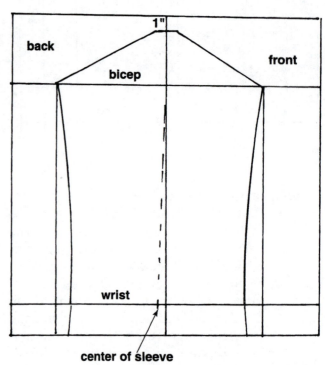

Figure 11.13 / Steps A1–9

10. To shape the cap:
 a. Using the Fairgate Vary Form curve, shape the cap by rounding off above the diagonal guidelines as illustrated. The cap should be scooped slightly in front, but not in the back.
 b. Crossmark the sleeve cap: one crossmark 3 inches from the underarm seam in front; and two crossmarks, ½ inch apart, 3 inches from the underarm in back (Figure 11.14).

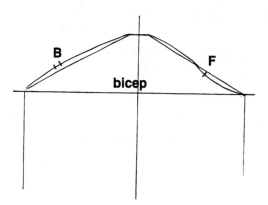

Figure 11.14 / Steps A10(a–b)

11. Cut out the sleeve and transfer it to muslin.
12. Add the hem and seam allowances, and cut out the sleeve.

13. Pin together following the order of assembly as practiced in casual wear production:
 a. Pin the shoulder seam.
 b. Set the sleeve into the armhole, pinning the right sides together along the seam line.
 c. Pin the side seam and underarm of the sleeve together from the hem to wrist.
 d. Pin up the hem.
14. Fit the jacket onto the dress form or preferably a live model.
15. See the finished pattern (Figure 11.15).

Working with Knitted Fabrics

Knitted fabrics are uniquely suited for casual apparel. Their natural elasticity and soft hand make knitted fabrics very comfortable to wear and the preferred choice for leisure and active wear apparel. From simple T-shirts to luxury sweaters; for tights and sleepwear; for soft, fluid dresses and sturdy double knit or warm fleece outerwear, knits are the universal choice of designers and consumers. Knitted fabrics may be cotton, linen, silk, wool, or every type of manmade fiber. Sometimes various fibers are combined to create interesting textures. Spandex is often added for additional elasticity and to aid in shape retention.

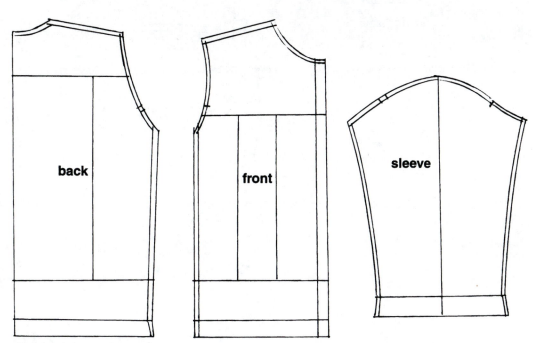

Figure 11.15 / Step A15

Casual knit separates are designed in traditional shapes. Tops include the basic crew, the tunic, the cardigan, the sweatshirt, the tank, and the twin set consisting of a cardigan over a tank or short-sleeve crew (Figure 11.16). Bottoms may be leggings, shorts, pajama pants, sweats, and their variations.

Knitwear designers work with two basic categories of knitted apparel. One category consists of apparel cut from knitted fabric, which is similar to working with woven fabric in that the garment is cut from a pattern and then sewn together.

The other category of knitted apparel is full fashioned. Here each part of the garment is knitted to shape. Computers are used to determine the number of stitches in each pattern piece. The knitting machines are then computer controlled. Not only does a computer control the number of stitches that make up each piece, but also the type of stitches used. Flat jersey knit, rib knit, cables, diamond effects, and all sorts of novelty stitches allow the designer to create a large variety of textures. When the pattern pieces have been knitted, they are joined together on special sweater sewing machines, that are called *linking machines.* Better-priced sweaters are usually made in this way. In order for a computer to do all this work, the pattern pieces of a basic body must first be developed and then digitized.

Draping is the simplest method of developing the basic body. Often, subtle changes occur in silhouette and fashionable fit, and for the designer to achieve precisely the look that is wanted, developing the basic body in knitted fabric on the dress form gives instant feedback. Once the basic body is fitted on a live model and perfected, it can be digitized into a computer where it will serve as the foundation for the many designs that make up a seasonal line.

The Basic Body for Knit Tops

This foundation pattern is used to develop T-shirts, polo shirts, bodysuits, and camisoles (Figure 11.17).

Figure 11.16

Figure 11.17

A. PREPARATION OF FABRIC—Use jersey or rib depending on the fabric that will be used for the finished garment. Using a fabric with a horizontal stripe is helpful in seeing the cross grain of knitted fabric.

1. Cut the fabric for the front and back (two pieces):
 a. Length—neckband to hipline plus 5 inches
 b. Width—full width across front (from side seam to side seam at hipline) plus 8 inches
2. Fold the fabric pieces in half lengthwise and baste the center front and center back line (Figure 11.18).

side seam to side seam + 8"

fold

neckband to hipline + 5"

Figure 11.18 / Steps A1–2

3. Mark the center front and neckline intersection 4 inches down from the upper edge of the fabric at center front.
4. Mark the center back neckline 3 inches down from the upper edge of fabric at center back.

B. DRAPING STEPS
1. Pin the folded front fabric piece along the center front—without ease at waistline or between bust.
2. Smooth across the hipline and smooth across the bustline, keeping the fabric on grain; pin at the side seam.
3. Cut away a rectangular piece of fabric 1 inch above the neckline and center front intersection. The cut should be 1 inch deep and extend upward to the edge of the fabric.
4. Smooth across the chest area and pin the neckline with minimal slashing at the neckline, keeping the fabric on the grain.
5. Extra fullness at the armhole will disappear near the apex. Shape the fullness into a small dart. This dart should not be larger than ¾ inch. For a full-busted figure, shape two or even three small darts.
6. For a fitted torso, gently pull and pin the fabric along the waistline from the center front to the side seam.
7. Pin along the side seam.
8. If there is still more ease in the waistline, pin a shallow dart.
9. Mark the outline of the basic knit body with chalk or pins:
 a. Drop the neckline at center front ½ inch.
 b. Lower the armhole by measuring down from the armhole ridge at the shoulder, over the center of the plate, to the side seam. The armhole depth should be lowered as indicated in the following table (Figure 11.19).

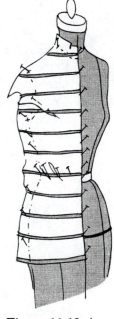

Figure 11.19 / Steps B1–9(b)

ARMHOLE DEPTH FOR THE BASIC KNIT BODY

SIZE	6 or XS	8 or S	10 or M	12 or L
ARMHOLE DEPTH	5½	5⅝	5¾	5⅞

10. Drape the back, following the same technique as for the front, except that the back is smooth without darts.

11. Pin the back and front together at the side seam and the shoulder; mark the outline (Figure 11.20).

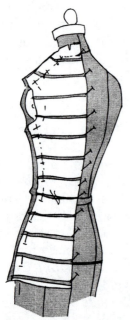

Figure 11.20 / Steps B10–11

12. Remove both the back and front from the dress form; mark the back side seam and shoulder and separate.

13. Transfer both pieces to paper using a tracing wheel:
 a. Keep the darts in the front pinned together.
 b. Pin the front to paper, pulling gently to flatten the fabric and maintain the grain.
 c. For a fitted body, follow the side seam as pinned; for a straight body, connect the side seam at the underarm with the hipline using a ruler.
 d. True the pattern, omitting the darts.
 e. Add ½-inch seam allowance all around (Figure 11.21).

Figure 11.21 / Steps B13(a–e)

 f. Check the shoulder seam—the back shoulder seam should be ¼ inch longer than the front.

14. Using paper for a pattern, cut a duplicate of the knit-top body and check the fit on the dress form. Check both fitted and straight versions.

15. Establish various style lines on the basic knit body at this time:
 a. For princess seaming, follow the princess seam on the dress form and mark.
 b. For a camisole, establish the strap line on the princess line ending 4½ to 5 inches from the shoulder. Mark a slip shape above the bust.
 c. For a strapless top, establish a horizontal line about 6 to 7 inches down from the shoulder.
 d. For a crop top, establish a horizontal underbust line about 13 inches down from the shoulder.
 e. For the hem level, measure 9 inches down from the waistline (Figure 11.22).

Figure 11.22 / Steps B15(a–e)

NOTE: The length of the actual sample garment is determined by the specifications set by the company for particular categories.

The Sleeve for the Knit Top

The sleeve for the basic knit top is developed with a flattened cap and fits smoothly into the armhole with very little ease.

SLEEVE MEASUREMENTS FOR KNIT TOPS

SIZE	6/XS	8/S	10/M	12/L
SLEEVE LENGTH	23	23½	24	24½
BICEPS CIRCUM.	14	14½	15	15½

1. Fold a large piece of paper in half.
2. On the fold, mark the appropriate sleeve length.
3. Square lines up from the fold for the top of the sleeve and the wrist.
4. Square a line up from the fold for the biceps level 4½ inches down from the top of the sleeve.
5. Mark off:
 a. ½ inch at the top of the sleeve.

b. One half the biceps circumference at the biceps' level.
 c. 3 inches at the wrist.
6. Connect the wrist and biceps for the underarm seam.
7. Establish the elbow level by dividing the underarm length in half and indicating the elbow level 1 inch above the halfway mark (Figure 11.23).

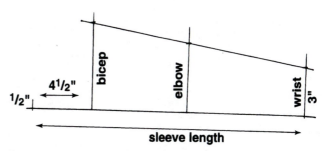

Figure 11.23 / Steps 1–7

8. To shape the cap:
 a. Draw a 4½-inch line extending from the biceps and fold at a 45-degree angle as illustrated (Figure 11.24).

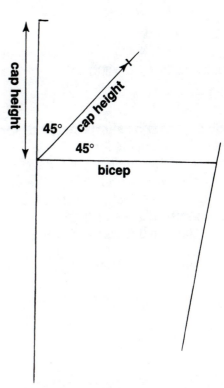

Figure 11.24 / Step 8(a)

b. With a tape measure, establish the sleeve cap in the traditional curve, using the 45-degree line as a reference point as illustrated (Figure 11.25).

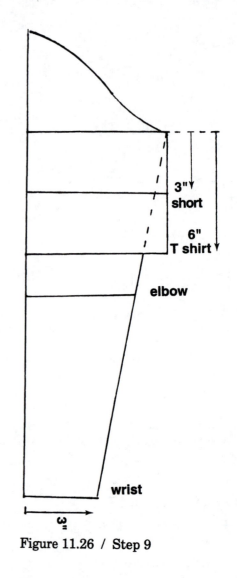

Figure 11.26 / Step 9

Figure 11.25 / Step 8(b)

9. Sleeves may be shortened as desired. The standard length for a short sleeve is 3 inches at the underarm; for a T-shirt, it is 6 inches at the underarm. The underarm seam for short sleeves is usually cut on the grain (Figure 11.26).

10. See the finished pattern (Figure 11.27).

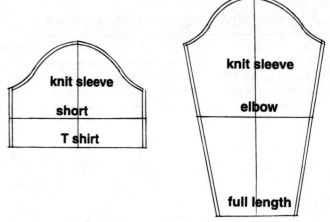

Figure 11.27 / Finished pattern

The Panty Extension for Body Wear

Bodysuit patterns, including those for exercise wear and dance wear, are developed from the knitted-top pattern. Essentially, the bodysuit is an attached panty. When the bodysuit is designed for dance or exercise wear, the crotch area usually has no opening. Bodysuits that serve as suit blouses, however, are designed with a snap fastener opening at the crotch. It is best to draft the panty section on paper after the top has been developed.

1. On the leg form, with a tape measure, measure the distance from the center front and hipline intersection, through the crotch, to the center back and hipline.
2. On a large piece of paper, draw one long line for the center front and the center back of the garment.
3. Centered on the long line, mark off the crotch measurement from the center front hipline to the center back hipline.
4. Square off lines for both the front and back hipline.
5. Place the front and back basic body for knit tops over the panty draft so that the hiplines are directly aligned.
6. Trace both the front and the back top to the panty.
7. To shape the crotch section:
 a. On the center line, measure 2 inches from the front hipline toward the back and square up a 1½-inch guide line.
 b. Measure down 3½ inches from this line and square up a 4¼-inch line to indicate the back of the crotch.
 c. From this line draw a straight guide line to the back hipline and side seam intersection; at the center of this line, mark up ¼ inch. Using the hip

curve, draw a shallow curved line for the back leg opening as illustrated (Figure 11.28).

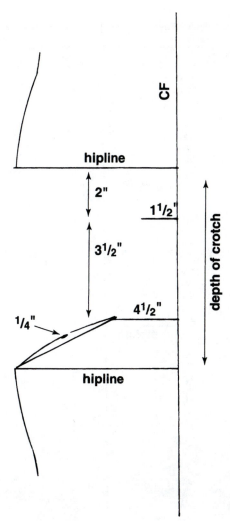

Figure 11.28 / Steps 2–7(c)

d. Using the French curve, connect the center of the crotch and 1½-inch guide lines to approximately the center of

the front hipline for the front leg opening (Figure 11.29).

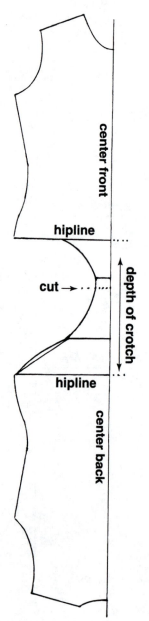

Figure 11.29 / Step 7(d)

e. Blend the entire leg opening into a smooth, curved line.

f. For a crotch opening, measure down ¾ inch from the 1½-inch guide line; at this point, square another line across the crotch and cut. At the back, add a ½-inch extension for overlap. The crotch opening is usually closed with snap fasteners.

8. Add seam allowances. Cut out the bodysuit, baste seams together, and fit on the

leg form or a live model. Correct any fitting problems.

9. See the finished pattern (Figure 11.30).

Finished Pattern

Figure 11.30 / Step 9

The Basic Body for Knit Pants

This foundation pattern is used for leggings, shorts, pajama pants, sweatpants and their variations. Knit pants may be constructed with or without side seams (Figure 11.31).

Figure 11.31

A. PREPARATION OF FABRIC

1. Cut the fabric for the front and back:
 a. Length—waistline to ankle plus 3 inches
 b. Width—
 (1) Front—center front to side seam at the hip level plus 6 inches
 (2) Back—center back to side seam at the hip level plus 8 inches
2. Baste a center front line 4 inches in from the right cut edge of the fabric front.
3. Baste a center back line 6 inches in from the left cut edge of the fabric back.
4. Mark the waistline 2 inches down from the upper edge at center front.
5. Mark a hip level cross grain line 7 inches down from the waistline on both front and back.
6. On the pants form, determine the length of the crotch by holding the L-square so that the short end passes between the legs at the highest possible point and the long end rests against the center front of the torso. The measurement indicated on the L-square at the waistline minus 1¼ inch is the crotch length. Pants made in knitted fabrics, especially if they are closely fitted, need no extra ease in the crotch. For looser fitting pajama pants or loungewear, crotch ease can be added.
7. Mark a crosswise crotch level grain line on the front and back at the correct distance from the waistline (Figure 11.32).

8. On the center back grain line, mark the halfway point between the waistline and the crotch level.
9. At the center back and the waistline intersection, measure in 1 inch. From this point, connect a diagonal line to the halfway mark on the center back grain line.
10. At the intersection of the center back and the crotch level, draw a diagonal line 2 inches long.
11. Place the French curve so that it touches the center back at the halfway mark, the diagonal line, and the crotch level; draw the back crotch curve as illustrated (Figure 11.33).

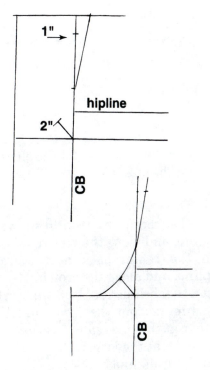

Figure 11.33 / Steps A8–11

12. At the intersection of the center front and the crotch level, draw a diagonal line 1½ inches long.
13. Place the French curve so that it touches the center front at the hipline, the diagonal

Figure 11.32 / Steps A2–7

line, and the crotch level; draw the front crotch curve (Figure 11.34).

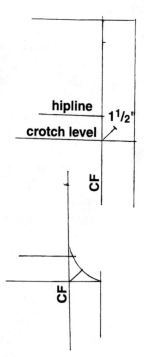

Figure 11.34 / Steps A12–13

14. Add a seam allowance at the crotch curve and trim away excess fabric; clip into the seam allowance along the curve.

B. DRAPING STEPS

1. Pin the center front at the waistline, hipline, and along the crotch.
2. Pin the center back at the waistline, hipline, and along the crotch.
3. Smooth fabric across the front and back at the hipline; pin the front and back together at the side seam. Overlap the front and back at the inseam.
4. Pin the waistline:
 a. For an elasticized or drawstring waistline—smooth fabric straight up from the hipline, divide extra fullness evenly along the waistline, and pin into place.
 b. For smooth pants that will have a waistband and zipper placket or will be cut in one with a top—smooth the fabric up from the hipline at the princess seam; pin at the waistline, gently smoothing toward the side seam, center front, and center back to absorb all fullness.
5. Pin the side seam and overlapped inseam, shaping the legs as desired. When the legs

are very tapered and shaped close to the body, the crotch seam will have to be lowered at the inseam intersection to achieve a smooth fit (Figure 11.35).
6. See the finished pattern (Figure 11.36).

Figure 11.35 / Steps B1–5

Figure 11.36 / Step B6

The Basic Body for Knit Pants without a Side Seam

Loosely fitted pants or tights in a very stretchable, often elasticized knit fabric may be cut without a side seam. When side seams are not used, the waistline is usually elasticized.

A. PREPARATION OF FABRIC

1. Estimate the width from the center back to center front, taking into consideration the extra fullness for loose pants or fabric stretch in tights.
2. Cut the fabric:
 a. Width—the estimated measurement in step 1 plus 12 inches
 b. Length—the distance from the waistline to ankle plus 3 inches
3. Fold the fabric in half lengthwise and baste a lengthwise grain line on the fold to indicate the location of the side seam.

4. Mark the location of the waistline at the side seam 2 inches down from the upper cut edge of the fabric.

5. Baste cross grain lines at the 7-inch hip level and the crotch level (Figure 11.37).

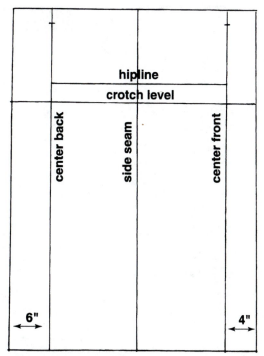

Figure 11.37 / Steps A1–5

6. Determine the crotch level and shape the crotch extensions at the center front and center back; see steps 8 to 13, pages 179–180 (Figure 11.38).

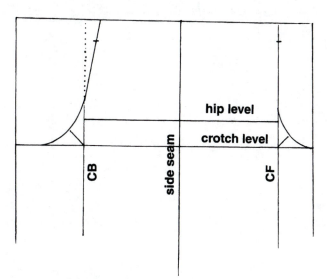

Figure 11.38 / Step A6

B. DRAPING STEPS

1. Pin the lengthwise grain line to the side seam of the pants form from the waistline to ankle.

2. From the side seam, smooth the fabric toward the center front and center back (for loosely fitted pants, leave the amount of fullness desired); pin at the center front and center back at the indicated hipline, making sure the cross grain remains absolutely straight.

3. Pin the back and front crotch lines to the form, leaving ease for loose pants but smoothing around the form with no additional ease for tights (Figure 11.39).

Figure 11.39 / Steps B1–3

4. Shape legs as desired.

5. Remove from the dress form; true the pattern outline and add seam allowance.

6. See the finished pattern (Figure 11.40).

Figure 11.40 / Step B6

12

Tailored Garments

Tailored garments are designed to fit smoothly, giving the illusion of a trim body. This smooth fit is achieved by designing the garment to fit with enough ease so that figure flaws are well hidden. The tailored garment is then characteristically constructed so that the garment can maintain its designed silhouette regardless of the figure beneath.

Tailoring involves the use of shoulder pads of varying thickness to suspend the garment smoothly from the shoulders. Backing, interfacing, and lining impart shape and body. Traditionally, wool-and-hair canvas was pad-stitched by hand into the fronts and the shoulder area of the back of jackets so that the fabric could lie smoothly on the figure. A firmer cotton-and-hair canvas was hand-stitched into collars and lapels. Today, fusible weft interfacing—a soft, pliable open weave fabric—takes the place of the wool-and-hair canvas. It is fused, rather than stitched into place. Fusible tricot with considerable stretch, and fusible non-woven interfacings in a variety of textures from very soft to quite crisp are also available, and they are used for backing and interfacing.

Toile muslin, a heavy-weight, firmly woven fabric, is usually used to drape tailored garments. This fabric has a similar body to the actual fabrics that are used for tailoring and helps in visualizing the finished product.

Preparation of the Dress Form for Tailored Garments

A. Pin the shoulder pads to the dress form so that they extend at least ½ inch beyond the armhole ridge and are centered on the shoulder seam.

B. Tape the dress form:
1. Hipline—9 inches down from the waistline at the center front. Tape from the center front to center back. If the lower edge of the torso is parallel to the floor, this edge may be used as a guide.
2. Bustline—from apex to apex and continuing to center back parallel to the hipline.
3. Shoulder seam—beginning at the shoulder seam and neckline intersection, the tape should extend over the shoulder pad and through the plate screw to the side seam.
4. Princess seam—from the front over the shoulder pad to the back as illustrated (Figure 12.1).

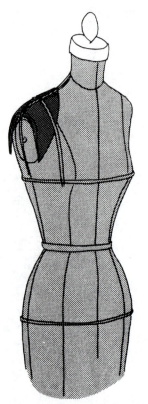

Figure 12.1 / Steps A/B1–4

The Basic Jacket

The basic tailored jacket is based on the man's suit coat. It is shaped to a greater or lesser extent away from the body. Uniquely placed seams and darts are used to achieve this shaping. A panel originating at the front and back of the armhole usually replaces the side seam. Additional darts may be placed below the bust for a closer fit to the body (Figure 12.2).

A. Side panel—Starting approximately ¾ inch below the screw level at the front and back of the armplate, tape the outline of the side panel. After the jacket has been draped and ease has been added, the panel will be wider (Figure 12.3).

Figure 12.2 / Basic jacket

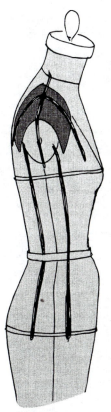

Figure 12.3 / Step A

6. Draw the center front grain line 3 inches from the right torn edge of the front panel.
7. Draw the center back grain line 1 inch from the left torn edge of the back panel (Figure 12.4).

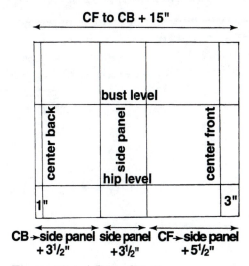

Figure 12.4 / Steps B1–7

8. Separate the panels, cutting along the grain lines (Figure 12.5).

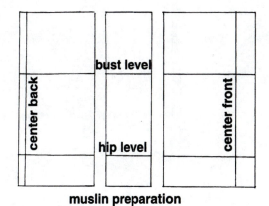

Figure 12.5 / Step B8

B. PREPARATION OF MUSLIN

 1. Tear the muslin:

 a. Length—from the top of the neck band to the hipline plus 6 inches

 b. Width—from the center front to center back at the hipline plus 15 inches

 2. Draw a cross grain line for the hip level 4 inches up from the lower torn edge of the muslin.

 3. On the dress form, measure the distance from the apex to the hip level; draw the bust level cross grain line on the muslin.

 4. Determine the width of the front, the back, and the side panels:

 a. For the front panel, measure the distance from the center front to the side panel seam and add 5½ inches.

 b. For the back panel, measure the distance from the center back to the side panel seam and add 3½ inches.

 c. For the side panel, measure the width of the side panel at the hipline and add 3½ inches.

 5. On the muslin, draw the lengthwise grain lines to indicate the front, side, and back panels. Cut along the grain lines.

C. DRAPING STEPS

 1. Place the muslin front and back onto the dress form with grain lines aligned with the tapes on the form. Pin along the bust level at the apex, center front, center back, and side panel seams. Leaving ease, pin at the hip level at the center front, side panel seams, and center back.

2. Pin at the neckline, at the center front, and at the center back.

3. Keeping the cross grain straight, smooth the front muslin over the shoulder.

4. Smooth some of the excess fullness above the bust level into a neckline dart. This dart should be approximately 1⅜ inches from the center front at the neckline and should end at least 2 inches above the apex. Shape the neckline, leaving enough ease for a pinch of approximately ⅛ inch. Some fullness is also shifted to the lower part of the armhole to be absorbed by the side panel seam when the body of the jacket is shaped (Figure 12.6).

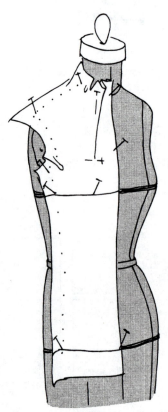

Figure 12.6 / Steps C1–4

5. Drape the back neckline and shoulder seam, shifting the muslin ¼ inch off center at the center back. Leave approximately ¼-inch ease in the back shoulder seam.

6. Pin the front and back shoulders together with the seam allowance extended. Trim away excess muslin (Figure 12.7).

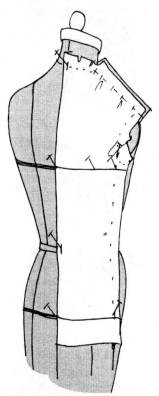

Figure 12.7 / Steps C5–6

7. Place the side panel with the cross grain lines at hip and bust level aligned with the front and back panels into position. Pin the side panel to the side seam at the armplate and the hipline. Cut away some of the excess muslin at shoulder level. Letting the seam allowance extend outward, pin the side panel to the front and back panels, shaping the jacket as desired. Maintain at least 3 inches of ease at the underarm and 4 inches of ease at the hipline.

8. If more shape is desired, add a front dart and/or shape the center back seam in slightly at the waistline.

9. Determine a temporary armhole with style tape—½ inch back from the edge of the shoulder pad at the top of the shoulder, ½ inch beyond the armplate at the shoulder blade level, and lowered at the side seam according to the measurements

shown on the following table. Measure the armhole depth down from the armhole ridge, over the center of the armplate to the side seam. Mark lightly.

ARMHOLE DEPTH FOR BASIC JACKETS

SIZE	6	8	10	12
ARMHOLE DEPTH	6¼	6⅜	6½	6⅝

10. Mark the neckline and shoulder; mark the seams and darts (Figure 12.8).

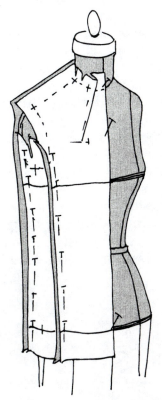

Figure 12.8 / Steps C7–10

11. Remove the jacket body from the dress form and true the seams and darts; cross-mark seams as illustrated.

12. True the neckline, lowering it ¼ inch at the center back, ¼ inch at the shoulder seam, and 1 inch at the center front.

13. True the armhole. Leaving the underarm at the side seam on grain for approximately ¾ inch, use the Fairgate Vary Form curve to shape the armhole as illustrated (Figure 12.9).

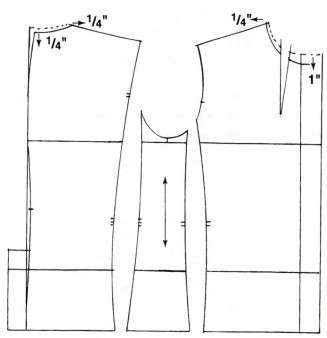

Figure 12.9 / Steps C11–13

14. If desired, add additional muslin below the waistline at the center back seam for a vent. Add seam allowances and cut out. This type of jacket is usually made with a notched collar that is developed after the body has been completed. See the finished pattern (Figure 12.10).

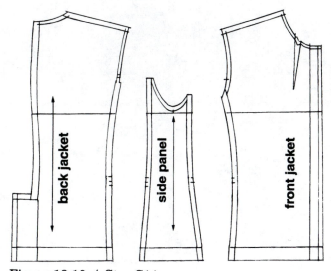

Figure 12.10 / Step C14

15. Tailored garments must be carefully fitted before the pattern is perfected. To prepare for a muslin fitting:

a. Trace the outline of the pattern pieces for the interfacing as illustrated.

b. Duplicate all pattern pieces for the right side of the garment.

c. Apply fusible weft interfacing to the fronts, the top of the side panels, the hem, and the back vent as illustrated.

d. Apply a secondary piece of fusible interfacing in the front shoulder and armhole area.

e. Sew percaline, a lightweight woven interfacing cut on the bias, to the upper section of the back. Let the lower edge of the percaline hang free. (Fusible weft interfacing may also be used if percaline is not available.)

f. Sew tape around the armholes and neckline, along shoulder seams, and at the front edge of the pattern pieces as illustrated. If the front seam that joins the front to the side panel has any bust ease, tape the seam at the side panel where it has to be absorbed (Figure 12.11).

g. Apply fusible interfacing to the collar and wherever else the garment might need support.

h. Sew the garment pieces together with a large machine stitch that can easily be removed if adjustments are needed.

i. Insert the shoulder pads.

16. Replace the jacket on the dress form; check the fit and make any necessary adjustments before drafting the sleeve.

The Basic Princess Jacket

By draping a basic princess jacket, designers can achieve precisely the silhouette they desire. Princess seams permit shaping and molding the jacket with exactly the amount of ease or close fit demanded by fashion. Princess seams also help to achieve perfectly straight and balanced grain. Once the princess jacket has been perfected, it can serve as a foundation pattern for other tailored jackets. The princess seams can be shifted, or they can be manipulated into darts. Various collars or pockets can be developed and incorporated into the design, and the jacket can be shortened or lengthened to the correct proportion required by the total ensemble (Figure 12.12).

Figure 12.11 / Step C15

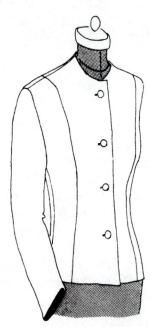

Figure 12.12 / Princess jacket

A. PREPARATION OF MUSLIN

1. Tear muslin:
 a. Length—the distance from the top of the neckband to the hipline plus 6 inches
 b. Width—divide a full width (approximately 45 inches wide) of muslin into 4 equal pieces

2. Draw the grain lines:
 a. Center front and center back panels—lengthwise grain 1 inch from the torn edge for center front and center back.
 b. Side panels—lengthwise grain in the center of each panel.
 c. All panels—crosswise grain for the hipline 4 inches up from the lower edge; crosswise grain for the bustline, measure the distance from the hip to bust level (Figure 12.13).

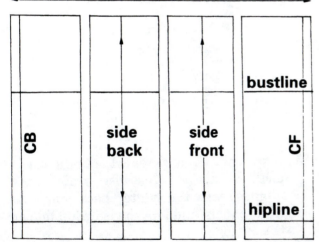

Figure 12.13 / Steps A1–2

3. Turn under 1-inch seam allowance at the center front and center back.

B. DRAPING STEPS

1. Pin the center front panel to the apex.
2. Keeping the cross grain straight throughout the panel, smooth up toward the shoulder and pin the center front at the neckline, chest, below the breast, and the hipline.
3. Pin at the hipline and princess seam, leaving approximately ½-inch ease in the panel.
4. Drape the neckline, slashing the muslin and leaving enough ease for a pinch—approximately ⅛ inch.

5. Leaving approximately 2 inches beyond the projected princess seam, trim away any excess muslin.
6. Slash into the 2-inch extension at the princess seam, above and below the bust level grain line and at the waistline. Mark the shoulder seam and neckline (Figure 12.14).

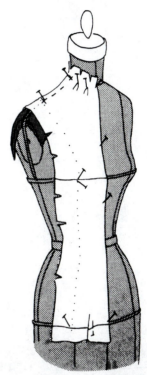

Figure 12.14 / Steps B1–6

7. Place the side front panel onto the dress form so that the cross grain lines are aligned to the cross grain lines on the center front panel, and the straight grain line is centered on the princess panel of the dress form. At the hip level, pin at the princess line and side seam, leaving approximately ½-inch ease. Above the bust level, smooth the muslin up to the shoulder, leaving a small amount of ease in the armhole area.
8. Along the princess line, pin the side front panel over the center front panel, slashing the muslin above and below the bustline and at the waistline.
9. Leaving about 2 inches beyond the projected princess seam and along the shoulder, trim away any excess muslin.

Mark the position of shoulder seam (Figure 12.15).

the excess muslin. Clip into the seam allowance from the bust level grain line to the hipline (Figure 12.16).

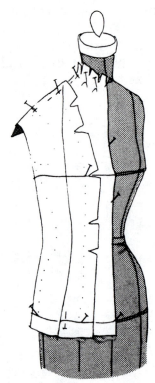

Figure 12.15 / Steps B7–9

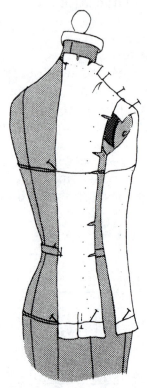

Figure 12.16 / Steps B10–14

10. Position the center back panel onto the dress form, aligning cross grain lines at the hipline and bust level with the tapes on the dress form. Pin into place.
11. Drape the back neckline, slashing the muslin as necessary. To eliminate the neckline dart, let the muslin shift ¼ inch into the center back seam at the neckline. Leave enough ease for a pinch—same as for the front neckline.
12. Smooth the center back panel up over the shoulder pad with ⅛-inch ease on the shoulder seam.
13. Pin at the hipline and princess seam leaving approximately ½-inch ease at the hip level.
14. Leaving approximately 2 inches beyond the projected princess seam, trim away

15. Place the side back panel onto the dress form with the crosswise grain lines aligned with the center back and side front panels, and lengthwise grain line at the center.
16. Pin into place overlapping the center back panel, allowing ⅛-inch ease at the shoulder and ½-inch ease at the hip level. Maintain the ease on the cross grain throughout the panel. Pin the side seam together with the grain balanced.
17. Pin the shoulder seam together, making sure that the back shoulder is ¼ inch longer than the front shoulder.
18. At the shoulder and side seams, trim away excess muslin, leaving approximately 1½ inches (Figure 12.17).

22. Leaving all the seams pinned together and the princess seam style tape in place, carefully remove the muslin from the dress form.

23. Trim away excess muslin at the princess seams and side seam to 1 inch so that the silhouette can more easily be evaluated.

24. Replace the jacket on the dress form before marking the seams to make any necessary adjustments.

25. Determine a temporary armhole with style tape—½ inch back from the edge of the shoulder pad at the top of the shoulder, ½ inch beyond the armplate at the shoulder blade level in the back, and 1¼ inches down from the armplate at the side seam. Mark lightly (Figure 12.18).

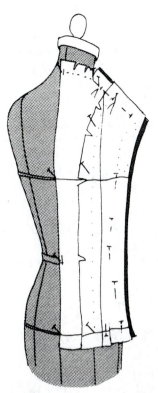

Figure 12.17 / Steps B15–18

19. Shape the front and back of the jacket at the side seam and the princess seam overlap as desired. Slash the muslin where necessary, and carefully maintain the balanced cross grain as the jacket is shaped. The center back seam may also be slightly shaped in at the waistline. Remember that most jackets must fit without strain over a blouse or sweater and skirt; therefore, maintaining adequate ease is essential. At least ½ inch of ease should be in each panel at the lower edge of the jacket. The side seam should extend 1 inch beyond the dress form at the armhole.

20. Using style tape over the muslin, determine the placement of the princess seam from the shoulder, 1 inch to the side of the apex, and down to the lower edge of the jacket. The princess seam of the jacket will not follow the princess seam of the dress form.

21. Mark the neckline.

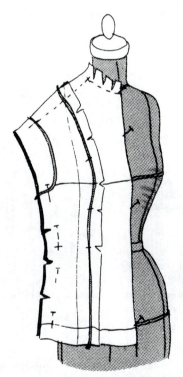

Figure 12.18 / Steps B19–25

26. Mark all seams. Mark the overlapped princess seams by marking at the edge of the style tape and turning back the upper layer in order to mark the lower layer.

27. Crossmark seams:
 a. Center back—3 notches in the center of the seam
 b. Back princess seam—2 notches, 3 inches apart, just below the shoulder blade level
 c. All seams—1 notch at the waistline
 d. Front princess seam—1 notch at the bustline, one notch 2½ inches above, and 1 notch 2½ inches below the bustline
28. Remove the jacket from the dress form and true all seams.
29. True the neckline, lowering it ¼ inch at the center back, ¼ inch at the shoulder seam, and 1 inch at the center front.
30. True the armhole, leaving the underarm extension at the side seam on grain for approximately ¾ inch. Use the Fairgate Vary Form curve to shape the armhole.
31. See the finished pattern (Figure 12.19).

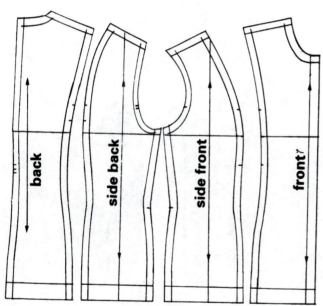

Figure 12.19 / Finished pattern

32. Prepare the muslin for fitting the same as for the basic jacket. Front and back princess seams should be pinned together above the apex before cutting the interfacing.
33. Replace the jacket on the dress form; check the fit and make any necessary adjustments before drafting the sleeve.

The Two-Piece Jacket Sleeve

The traditional tailored jacket sleeve is cut in two pieces, permitting subtle shaping that conforms to the forward bend of the arm below the elbow. The cap of the sleeve fits smoothly into the armhole, with just the right amount of ease so that the sleeve hangs straight with no pull or excessive fullness. The sleeve must be cut wide enough to comfortably accommodate a blouse or sweater to be worn under the jacket.

SLEEVE MEASUREMENTS FOR THE TWO-PIECE JACKET SLEEVE

SIZE	6	8	10	12
SLEEVE LENGTH	23	23½	24	24½
CAP HEIGHT	6⅛	6¼	6⅜	6½
BICEPS CIRCUMFERENCE	14	14½	15	15½

A. DEVELOPING THE TWO-PIECE JACKET SLEEVE
 1. Fold a large sheet of paper in half.
 2. On the fold, mark the appropriate sleeve length.
 3. Square the lines up from the fold for the top of the sleeve and the wrist.
 4. Measure the cap height down from the top of the sleeve, and square a line up from the fold at this point for the biceps level.
 5. Establish the elbow level by dividing the underarm length in half, and indicating the elbow level 1 inch above the halfway mark (Figure 12.20).

Figure 12.20 / Steps A1–5

6. Mark one half the biceps circumference on the biceps line.
7. The *wrist circumference* of a jacket sleeve usually measures *10½ inches.* Mark one half the wrist circumference on the wrist line.

8. Connect the wrist with the biceps and extend the line to the top of the sleeve (Figure 12.21).

Figure 12.21 / Steps A6–8

9. Add a 1-inch extension at the underarm and a 1½-inch extension at the bottom of the sleeve, and cut out the sleeve.
10. Open the sleeve; draw a line for the center of the sleeve; draw the other underarm line; and complete the other half of the biceps line, the elbow, and the wrist (Figure 12.22).

Figure 12.22 / Step A10

B. TO SHAPE THE CAP
1. At the top of the sleeve, mark off 2 inches at each side of the center.
2. On the biceps line, mark off ⅝ inch from the underarm seam at the back and 1¾ inches from the underarm seam at the front of the sleeve. Connect these points with the 2-inch marks at the top of the sleeve (Figure 12.23).

Figure 12.23 / Steps B1–2

3. Using the Fairgate Vary Form curve, shape the cap as illustrated. The edge of the cap should measure 1 to 1½ inches larger than the armhole (Figures 12.24 and 12.25).

Figure 12.24 / Step B3

Figure 12.25 / Step B3

4. Cut out the sleeve cap.
5. Crossmark the sleeve cap: one crossmark, 3 inches from the underarm seam in front; and 2 crossmarks, ½ inch apart,

3 inches from the underarm seam in back (Figure 12.26).

Figure 12.26 / Step B5

C. TO SHAPE THE ELBOW

1. Trace the center of the sleeve and the biceps and elbow lines to the other side of the sleeve. Fold the sides of the sleeve to the center, overlapping the extensions as illustrated (Figure 12.27).

Figure 12.27 / Step C1

2. Open the sleeve, and on the elbow line, slash the back and front of the sleeve to the fold.
3. At the wrist, place a mark 1½ inches from the center toward the front of the sleeve. Draw a line from this point to the center of the sleeve at the elbow and trace to the other side of the paper. This line is the new center of the sleeve (Figure 12.28).

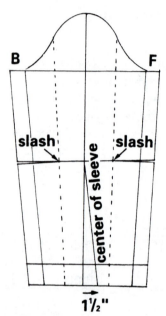

Figure 12.28 / Steps C2–3

4. Refold the lower part of the sleeve, bringing the sides to the new center and letting the back sections overlap at the elbow. The front sections will spread at the elbow.
5. Tape the sleeve into the folded position along the underarm seam and the back overlap.
6. Square off the wrist of the sleeve by adding approximately ¾ inch to the length of the back fold and connect this point to the wrist at the front fold (Figure 12.29).

7. Cut away excess paper.
8. Draw the seam lines as illustrated:
 a. Back—½ inch from the fold at the cap curving to the fold at the elbow.
 b. Front—2 inches from the fold at the cap, and using the straight end of the hip curve, draw a gently curving line to a point 1 inch from the fold at the wrist. Place crossmarks in the front seam, 3 inches down from the cap, and 4 inches up from the wrist.
9. Draw a grain line on the underarm section by tracing the original center of the sleeve line (Figure 12.30).

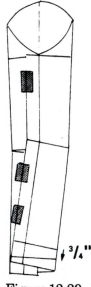

Figure 12.29 / Steps C4–6

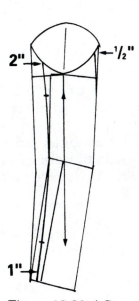

Figure 12.30 / Steps C7–9

10. Trace the underarm section to another piece of paper.

11. Cut the sleeve draft at the seam lines, and trace the top-of-sleeve section to another piece of paper.
12. On both sleeve sections:
 a. Back seam—add ¼ inch at the biceps level, and take away ½ inch at the wrist.
 b. Front seam—add ½ inch at the wrist tapering to nothing at the elbow.
13. Using the hip curve, blend seams as illustrated (Figure 12.31).

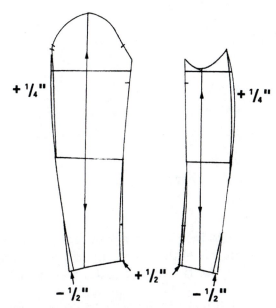

Figure 12.31 / Steps C10–13

14. At the wrist of both sections, add a 1½-inch hem. On the undersleeve section, add an extension for the placket at the back wrist 4 inches long by 1½ inches wide. At the extension, add ¼ inch at the hem for 3 inches as illustrated.
15. On the upper sleeve section, add a turn back for the placket at the back wrist 4 inches long by 1½ inches wide. Leaving ¼-inch seam allowance, cut off the corner at the hem at a 45-degree angle in order to form a miter

when the sleeve vent is finished (Figure 12.32).

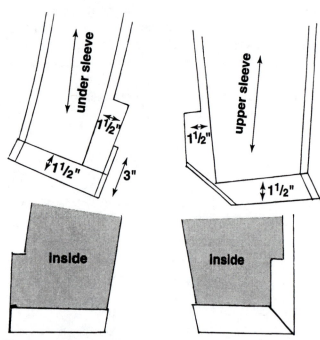

Figure 12.32 / Steps C14–15

16. Add ½-inch seam allowance all around both sections of the sleeve, and cut out the pattern. See the finished pattern (Figure 12.33).

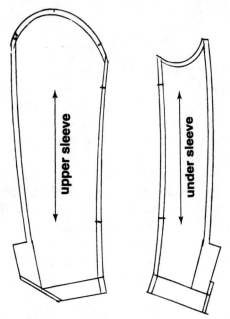

Figure 12.33 / Finished pattern

17. Transfer the sleeve pattern to muslin; add the seam allowances and a 1½-inch hem. Cut out and baste the sections together. The front seam of the top-of-sleeve section must be stretched to fit the underarm section.

18. Ease the cap to flannel bias tape, and set the sleeves into jacket.

19. Fit the jacket on the dress form or, preferably, a live model.

The Jacket Lining

Almost all tailored jackets are lined, for several reasons. Linings lend additional body to a jacket. Sliding in and out of a jacket is easier when it has a smooth lining, and the lining gives a jacket a clean finish, hiding all interfacings and seams.

The lining has to conform to the shape of the jacket, but if the jacket has seams that are only decorative, they need not be repeated in the lining. Sometimes a seam in the jacket can be replaced in the lining by a dart or a pleat. The center back seam of the jacket is replaced with a 1¼-inch pleat.

The lining does not reach to the edges of the jacket. The front opening and neckline are always faced to the shoulder seam in the fabric of the jacket. When the jacket has a collar, the back lining may reach to the neckline, but in better apparel and always for cardigan jackets, the back neckline is also faced in the jacket fabric. (See facings, pages 200–201). Linings are seamed to the inside edge of the facing.

A. TO CUT A LINING—Trace the jacket pattern with the following corrections:
 1. Front:
 a. Place the front facing over the lining pattern and trace the facing seam line without the seam allowance.
 b. Cut the lining pattern 1 inch shorter than the jacket pattern.
 (1) At the front side seam and armhole intersection, measure up ¼ inch and out ⅛ inch.
 (2) Blend extensions into the armhole and side seam as illustrated (Figure 12.34).

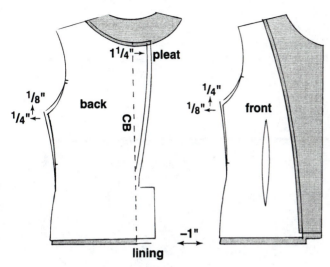

Figure 12.34 / Steps A1(a–d)

c. Side panel:

(1) Shorten the lining pattern 1 inch.

(2) At the front side seam and armhole intersection, measure up ¼ inch and out ⅛ inch. Blend the extensions into armhole as before.

NOTE: For a jacket lining without a side panel, the armhole extension is made at the side seam front and back.

d. Back:

(1) Shorten the lining pattern 1 inch.

(2) Place the back neck facing over the lining pattern and trace the facing seam line without the seam allowance.

(3) At the center back, add a 1¼-inch pleat extension from the neckline to the waistline as illustrated (Figure 12.34).

e. Sleeve:

(1) Shorten both the upper sleeve and undersleeve patterns 1 inch.

(2) At the front upper sleeve and front undersleeve seam and armhole seam intersections, measure up ¼ inch and out ⅛ inch. Blend extensions into the armhole and sleeve seam as illustrated (Figure 12.35).

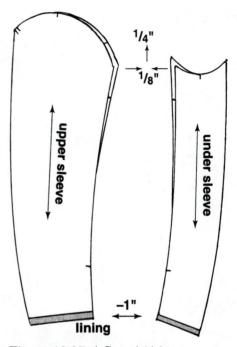

Figure 12.35 / Step A1(e)

f. Add a ½-inch seam allowance on all seams. The traced facing seams on the front and back are the edge of the lining.

13

Functional
Finishes

Facings are used to finish the edge of fabric when hems are impractical. Curved and irregularly shaped edges should be faced. Necklines, armholes, and collars are almost always finished with facings.

Facings

A. TO CUT A FACING

1. Prepare a piece of muslin large enough to cover the area of the rough edge that is to be finished.
2. Place the pattern piece of the area that is to be finished over the prepared muslin for the facing. Close any darts that are in the area to be faced. The grain of the facing must match the grain of the garment pattern.
3. Trace the outline of the neckline or armhole as well as at least 2½ inches of the intersecting seams (Figure 13.1).

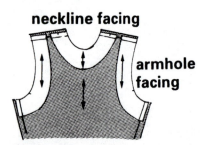

neckline facing

armhole facing

Figure 13.1

4. Remove the garment pattern and complete the outer edge of the facing. Facings should be at least 2½ inches wide, but they must not go beyond the vanishing point of any dart.
5. In order to keep the facing inside the garment, both the neckline and armhole circumference of the facing should be approximately ½ inch smaller than the neckline and/or armhole circumference of the garment. To reduce the size of the facing, take off ⅛ inch at the shoulder seams or the underarm seams of the facing.

6. Seam allowances on facings should be one half the width of the seam allowances on the garment. Add seam allowances and trim away excess muslin.

All-in-One Facing

All-in-one facings are used on sleeveless garments with deep necklines and narrow shoulders. Cut as illustrated (Figure 13.2).

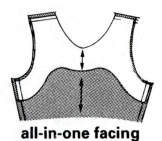

all-in-one facing

Figure 13.2

Deep Diagonal Facing

On a deep diagonal neckline, facings cut with the grain position as illustrated will prevent stretching of the neckline (Figure 13.3).

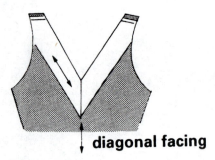

diagonal facing

Figure 13.3

Bodice Front Facing

For a bodice with a front closure, cut the facing from the shoulder to the waistline so that it measures at least 2½ inches at the shoulder seam and 2½ inches from the center front at the waistline (Figure 13.4).

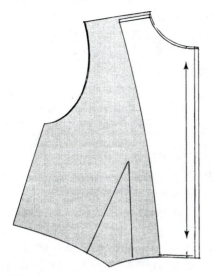

Figure 13.4

Jacket Facing

The jacket facing follows the outline of the front from the shoulder to the hemline. The facing reaches to approximately the center of the shoulder and should be 3 inches wide reaching from the center front to the lining seam. It should overlap 1½ inches with the hem of the jacket at the hemline (Figure 13.5).

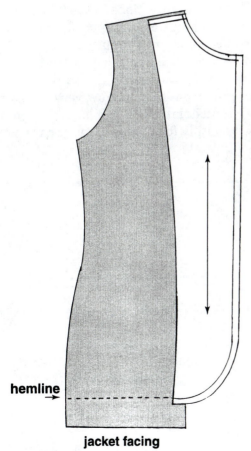

hemline →

jacket facing

Figure 13.5

Waistbands

Skirts and pants that end at the waistline are usually finished with a waistband. It is a folded band of fabric cut to fit snugly, but without binding, around the waistline. The waistband is usually interfaced so that it is firm enough to hold the skirt or pants securely in place. Waistbands can be styled and shaped in various ways (Figure 13.6).

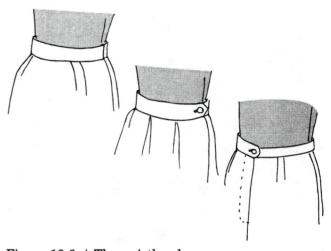

Figure 13.6 / The waistband

The Standard Waistband

A. PREPARATION OF THE MUSLIN

1. Measure the waistline circumference and add ⅝ inch for ease.
2. Decide on the width of the waistband. Standard waistbands are usually 1¼ inches wide, although they may be wider or narrower as desired.
3. Cut the muslin:
 a. Lengthwise grain—waistline circumference measurement with 1 inch added for ease, plus 1¼-inch extension
 b. Crosswise grain for standard waistband—3½ inches
4. On the muslin, draw a lengthwise grain line at the center of the muslin for the upper folded edge.
5. Draw lengthwise grain lines 1¼ inches from the center-fold line on each side of the center.
6. For a side opening, starting at the left end of the waistband:
 a. Mark off ½ inch for the seam allowance with a cross grain line.

b. Mark off 1¼ inches for the underlap with another cross grain line.

c. From the underlap line, mark the back waistline plus ½-inch ease with a crossmark. This mark indicates the location of the side seam.

d. From the side seam crossmark, mark the front waistline plus ½-inch ease with a cross grain line.

e. Indicate the center front and center back with crossmarks (Figure 13.7).

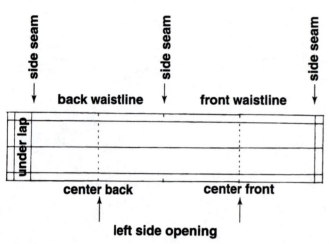

Figure 13.7 / Steps A6(a–e)

7. For a center back opening:

a. Mark off ½ inch with a cross grain line for the seam allowance.

b. From the cross grain line, mark one half the back waistline measurement plus ¼ inch for the ease with a crossmark for the side seam.

c. From the side seam, mark the front waistline measurement plus ½ inch for the ease with a crossmark for the other side seam.

d. From this crossmark, mark one half the back waistline measurement plus ¼ inch for the ease with a cross grain line; add 1¼ inches for the underlap and finish with another cross grain line.

e. Indicate the center front with a crossmark (Figure 13.8).

To drape a shaped or contoured waistband, see the fitted midriff (page 110).

Closures

Most items of apparel, if they are not wrapped around the body, need an opening in order to get into them. These openings need some sort of closure, and the closure, although basically functional, also provides an opportunity for design. The type of closure selected for a garment must be considered before the draping process can begin. Closures affect the muslin preparation if extensions for overlap and cut-in-one facings are needed. The draping requirements of the most common closures are discussed in this section.

Zippers

Probably the most frequently used device for closing a garment is the zipper. It is also the most functional. Unless deliberately decorative, zippers can be inconspicuously hidden from view. Available in many weights and unlimited colors, zippers can be matched to the fabric so that when closed, they appear no different from an ordinary seam. Except for variations in the width of seam allowances for different applications, zippers have no special draping requirements.

Zippers are made in various materials. Originally, only metal was used and sturdy metal zippers, ranging from fine, narrow, very lightweight to heavy industrial types, can be depended upon to work smoothly for the life of the garment. Wide

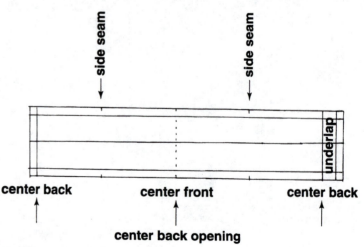

Figure 13.8 / Steps A7(a–e)

metal zippers are often used for decorative effect in outerwear, especially in leather jackets. Zippers made of nylon are very lightweight, but they do not always work as smoothly as those made of metal. Also, wide plastic zippers in various colors can be very decorative.

Four types of zippers are available; each type serves a distinct purpose. The ordinary zipper that is securely held together at one end with a prong is used most often. It is used for neck openings in dresses as well as in skirt and pants plackets. The placket zipper, which is held together at both ends with prongs, is used in side seam dress plackets and in pocket openings. The invisible zipper is uniquely constructed, so that when it is sewn into a seam, no stitches show on the outside, and it becomes invisible when the zipper is closed. Separating zippers (that separate completely) are usually heavyweight and are useful in jackets and coats (Figure 13.9).

All these zippers, except the invisible type, can be applied in several ways:

1. LAPPED OR WELT—The zipper is inserted so that it lies to one side of the seam, with the seam allowance forming a slight extension on the opposite side permitting the zipper to be completely hidden. The side covering the zipper overlaps the extension, and the topstitch that holds the zipper in place forms a ⅜-inch welt. The lapped or welt application is usually used for the side openings in skirts and slacks. Occasionally, this application may also be used for the front or back opening in dresses. A 1-inch seam allowance is required at the zipper area.

2. FLY—The zipper inserted under a fly is similar to the welt zipper, except that the fly forms a much wider welt. A separate facing is used to finish the edge of the fly, and a separate extension is inserted under the zipper. Usually used for the front opening of slacks, this application is based on the construction of men's trousers. Occasionally, fly fronts with separating zippers are also used to close coats and jackets. When separate facings and extensions are used, no special seam allowances are needed.

3. CENTERED OR SLOT—The zipper is inserted so that it is centered behind the seam. It is topstitched into place with the stitching even on both sides approximately ¼ inch from the edge. The centered or slot zipper application is usually used for neck openings. A ¾-inch seam allowance is required in the zipper area.

4. INVISIBLE—The unique construction of this zipper, combined with a special sewing technique, results in an application that hides all stitches. When the zipper is closed, it looks like a smooth seam. This zipper can be used as a closure for neckline openings as well as skirt and slacks plackets. A ½-inch seam allowance is sufficient.

Buttons and Buttonholes

When buttons and buttonholes are used to close garment openings they are a significant design

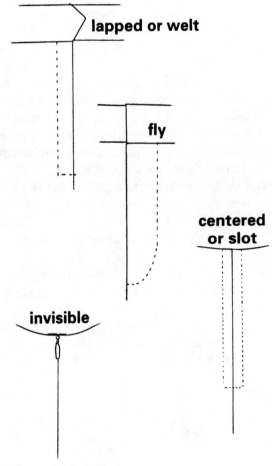

Figure 13.9 / Zippers

feature and must be carefully planned. The buttons selected, as well as their placement on the garment, affect the proportion and impact of the design. Buttons are made of various materials. Fine buttons made of bone, mother of pearl, leather, metal, and beautiful jeweled designs often become an essential ingredient of the design. By far the greatest number of buttons used, however, are of relatively inexpensive plastic in all colors and sizes.

When a button closure is to be part of the design, it must be taken into consideration as muslin is prepared for draping. Because buttons and buttonholes require an overlap of fabric in order to function, fabric extensions must be planned on both sides of the projected opening. The width of the extension depends on several factors: the size of the button, the weight and texture of the fabric, and whether the garment is to be single- or double-breasted. The minimum width for an extension is the diameter of the button; more is usually needed for bulky fabrics, especially on jackets and coats. In addition, when the edge of the extension is straight (on the grain), the facing is usually cut in one with the garment and requires special consideration.

A. PREPARATION OF MUSLIN WITH BUTTON CLOSURE AND CUT-IN-ONE FACING
1. Plan the width of the facing—If the facing is to reach to the shoulder, it should be at least 2½ inches finished at the shoulder seam. Otherwise, a 2½-inch to 3-inch facing is sufficient.
2. Plan the width of the extension—The minimum width of the extension equals the diameter of the button. Double the width of the extension, and the width of the facing is added to the center front of the garment.
3. Tear the muslin—The same as is usually required by the design of the garment, plus extensions and facing.
4. Draw the grain lines:
 a. Width of the facing

b. Two times the width of the extension
c. Center front (Figure 13.10)

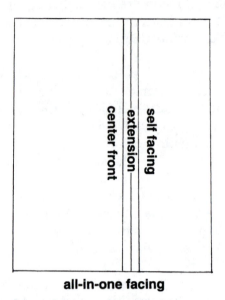

all-in-one facing

Figure 13.10 / Steps A4(a–c)

B. PREPARATION OF MUSLIN WITH BUTTON CLOSURE AND SEPARATE FACING
1. Tear muslin—The same as is usually required by the design of the garment, except at the edge where the button closure will be. Add the width of the extension and the width of the seam allowance. When a garment is designed to be double-breasted, the edge of the overlapping side should be taped on the dress form, and the distance from the center front becomes the width of the extension.
2. Plan the width of the facing—If the facing is to reach to the shoulder, it should be at least 2½ inches finished at the shoulder seam. Otherwise, a 2½-inch to 3-inch facing is sufficient.
3. At the lengthwise edge of the muslin, estimate the width of the extension plus seam allowance. Draw a grain line, the width of the extension and seam allowance, parallel to the edge of the muslin. This line is the center front (Figure 13.11).

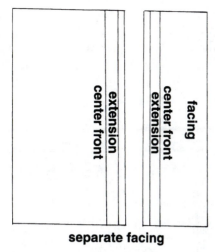

separate facing

Figure 13.11

When buttons are hidden under a fly front, the left side of the garment, where the buttons will be sewn, is handled the same as above, but the right side has only 2 times the width of the extension added. The right side facing with 2½ times the width of the extension is cut separately. Vertical buttonholes are worked into the extension, and then this piece is joined to the right bodice as illustrated (Figure 13.12).

The spacing of buttons and buttonholes depends on several factors. The design of the gar-

ment and the size of the buttons must certainly be considered. In garments that are fitted close to the body, place a button where special stress might occur such as at the waistline and the bust level. The top button at the neckline should be placed so that the edge of the button is at least ¼ inch from the finished neckline edge. The rest of the buttons should be evenly and appropriately spaced in between.

The placement of the buttons is marked with a dot directly on the center front line of the left side of the garment. The buttonhole is marked on the right side of the garment with a horizontal line that is 1/16 inch longer than the diameter of the button. High domed or jeweled buttons may need slightly larger buttonholes. A ¼-inch vertical line at each side of the buttonhole marking will leave no doubt as to the precise length of the buttonhole. To keep the buttoned button exactly at center front, the buttonhole is placed ⅛ inch beyond the center front line (Figure 13.13).

Figure 13.12

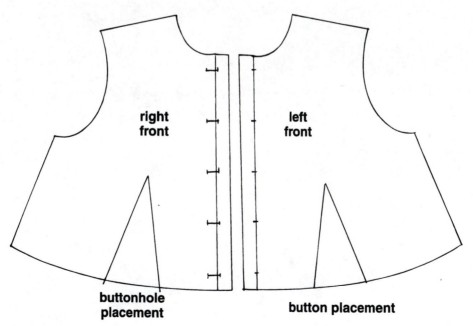

Figure 13.13

Velcro®

Velcro is a secure, adjustable closure that is simple to use. It is probably the safest and easiest of all fasteners to handle, and it is particularly suitable for childrenswear or clothing for the disabled. It consists of two tapes with fibers projecting from the surface that when pressed together form a closure that can only be opened when the tapes are pulled apart.

One side of one tape is made of minute hooks; the opposite tape has a side with a fuzzy, looped surface (Figure 13.14). Velcro is available by the yard or in patches of various sizes. When patches are used, they do not affect the flexibility or stretch properties of the fabric.

When planning a Velcro closure, prepare facings the same as for buttons and buttonholes. Velcro provides a concealed closure when stitched to the facing or waistband before these are joined to the garment. The hook side of the Velcro is stitched to a garment so that it faces away from the body (Figure 13.15).

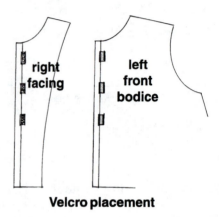

Velcro placement

Figure 13.15

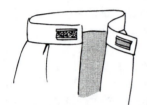

Figure 13.14 / Velcro

14
Pockets

Women have become accustomed to pockets. An item of apparel that does not have a functional pocket as part of its design is difficult to sell. At work or at play, carrying a handbag is often inconvenient, and pockets are needed for keys, money, and other essentials. Dresses, skirts, slacks, and especially jackets and coats, need pockets. Pockets can be important design features, but if they become intrusive, strictly functional pockets can be inconspicuously hidden in a seam.

Although the pattern pieces needed for pockets are usually drafted on the flat, considering the placement and size of pockets when draping is important. Pockets must be in proportion to the rest of the design, and they can be outlined with style tape when the muslin is on the dress form. Plenty of ease must also be in a garment wherever a pocket is planned. The garment should have at least enough ease, and the pocket itself should be large enough, to put your hand inside the pocket and to carry a few needed items.

In-Seam Pockets

Usually set into the side seam on both sides of a skirt or slacks, in-seam pockets are not visible and are truly functional. The pattern is very simple. It consists of two pieces: the front and the back of the inside pocket. When the garment has a waistline seam, the upper edge of the inside pocket is suspended from the waist, and the opening of the pocket is approximately 1½ inches below the waistline. In a shift or princess garment, the pocket is only attached to the side seam. The pocket opening must measure at least 5½ inches, and the inside pocket should be approximately 6 inches wide and 10 inches deep (Figure 14.1).

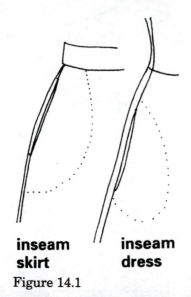

inseam skirt **inseam dress**

Figure 14.1

Patch Pockets

Patch pockets are created by sewing a piece of fabric over an area of the garment. The pocket is topstitched or blind-stitched on three sides with the upper edge finished and left open. Patch pockets can be placed anywhere, and they are often used as breast pockets in shirts and shirtwaist dresses.

There are several variations of patch pockets: the *simple patch pocket,* in which the opening is finished with a plain hem; the *cuffed pocket,* finished with a cuff; the *flap pocket* in which a separate flap, attached to the body of the garment, buttons over the opening of the pocket; the *kangaroo pocket,* with an inverted pleat at the center and an opening that is finished with an outside facing or a cuff; and the *pouch pocket,* which can be gathered or pleated and is finished with a binding or a band (Figure 14.2).

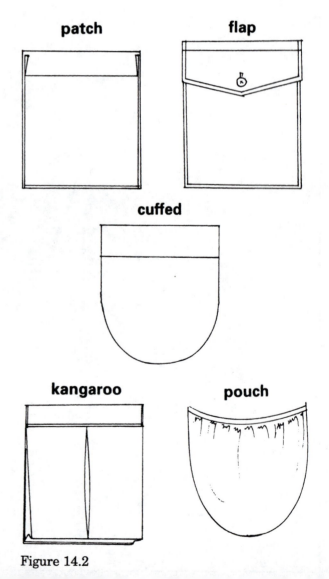

Figure 14.2

Stylized patch pockets can take various shapes and can become the focal point of a design. When the outside edge of a pocket becomes too complex for conventional machine stitching, it may be appliqued into place. Appliqued patch pockets are usually reinforced entirely with fusible interfacing.

Slash Pockets

The slash pocket is simple to construct. The pocket must be suspended from a seam. The fabric is first slashed to provide the pocket opening. A facing in the shape of the inside pocket is used to finish the slash and to serve as the front layer of the inside pocket. Seam allowance at the upper edge of the slash (at the seam from which the pocket is suspended) is usually ¼ inch and gradually is reduced to nothing at the bottom of the slash. The facing outline is traced for the back of the pocket.

A variation of the slash pocket is the *keyhole pocket.* Instead of a slash, a circle or teardrop shape is cut out and faced with the front of the inside pocket, the same as for the slash pocket (Figure 14.3).

yoke

Figure 14.4 / Yoke

Skirt or Pants Side Pockets

These pockets are inserted into skirts or pants at each side. The opening begins at the waistline and slants to the side seam. The opening may be a simple straight line, as in the men's wear *slant pocket* trouser, or it can be stylized, as in the typical *western pocket.* The facing for the opening of these pockets is cut large enough to form the upper layer of the inside pocket. The back layer of the inside pocket extends to the waistline and side seam, so that when the pocket is assembled, the skirt or pants front is complete (Figure 14.5).

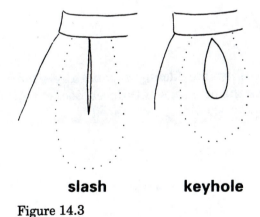

slash **keyhole**

Figure 14.3

side **western**

Figure 14.5

Yoke Pockets

This pocket is worked into the seam of a yoke, usually a shoulder yoke. It is a popular design feature of western shirts. Sometimes, an extension of the yoke forms the inside pocket. The yoke can also form a buttoned or snapped flap for the pocket. In that case the inside pocket can be cut separately or in one with the main pattern piece of the bodice (Figure 14.4).

Tailored Pockets

In women's apparel, tailored pockets are primarily used in jackets, coats, and sportswear. These pockets are finished with welts or flaps, and they are a traditional, functional design component of tailored garments. Once the position and size of

the pockets are determined and indicated on the muslin, the pattern pieces for these pockets must be precisely drafted, so that all pieces will fit together as the pocket is sewn. In jackets and coats, the actual pocket pouch, always on the inside of the garment, is cut in a soft, tightly woven cotton fabric, called *pocketing*.

In traditional men's wear tailoring, the *welt pocket* is used only as a breast pocket, but in women's wear, it may be used anywhere and inserted at any angle. The opening of the pocket is covered with a welt that can range in width from ½ inch to 1½ inches. The traditional welt for a men's wear breast pocket is 1 inch wide and 4½ inches long, and it is inserted horizontally at a slight angle (Figure 14.6).

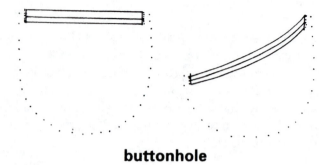

buttonhole

Figure 14.7

A *flap pocket* can be constructed in two ways. The flap can be inserted below the upper piping of a double-piping pocket or the flap itself can be used to finish the upper edge of the pocket opening. In that case, the lower edge of the pocket opening is usually finished with a narrow welt (Figure 14.8).

welt

Figure 14.6

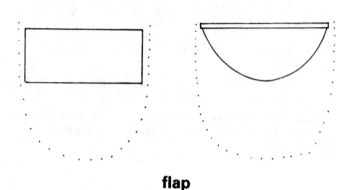

flap

Figure 14.8

The *double-piping pocket,* or the *buttonhole pocket* as it is also called, looks like a large bound buttonhole. The opening may be straight or curved. When the opening is slightly curved, the pocket is less likely to sag (Figure 14.7).

Fusible interfacing is generally used to reinforce the openings of tailored pockets. All flaps and welts should be interfaced.

Draping in Fabric and Fitting

Instead of draping in muslin, some designers find draping ideas in the final fabric easier. Some even eliminate the sketch and create new designs directly on the dress form. Often the texture and pattern of the actual fabric will suggest ideas that become clearer as the fabric is manipulated. In addition, draping directly in the fabric of the finished garment will show precisely the effect that is desired. Stiffness or softness of hand, as well as the effect of surface texture, is immediately apparent. The feel and texture are particularly important when working in knits or other stretch fabrics. The *amount* of stretch varies considerably from fabric to fabric, and draping in the selected fabric is the only way that the desired fit can be achieved.

A. PREPARATION OF FABRIC FOR DRAPING

Because a whole garment must be cut, rather than the usual muslin where only one half is draped, the pieces of fabric required for a section of the garment must be large enough for both sides of the figure if the center front or center back is to be cut on the fold.

1. Cut, block, and press the fabric, the same way as for the muslin, for the desired style. Permanent-press finished fabrics often cannot be blocked. Cut these fabrics following the pattern of the fabric so that the effect is as straight as possible.
2. Thread-trace all necessary grain lines. Stone chalk may be used to mark grain lines, but thread-tracing tends to be more accurate and will not stain the fabric. On fine fabrics, silk thread which does not leave a residue should be used for all tracing. The center front and center back are always thread-traced.

B. DRAPING STEPS

1. Pin the center front or center back to the dress form. If the center seam is to be cut on the fold, temporarily pin the excess fabric to the right side of the dress form.
2. Drape the left side of the garment as desired. When draping a garment section with a center fold on bias grain, drape both sides of the section to prevent any distortion of the grain.
3. Mark only the left side of the garment using pins. The pins should follow the direction of the seams and darts.

4. Remove the work from the dress form, and true the pin markings on the wrong side of the fabric with stone chalk.
5. Fold the fabric, right sides together, along the center. Pin the sides together to prevent shifting, and using *white* tracing paper, transfer all lines. *When the garment is cut on the bias grain,* smooth the fabric carefully only on the lengthwise or crosswise grain in order to prevent any stretching or twisting. Also, the fabric may not be wide enough to include the entire other half of the pattern piece. In that case, another piece of fabric may be joined along the lengthwise grain to complete the shape as illustrated. If there is no center fold, duplicate the pattern on another piece of fabric for the second half of the garment, using the same method as above (Figure 15.1).

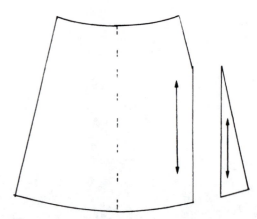

Figure 15.1 / Step B5

6. While both sides are pinned together, trim away the excess fabric, leaving the seam allowance. Leave wider seam allowances on *bias-cut garments*. These garments should hang, completely pinned together, for at least 24 hours. After the pattern pieces have been allowed to stretch, replace the garment on the dress form, and make any necessary adjustments before the pattern is completed.
7. Transfer markings to the right side of the fabric by thread-tracing.
8. If the garment is to be duplicated, a pattern in either muslin or paper should be traced from the fabric pieces before they are sewn together.
9. Add seam allowances and cut out the pattern.

Eliminating Darts

Garments may be fitted to the body without darts. As previously discussed, gathers, pleats, tucks, and seams can all serve to take up excess material, shaping the flat fabric to the curves of the human form. However, garments often flow over the body, easily fitting without any apparent fitting devices (Figure 15.2).

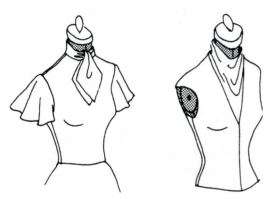

Figure 15.2

By skillfully distributing ease into the armhole and shoulder area, and by shrinking and shaping the fabric wherever possible, darts do not need to be used to fit the fabric. This method is not suitable for fabrics with nonshrink or permanent-press finishes. On the other hand, knits or stretch fabrics can easily be molded to the body, and a wide range of linens, silks, cottons, and shrinkable woolens respond to careful shaping and handling. Loosely woven fabrics can be molded more easily than firmly woven fabrics.

When planning to fit a garment without darts, draping in the fabric of the finished garment is best. Either of two methods may be used.

A. FIRST METHOD
1. Distribute the ease and pin it into place.
2. Pin the style tape over the shoulder seam and armhole. Baste into place.
3. Baste along the area where the excess fullness disappears.
4. Remove the fabric from the dress form.
5. Shrink out any excess fullness, using steam.
6. Use a press cloth for woolens and other fabrics that are easily marked by the iron. (Figure 15.3).

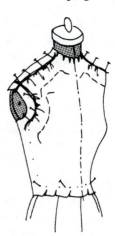

Figure 15.3 / First method

B. SECOND METHOD—This method is best for production purposes.
1. Distribute the ease and pin it into place. Mark the seams and trim away any excess fabric.
2. Pin a piece of muslin smoothly over the area to be molded; mark the seams and trim away all excess muslin.
3. Remove the fabric and muslin from the dress form.
4. At this point, before the shape is molded into the fabric, remove the muslin from the fabric and flatten the fabric. Transfer the fabric and muslin pattern to paper. This paper pattern is then used to cut duplicates of the original when they are needed.
5. Return the fabric carefully to the dress form, shaping ease as before. Baste the muslin to the fabric; do not disturb the ease (Figure 15.4).

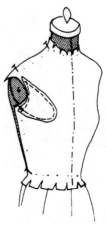

Figure 15.4 / Second method

6. Remove from the dress form.
7. Work on the wrong side of the fabric (the muslin must be underneath) and shrink out excess fullness, using steam.

Transferring Fabric Patterns to Paper

To transfer fabric patterns to paper accurately, care must be taken to maintain grain position, and all seam lines must be precisely duplicated. Even slight departures from the original can have devastating effects on the fit and proportions of any garments that are ultimately developed from these patterns.

1. Separate pattern pieces, open darts, and press flat without disturbing the grain.
2. For garments cut on the straight grain:
 a. Chalk-mark or thread-trace crosswise and lengthwise grain lines across the back and front of the bodice pattern at 2-inch intervals, starting at the intersection of the armhole and side seam. For skirt and slacks patterns, start the crosswise grain lines at the hip level, and the lengthwise grain lines spaced evenly from the previously marked length grain (Figure 15.5).

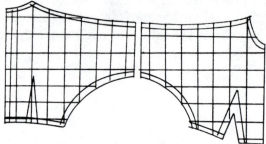

Figure 15.5 / Step 2(a)

 b. On pattern-making paper, draw a grid with lines spaced 2 inches apart to correspond with the lines marked on the muslin or fabric pattern (Figure 15.6).

Figure 15.6 / Steps 2(b)–3

3. Place the fabric patterns on the paper with the straight grain and cross grain lines aligned. Smooth the rest of the fabric patterns into place and secure with pins or weights. Trace carefully on the seam lines with a tracing wheel.
4. Retrue all seam lines making sure that side seams are the same length, that all other seams match except for areas that are to be eased, that all crossmarks correspond, and so forth.
5. Add the seam allowances and cut out the patterns.
6. For a finished pattern, change all the crossmarks into notches at the edge of the seam allowance.

Fitting

After the muslin is draped and again when the first sample has been sewn, the garment should be fitted on a live model. Although the muslin may fit well and look great on a dress form, the true fit and look of a garment can only be accurately evaluated on a moving person. Will the sleeves still be comfortable when the arms are lifted? Will slacks and skirts still fit when the model sits or walks? These, and many other aspects of a garment must be checked and, if necessary adjusted, before the garment is manufactured and delivered to the customer.

Especially today, when first samples for mass production are often sewn in distant factories, the fitting and evaluation of each sample prior to approval for the line is extremely important. Each sample or prototype is shipped back to the company headquarters where it is fitted on a model, evaluated and either rejected, approved, or adjusted. When the style is approved but adjustments are necessary, pattern corrections are determined at the fitting and then entered into a computer. This method creates an instantly adjusted pattern. The sample is then recut and a new sample is sewn, which again must be fitted on a model prior to final approval.

A first muslin fitting is still required in better sample rooms and is absolutely essential in custom dressmaking. After the garment has been draped and the pattern is trued, it is ready for the first fitting.

A. PREPARATION OF MUSLIN FOR FITTING— Before a muslin is fitted, it must be recut as a full garment. It is then sewn together with a machine-basting stitch. If a set-in sleeve is used, the sleeve is finished, but not sewn into the armhole. Shoulder pads and interfacings are basted into place.

B. FITTING STEPS
 1. Check whether the line desired requires changes in the shoulder line. Remove or add to shoulder padding if necessary.
 2. When fitting a muslin, check that grain lines are straight both lengthwise and crosswise. Whether finished or partially finished, a garment must fall with grains balanced. To adjust the grain, open the seams and raise or lower the fabric as necessary so that the garment falls correctly and is pleasing to the eye.
 3. For a set-in sleeve:
 a. Check the armhole. When fitting a muslin or partially finished garment, check that the bodice above the bustline is wide enough so that there is no pull at the gusset point, which is located halfway between the base of the neckline and the apex level (Figure 15.7). Adjust the armhole if the upper chest area is too narrow. If desired,

lower or raise the armhole. An armhole that is too high will be tight and will bind. A lowered armhole is usually more comfortable, but if it has been lowered below a certain point, the sleeve cap must be raised at the underarm. If adjustments in the armhole are needed when fitting a finished garment, remove the sleeve and follow the same instructions.

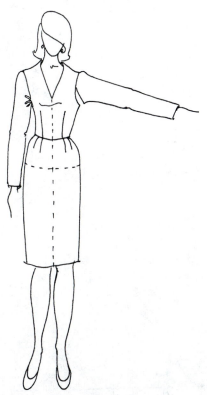

Figure 15.7 / Steps B3(a–b)

 b. If the model cannot raise the arm without pull in the bodice, the sleeve cap must be raised at the underarm. In order to determine the amount needed at the underarm area of the sleeve cap, release the armhole seam at the underarm from the front to the back gusset point. Then have the model raise her arm and determine the exact amount needed for comfortable movement (Figure 15.7).
 c. Use the gusset point at the sleeve cap as the pivot point, pivot the sleeve sloper

up at each side the amount determined to facilitate ease of movement. See the illustration (Figure 15.8).

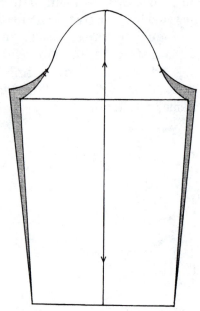

Figure 15.8 / Step B3(c)

d. Check the width of the sleeve. If the sleeve is tight, add width by splitting the sleeve (Figure 15.9).

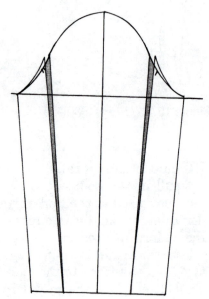

Figure 15.9 / Step B3(d)

e. Check the ease in the sleeve cap:
 (1) If the sleeve cap has too much ease, several adjustments may be

made. The armhole may be slightly lowered, the side seam extended, or both.
 (2) If the sleeve cap does not have enough ease, the sleeve is cut wider.
f. When the armhole and sleeve have been adjusted, set in the sleeve. The sleeve should fall straight down above the elbow and curve slightly forward below the elbow following the shape of the human arm. Reset the corrected sleeve (Figure 15.10).

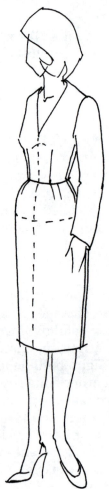

Figure 15.10 / Step B3(f)

4. Check the side seams. Release or take them in on both sides as needed, maintaining the balanced grain.
5. Check the waistline:
 a. If the waistline is too low, raise it by taking a tuck between the bustline and the waistline.

b. If the waistline is too high, lower it by splitting the bodice between the bust-line and waistline and add material (Figure 15.11).

Figure 15.11 / Step B5(b)

c. When fitting skirts and slacks with a waistline seam, check for horizontal pull in the back of the garment, below the waistline. This pull can be corrected by lowering the back waistline (Figure 15.12).

Figure 15.12 / Step B5(c)

6. Check the neckline. If tight, adjust by lowering; if too low, raise as necessary. If any adjustments are made in the neckline, the facing and collar must also be adjusted to fit the new neckline dimensions.

7. Check all style lines, including pockets, collars, etc. Proportions and the general silhouette can best be evaluated on a live, moving model (Figure 15.13).

Figure 15.13 / Step B7

Selected Bibliography

For those who wish to learn more about the areas related to draping mentioned in various sections of this book, this selected bibliography may be used as a resource for further study.

Flat Patternmaking

Armstrong, Helen Joseph. *Patternmaking for Fashion Design,* 2d ed. New York: Harper and Row, 1995.

Kopp, Ernestine, Vittorina Rolfo, and Beatrice Zelin. *Designing Apparel Through the Flat Pattern,* 6th ed. New York: Fairchild Publications, 1992.

———. *How to Draft Basic Patterns,* 4th ed. New York: Fairchild Publications, 1991.

Price, Jeanne, and Bernard Zamkoff. *Basic Pattern Skills for Fashion Design.* New York: Fairchild Publications, 1987.

———. *Creative Pattern Skills for Fashion Design.* New York: Fairchild Publications, 1990.

———. *Grading Techniques for Modern Design,* 2nd ed. New York: Fairchild Publications, 1996.

Sample Sewing

Amaden-Crawford, Connie. *A Guide to Fashion Sewing.* New York: Fairchild Publications, 1986.

Reader's Digest Complete Guide to Sewing, rev. ed. Pleasantville, NY: The Reader's Digest Association, 1995.

Relis, Nurie, and Gail Strauss. *Sewing for Fashion Design,* 2d ed. Upper Saddle River, NJ: Prentice Hall, 1997.

Singer Sewing Step by Step. Minnetonka, Minn.: Cy De Cosse, Inc., 1990.

Tailoring

Cabrera, Roberto, and Patricia Flaherty Meyers. *Classic Tailoring Techniques: A Construction Guide for Women's Wear.* New York: Fairchild Publications, 1984.

Ledbettr, N. Marie, and Linda Thiel Lansing. *Tailoring: Traditional and Contemporary Techniques.* Reston, Va.: Reston Publishing Co., 1981.

Wyllie, Ethel. *Today's Custom Tailoring.* Mission Hills, Ca.: Glencoe Publishing Co., Macmillan, Inc., 1987.

Fashion Sketching

Abling, Bina. *Fashion Sketchbook.* New York: Fairchild Publications, 1988.

———. *Advanced Fashion Sketchbook.* New York: Fairchild Publications, 1991.

Gersten, Rita. *Innovative Fashion Sketching.* New York: Innovative Enterprises, 1984.

Tain, Linda. *Portfolio Presentation for Fashion Designers.* New York: Fairchild Publications, 1998.

Tate, Sharon Lee, and Mona Shafer Edwards. *The Complete Book of Fashion Illustration.* New York: Harper and Row, 1987.

Special Interest

Frings, Ginni Stephens. *Fashion from Concept to Consumer,* 6th ed. Upper Saddle River, NJ: Prentice Hall, 1999.

Jaffe, Hilde, and Rosa Rosa. *Childrenswear Design,* 2d ed. New York: Fairchild Publications, 1990.

Tortora, Phyllis, and Keith Eubank. *Survey of Historic Costume,* 3d ed. New York: Fairchild Publications, 1998.

Zangrillo, Frances Leto. *Fashion Design for the Plus-Size.* New York: Fairchild Publications, 1990.

Index